FRENCH SCULPTURE
AT THE BEGINNING OF THE GOTHIC PERIOD
1140-1225

FRENCH SCULPTURE
AT THE BEGINNING OF
THE GOTHIC PERIOD

1140 - 1225

by

MARCEL AUBERT

HACKER ART BOOKS

NEW YORK

1972

First published by Pantheon. Casa Editrice
Firenze, 1929
Reprinted by Hacker Art Books, Inc.
New York, 1972

Library of Congress Catalog Card Number: 75-143337
ISBN: 0-87817-057-X

CONTENTS

LIST OF PLATES

XIII

THE TEXT

THE GROWTH OF THE EARLIEST GOTHIC SCULPTURE
IN THE ILE-DE-FRANCE

DURING that period when the Romanesque sculptors in every county of France were employing their art in adorning the capitals and façades of cathedral and abbey with scenes from the Old and New Testament; when in Languedoc and Burgundy, in Saintonge and Poitou, the most complicated schemes had been successfully carried out, in the Ile-de-France the first half of the 12th century had seen as yet the production of only a few works of poor quality, until there appeared in 1140 the extraordinary front of St.-Denis with its three doors, entirely covered with sculpture, which marks the commencement of a new style.

I have shown elsewhere[1] the reasons for the revival of architecture in the Ile-de-France in the middle of the 12th century; I have shown how in the neighbourhood of Saint-Denis huge churches were built on the plan of the old abbeys, but larger, lighter and more graceful than any before them. This new type of architecture, which, though based on an older style, was destined to transform the whole art of the Middle Ages, brought a new type of sculpture with it. It is in the Ile-de-France that the seeds of Gothic architecture may be unearthed; it is there, too, that the first beginnings of Gothic sculpture appear. The new formula of the architect produced a new formula for the sculptor.

The primary effect of Romanesque sculpture was a decorative one. Round the capitals, on the tympana of the great abbeys of Languedoc and Burgundy, on the vaultings and façades of the churches of Saintonge and Poitou, the sculptors carved in a style at once pictorial, witty and decorative — it is most common, perhaps, in the West, where scenes from oriental art were often adopted bodily without any particular heed to the iconography — the life of Christ, the visions of the Revelation, the miracles of the Saints, or the struggles between Man and the Powers of Evil.

These great scenes, carved in relief, with the figures standing out against the deep shadow of the under-cutting, were enlivened by the application of paint, which recalls the frescoes and mosaics of the old basilicae. As in illuminated manuscripts, of which these reliefs seem to be merely enlargements, the design-

er tried to fill up all the blank spaces and so the composition became fussy.

The Romanesque sculptors were incapable of representing the human form in the round and contented themselves with the flat, but being ignorant of the rules of perspective or of foreshortening, they represented figures in profile or, if a frontal seated figure was necessary, the legs were twisted to the side or the knees splayed, the toes pointing downwards. The robe clinging to the body was wound tight round legs, arms, and stomach to emphasize the angles, while the arms were caught close to the body and the hands flattened on the breast. The figures on the great Romanesque tympana, on the jambs, the doors, the pillars of the cloisters or the capitals are in low relief and cannot be classed as statues.

At the same time, being unable to render expression, the Romanesque sculptors accentuated movement, twisted the body, crossed legs and arms in conventional attitudes, and made the drapery flutter in restless, impossible folds, which smack of calligraphy rather than of sculpture and recall the drawing of illuminations. This movement sometimes even overflows beyond the surrounding frame.

In many churches, indeed in some of the most important, the door is not placed in a position worthy of it, but is overweighted by a vast porch, in which it counts no more than the blind arcades beside it in a façade loaded with ornamentation taken from the illuminated page, the ivory diptych or the goldsmiths' altar-piece. Occasionally it is found at the side of the nave, a kind of accessory to the main structure.

The new formula is quite different. The door occupies the place of honour in the centre of the façade, which is flanked by tall towers. Iconographic sculpture is not permitted in the interior, but reserved exclusively for the doors of the façade, the lines of which it follows. The composition is more clear-cut and expresses rhythmically a much simpler idea. The tympana are decorated with great reliefs, as in Languedoc and Burgundy, but harmony and symmetry are the order of the day. On the walls, statues are allied to the columns, an idea both new and original. The sculpture ceases to be merely a series of decorative slabs fastened to the wall; it becomes an integral part of the construction and derives its form and character from the same source. As a contrast to the restlessness of Romanesque, comes the repose of Gothic, with its restrained ges-

tures and attitudes. The reaction was too rapid and produced statues which are archaic and stiff and sometimes deceive the superficial observer as to their date; but the style soon softens and is content to preserve the grand and restrained ideal which fits sculpture for its place in architecture. Moreover the style does not change completely in a year or so, so that here and there one may see certain conventions of attitude, as for instance the crossing of legs, while the drapery still retains in some cases the geometric or fluttering folds, which are characteristic of Romanesque; fifty years must pass before experiment has achieved those fuller, freer draperies which come closest to actuality. Decorative motives became simpler and even in the most important doorways the monsters of the oriental animal myths disappear almost entirely. The voice of St. Bernard is heard; the artist rejects little by little « those strange beings, whose beauty consists in distortion, those dragons, monkeys, centaurs, tigers and bristling lions, those monsters with many heads, that disturb the fancy and the attention ». Only a few motives are left, the meaning of which is quite plain. Iconography bows to rule, as dogma does; Sculpture cannot be left to the whims of artists, she has her teaching mission. Suger states that « Men's minds must be led by material things towards the immaterial ». Rules are laid down as to iconography. The Appearance of the Son of Man in Majesty with the symbols of the Evangelists, which was destined to give way gradually to the theme of the Last Judgement: the Ascension, or the Childhood of Christ; and the Virgin in Majesty holding the Child in her arms or showing it to the Magi, a theme which at the end of the 12th century at Senlis, in proof of the ever-increasing popularity of the worship of Mary, will be replaced by the Triumph of the Virgin.

So theologians and architects joined together to define the rôle which sculpture was to play. For fifty years we shall see here in the Ile-de-France, where Romanesque tradition was less firmly established and where Gothic architecture was to develop its principles, sculpture adapting itself to this rôle; little by little Romanesque archaism will vanish, the stiffness of the first reactionary attempts will soften, and towards the end of the century will come at last that ideal of beauty, to which have contributed naturalism in pose and drapery and restraint, calm and nobility of feeling, indispensable adjuncts of monumental sculpture.

3

St.-Denis is the church where the new formula first appears. We possess full details about the rebuilding of the abbey in the 12th century and about its decoration, left us by the Abbé Suger, who inspired and supervised the work. It is true that in his two works[2] he does not describe the sculpture of the façade with the same detail which he lavishes on the fittings, the glass and the treasure, but he alludes to it; he tells us that he ordered the best masons and sculptors from every corner of France and points to the inscription, which he had engraved under the tympanum of the central porch with its representation of the Last Judgement.

Suscipe vota tui, judex districte, Sugeri,
Inter oves proprias fac me clementer haberi.[3]

The decoration of the façade was thus done at the same time as the building, and the sculpture must have been in place on the 9th of June 1140, when the solemn dedication took place of the narthex and the new façade. Suger had been thinking of it for a long time and since 1126 he had exempted from the tax of mortmain every inhabitant of Saint-Denis, who had given him £ 200 for the « carrying-out of the new church ».[4] He had undoubtedly planned the work before, the work was possibly already under way, but the sculpture could not have been carried out till a little later, between 1135 and 1140.

The façade is pierced by three doorways which were covered with statues and bas-reliefs of the highest importance in the history of French art; for they constitute the beginning of Gothic sculpture. It has unfortunately suffered through changes of taste and politics. From 1771 onwards, the statues on the columns began to be mutilated and, during the Revolution, the same thing happened to the tympana and the arch-rims, while the decoration and inscriptions were smashed. An unfortunate restoration by Debret and his sculptors in 1835, in which the architect tried to reconstruct the iconography and the inscriptions, has tended to discredit the doors of St.-Denis in the eyes of the archaeological world, who refused to recognize the fragments of original work still left among the modern restorations. Happily Baron de Guilhermy, who in 1846 at last succeeded in stopping these deplorable onslaughts, had jotted down what parts had been preserved, and these notes, now kept at the Bibliothèque Nationale,[5] allow us to allocate to the bas-reliefs, which frame the doors, the importance of which they have been for long deprived.

The tympana of the two side doors, representing the Last Communion of St. Denis and the Death of the Three Martyrs, are the work of the sculptor Brun; the left-hand relief replaces a mosaic ordered by Suger from an Italian workshop. Brun and his assistants also re-carved, under the supervision of Debret, the heads, hands, attributes and inscriptions of the Last Judgement on the central tympanum, the inner arch-rim which frames it, with scenes from Paradise and Hell — it is signed and dated 1839 — and the two arch-rims of the side doors.

The three arch-rims of the central door, on which are carved the Elders of the Revelation, have been scraped and refurbished, but still belong to that portion which is Suger's work, as do the roundels and arabesques and the decoration of the abutments, though all has been restored and some re-cut by the chisel of repairers, who have even gone so far as to deepen the niches to set off the figures, to heighten the reliefs, and sometimes to alter the costumes and gestures.

The general arrangement, then, is the old one, but for the first time we find a Gothic door per se; a pierced recess under a sculptured tympanum enclosed by deep arch-rims ornamented with statuettes, which as time goes on will become more and more numerous, and set in a framework of piers decorated with reliefs and statues, aligned to columns. These last are no longer in existence, but we know what they were like by Bernard de Montfaucon's [6] engravings and better still by the lovely drawings preserved in the Manuscript Room at the Bibliothèque Nationale in the precious mass of material put *Plate 2* together by the Benedictine scholar for his magnum opus. [7]

The Last Judgement on the tympanum of the central doorway is the same in composition as that of the Abbey of Beaulieu in the Corrèze district. They are *Plate 1* almost contemporary and are doubtless inspired by a common original now lost. In the middle Christ is seated as Judge, his arms extended, the left draped, the right bare. Behind him is the Cross, at either side the Apostles; while below, on the lintel the dead are issuing from their graves. M. Mâle, who was the first to point out the resemblance between the art of St.-Denis and that of Languedoc, has also shown how the Wise and Foolish Virgins, who here for the first time appear on the walls beside a doorway of the Last Judgement, and are arranged, the first group bareheaded, with flowing robes clinging to them, their lamps extinguished, the second with veiled faces, wrapped in

5

long mantles, their lamps held high, recall in their poses — a few have crossed legs — their gestures and their draperies certain of the capitals of the South carved with this scene, in particular one of those now in the Musée des Augustins at Toulouse.

Plates 3, 4 The abutments of the side doors are also decorated with reliefs : on the left the Signs of the Zodiac, on the right the Occupations of the Months, set in big roundels edged by foliage which vanishes down the throats of monsters. This scheme is framed by small columns decorated with knots, lozenges and beads, which are crowned with capitals of acanthus and interlaced design and stand on bases ornamented by confronted beasts. Atlantes support these columns and above, on the chamfering, are lying nude figures. We see in all this decoration, in itself as rich and sumptuous as the Romanesque doors of Languedoc, Aquitaine, of Apulia and North Italy, that taste for the antique to which Suger's letters to Peter the Venerable bear witness, in which Horace, Lucan, Virgil, Terence, Juvenal and Ovid are quoted as often as the Fathers of the Church. [8]

Plate 2 The statues on the columns which used to stand round these three doors were quite an innovation in design. They represented the Kings and Queens of the Old Testament, and old men in Jews' hats, the forerunners of Christ, the Patriarchs and Prophets who foretold his coming. Two statues on the left door and one on the right were barefooted and may have represented St. John the Baptist or Apostles. On the centre door were eight statues and on each of the side doors six; seven of these, five on the left and one each on the centre and right, had their legs crossed. These statues, backed to the columns and cut from the same block as they, were of an elongated type, the legs close together or crossed, the arms tight to the body and enveloped in flowing robes which fell to the ground in many folds; the women wore tunics which fitted the body tightly, and cloaks, the men togas or cloaks, one of them pulling the skirts round his body. Other statues of the same type were in the abbey cloisters. Montfaucon tells us of two in what was then called the old cloister, which were of Suger's period[9]; they were fastened to columns and represented men with haloes, one in a great cloak and crown, the other in a toga and Jew's hat.

These statues at Saint-Denis draw their inspiration from the doorways at Moissac, Beaulieu and Souillac, from the chapter-house of Saint-Caprais at Agen [10] and also from the well-known figures of apostles on either side of the

6

door of the chapter-house of St.-Etienne at Toulouse, which were dismantled when the cloister was destroyed in 1812 and are now kept in the museum there. They are Apostles in long robes with delicate folds, standing (some with legs crossed) talking to each other, and are perhaps the prototypes of the statues on the abutments and the pier of the great door at Vézelay, while at St.-Denis they have a value and significance all their own. They are no longer a simple decoration making a vivid pattern on the blank wall, as at Moissac and Beaulieu; they do not only add to the enrichment of the door as at Toulouse or in the old Hôtel-Dieu at Le Puy (three pillarets are now in the museum); or again as at Modena, Cremona and many doorways in North Italy, they are not kept for the corner of some pier, already loaded with sculpture, or hidden behind columns where their importance is scarcely greater than the rest of the decoration. They are the actual columns which support the arch and doorway of the sanctuary; cut with the column, they take on its form, grow tall and slender, become column-statues and so part of the new formula of Gothic.

At the same time that the construction grows more airy, graceful and light, and launches out into a delicate network of ribs, by the play of balance and counter-balance which tends to support masonry of less formidable proportions, the statues step out from their background and take on their proper value, though remaining an integral part of the unity of the scheme. This done they become part of this new art of Gothic which was to develop throughout the second half of the 12th century, to reach its full flower in the 13th. It is then that appears, under the powerful influence of Suger, whose inspiration, instinct with order, harmony and symbolism, is apparent in every line of this façade, the type of the Gothic door with its great sculptured tympanum, framed in a succession of arches, its walls decorated with medallions, and its column-statues standing in embrasures, which, after elaboration in the 13th century cathedrals, was destined to spread throughout all Europe.

The column-statues, which we can only reconstruct in imagination at St.-Denis, were destined to prove widely popular. They will reappear on the Portail Royal at Chartres and in a group of churches, which felt the influence of St.-Denis and Chartres; then little by little we shall see them change, lose the stiffness of the column and the resulting deformity, and come to life.

Plates 5-18

There has been considerable discussion as to the date of the Portail Royal of the west façade at *Chartres*. M. Marignan thought it later than 1194[11]; the Abbé Bulteau, who first believed it to be about 1170, later put it back to between 1110 and 1149[12]; the Comte de Lasteyrie, in his beautiful «*Etudes sur la sculpture française du moyen âge,*[13] dates it in the third quarter of the 12th century, while Vöge put it before 1145.[14] Viollet-le-Duc[15] thought it had been executed immediately after the fire of 1134, and M. Albert Mayeux[16] several years before that.

If we look at the form of mouldings, of bases, of abaci, and the style of the capitals we shall see that this door is appreciably later than the north tower or even the south tower of the façade, and that it dates from the middle of the 12th century.

Lanore's work[17] and the researches of Eugène Lefèvre-Pontalis[18] prove that after the fire of 1134, which destroyed the façade of Bishop Fulbert's church, the foundations of the north tower were laid at some distance from the old façade. The work went on quickly thanks to the enthusiasm of the people, as we know from Haimon, Abbé of St.-Pierre-sur-Dives, and Hugues of Amiens, Archbishop of Rouen. The south tower was begun a little before 1145; for Robert de Torigny, who went there in that year, saw two towers in course of construction. The north tower was finished about 1150, the south about 1170.

In addition the death-notice of the Archdeacon of Dunois, Richer, between 1152 and 1156, a date which M. Merlet has established,[19] reminds us that he gave a gilded statue of the Virgin to decorate the main door, which can be identified with that on the tympanum of the right-hand section of the Portail Royal, on which Paul Durand was still able to find some traces of gold.

So we can date the Portail Royal roughly between 1145 and 1155 with Lanore and Lefèvre-Pontalis. After St.-Denis it is the oldest of this group of doors with column-statues, which were so popular in the Ile-de-France in the second half of the 12th century and were the ancestors of the great Gothic doorways. Its nearest neighbour in date is the south door of the nave at Le Mans, which can be roughly dated between 1150 and 1155, as we shall show later.

The Portail Royal at Chartres did not stand on its present site originally. One is astounded by certain clumsinesses, mistakes and uncertainties in the unity of the composition; and certain stylistic differences leap to the eye in

8

various parts. The door is not in harmony with the towers that flank it; the unity is broken; the balance is different. The south tower looks to the west, the north to the east and the façade has been raised to overcome this difference.

The materials are different. The towers, like the rest of the cathedral are made of Berchères stone, but the plinths and walls are of grey stone from Senlis, while the tympana, statues and columns are of a softer stone, which may have come from the Oise valley or, according to M. Mayeux, from Normandy. All show traces of reconstruction, which the researches of Eugène Lefèvre-Pontalis in 1901 and 1902 have proved.[20]

The Portail Royal was first erected about 2.20 m. behind the clock-towers in front of a porch of three bays with pointed vaulting, which was built about 1145 at the base of the façade of the 11th century church and not at the end of this porch, as Paul Durand and the Abbé Bulteau believed.

After the fire of the night of the 9th and 10th of July 1194 destroyed the 11th century Cathedral, though the crypt was untouched, the west front and the towers,[21] the Portail Royal and the three windows above it were brought forward into line with the west face of the two clock-towers, and later, about 1220, the architect built above them a rose-window, and launched two great pointed vaults to bind the front to the vaulting of the nave, which had just been completed.

The new site was unfortunately slightly narrower than the old, and several portions had to be sacrificed to the new position. To begin with, the buttress of the north tower had to be lowered to make room and that of the south tower was cut to let in the last capital of the right-hand door, which represented Christ appearing to the Apostles; then the small column to the left of the lintel of the centre door had to be masked by the angels of the first arch-rim, the tympanum and lintel of the right door had to be cut back ten centimetres to the right, into the middle of a group of a shepherd and a lamb and on top of one of the figures in the Presentation, and the canopy of the Virgin on this same door had to be removed altogether or at least pared away by the same saw which was reducing the width of the tympanum.[22]

Certain pieces of re-cutting are noticeable, which must have been done to replace details that were broken in the course of the transference or to fill gaps in the new site; some statuettes of a later style, as, for instance, the angels carrying a crown at the key of the arch of the central door; the canopy on the

right door with its cresting of pinnacles, decorated with rows of lozenges, which foreshadow those on the transept doors; columns, which have been re-cut, lengthened or shortened to fit their new places. There can be no objection to the possibility of such a construction; several other instances are known in the 12th and 13th century. We have Suger's word that he preserved an old door in his new church; at Saint-Denis too, a 12th century door was put in the north front of the 13th century transept; at Notre-Dame in Paris, the tympanum and part of the 12th century series of statuettes have been preserved on the St. Anne door, which was carved about 1230; in the north transept at Rheims 12th century sculptures are still visible; while at Moissac and Cahors the great west doors were taken down, to be put up again one on the south, the other on the north.

The composition of the Portail Royal shows the debt due to the new ideas seen at St.-Denis. The division of the façade into three parts by means of two buttresses, the perfect symmetry of the two side doors with the corresponding iconographic obligations, which M. Hourticq noted so admirably in a recent work,[23] and the simplicity of the component parts, gives an immediate and striking effect of grandeur. The three doors open on to the nave; the side-aisles run right up to the flanking towers of the façade; an arrangement which is uncommon in the great Gothic cathedrals and one which can only be explained by the changes mentioned above.

The lintel and tympanum are set deep in great arch-rims, which are decorated with statuettes and edged with a string-course, slightly restored by the work of the 19th century, and supported on columns against which rest statues, divided from each other by demi-columns of smaller diameter, which bear scrolls carved with flowers and delicate reliefs, and carry statuettes. On the capitals of both columns and demi-columns are carved small scenes with various characters in the manner of the Romanesque. The bases are decorated with fluting. St.-Denis has already shown us the beauty of this rich tapestry carved on wall, pier and column; we shall meet it again on several doors of the same type, but it will become less elaborate and disappear entirely at the end of the 12th century, when the Gothic door comes finally into its kingdom and statuary will have prevailed over decorative sculpture.

The technique is still close to that of the Romanesque sculptors. The style of artists, who undoubtedly came from the workshops of the great Roman-

esque abbeys, could not change except by degrees and there are still to be seen, particularly in the capitals, a few figures in distorted poses; the close-fitting draperies are still designed on conventional lines and the wind-blown fold still flutters at the base of robes and mantles. But in the general effect, in tympanum, vaulting and wall especially, a sense of quietude and restraint, to quote the phrase applied by Courajod to art on the banks of the Loire at the end of the 15th century, opposes the restlessness of Romanesque work of the middle of the 12th century and marks the desire for a return to monumental sculpture.

The iconography is still partly Romanesque, but here and there are to be seen new scenes and new interpretations; and so, side by side with the Romanesque tradition, but still reminiscent of the great doors of Burgundy, Languedoc and Aquitaine, from which the artists of St.-Denis and Chartres drew their inspiration, here, as at St.-Denis, bursts forth a new inspiration.

The statues of the columns are the most remarkable witness to this. On the abutments of the three doors there ought to stand twenty-six statues. Were they there, perhaps, when the façade was on its original site? For the two outer statues are crushed by the buttresses of the two towers and are obviously not as originally planned. Others have vanished to be replaced by columns and there are left nineteen, of which some are mutilated or disfigured, while on a few the heads have been re-carved or replaced by those from other statues. The statues of the central door are the finest and in the best state of preservation; *Plates 6-8* of these there remain, on the left, four with haloes, two bearded men, one of whom wears a cap with lappets, and two crowned women; on the right four also with haloes, three men with beards, two of whom are crowned, and a queen wrapped in a long mantle. On the left door, of the two male statues still *Plate 9* standing in the right-hand embrasure, both nimbused, one is very much mutilated, the other has his legs crossed, as in Languedoc, Aquitaine and at St.-Denis, and wears a cap with lappets. To the left are three figures without haloes; these have canopies over them and surmount small groups, one of a charming crowned maiden slaying a dragon, the other two a monkey fighting with some beasts and a very battered figure, which is apparently being strangled by a serpent. The figures themselves are of a crowned woman, whose mantle is held upon her shoulders by a girdle, and two men with long sticks in their hands, one bearded and the other seeming to have been fitted with a head that formerly belonged to the statue of a woman.

11

Plate 10
Plate 11

On the right door, the three statues on the left, all nimbused and canopied, represent a bearded man between two kings without beards; to the right three statues with canopies, representing, the first two a bearded man and a king, both with haloes, standing on monsters, the third a crowned maiden.

These statues seem not to have belonged originally to the same composition or at least to have been arranged differently. Some are too short, and have had to have their columns heightened; others are too long with the reverse result, to remedy which the block under the feet has had in a few cases to be cut away. A few statues seem to have been unable to find a place in the new façade, and it is doubtless one of these which is at the angle of the south tower.

They do not all belong to the same workshop. To one, presided over by the master who is responsible for the new spirit at Chartres, the Master of the Portail Royal, must be assigned the eight statues of the central door and the two statues of the embrasure to the right of the left door; their proportions are very slender, their heads small, the folds of their robes stiff and parallel and their haloes plain, while their feet rest on an inclined tablet. The two first statues to the left of the right door are possibly also from the same workshop, but the proportions are more thickset, the faces broader and lacking character; this is also true of the first statue in the embrasure to the right of the right door, a bearded man standing not on an inclined tablet, but on a monster, a detail to be found for the future on the majority of column-statues. Much finer and much nearer in style to that of the principal workshop, though they stand on monsters and their haloes are decorated with a circle, are the third figure on the left and the king in the right embrasure of the right door. Another workshop, quite different from the first, carved the third statue to the right of the right door and the three statues to the left of the left door; these are less stiff, less elongated, their shoulders and flanks are more emphasized, their gestures more varied, their robes marked with deep folds, which serve to emphasize the shape of the body by quite artificial means. They are the fellows to those on the door at Etampes and differ completely in style from the figures of the first workshop. In spite of their more natural proportions and attitudes they are much closer to Romanesque originals, especially in their draperies and the convention of their conception.

In spite of this difference, all these statues leave an impression of singleness of idea and technique, which bears out the feeling of unity given by the exqui-

site harmony of the composition of the Portail Royal. Slim and elongated, without shoulders or flanks, the legs flattened together, the arms clasped to the body, the head erect, the robe clinging to the flesh and by its straight fall and numerous narrow folds completing the elegance of the line, the feet slant-wise on the tilted pedestal or the monster carved beneath it, they seem to length-en the column to which they are attached and of which they form part. With-out depth, and intended to be seen from the front, they are carved from the same stone as the column and treated flatly, like bas-reliefs, that have lost their setting, in the manner of Romanesque sculpture, which dares not depart from the surface of the stone on which the guiding hand has drawn the design. This elongation, this stiffness, this immobility, which are emphasized by the simplicity and the familiar gestures of the right arm crossed, the left hanging down, are intentional and correspond to the idea fixed by the master of the school. As at St.-Denis, the sculpture is part of the construction and empha-sizes its lines; it is incorporated in it, and shares its majestic grandeur.

The master has kept the sculptors tight shut within the prison of his instruc-tions, but the latter have expressed their individuality in the execution of the heads. These are in full relief and are carved with a sincerity and truth, which struck Rodin forcibly. The variety of their expression and their vitality is masterly; in their stiffness, in their occasional inaccuracy, these statues stand out by their individuality and beauty from the more perfect types of a later date. Though too small, perhaps, for the size of body, the heads have been modelled with loving care; the features are clearly marked, the nose well mo-delled, the eyes big beneath the arch of the brows, which almost overshadow them, the lips are delicate and compressed, the cheeks round, the hair, beard and the long curls of the women carved with nice precision. This careful obser-vance of fact, which shows how these artists of Chartres understood and loved nature, is to be seen also in the details of dress, the embossing of stuffs, finely pleated, with different designs on yoke and bodice, on tunic and mantle, in the embroidery of collars and cuffs, in chains which girdle the waist and are knotted on the belly, in jewelry, brooches and in fact, every detail, which is carved with such accuracy, that the reconstruction of hair-dressings, clothes and jewels of the period has been possible with exactitude.

The significance of these statues, the meaning given them by Suger, which belonged to them throughout the second half of the 12th century, gives

13

them an additional importance. They are not, as has sometimes been thought, the ancestors of Christ, who only appeared up to this time on Jesse-trees, but the elders and prophets of the Bible, the different books of which they represent, like the initials in Mss., long stiff figures painted at the beginning of each book. It is the Old Testament acting as sponsor for the New, introducing it to the Church, or rather holding up the columns of the Temple which protects the Son of God.

The statues of the side doors are crowned by canopies, which were added perhaps at the time of the erection of the new façade, canopies with towers and crockets, foreshadowing those of the 13th century on the transept doors.

Apart from six statues on the side-doors, the rest stand on small columns decorated with geometric designs, key-patterns, windings, chevrons, flowrets or spirals. Some, as we have seen, have been re-carved; a few were made for the particular places they occupy and are flanked by flat spaces. Their bases, with flattened circular mouldings, are decorated at their springing with geometric piercing and the pedestals ornamented with short vertical fluting as one often finds on doors of this type towards the close of the 12th century — for instance, at Etampes, Notre-Dame-en-Vaux, at Châlons, at St.-Germain-des-Prés in Paris and also on the side doors of the cathedral front at Rouen.

Numerous statuettes decorate the walls which support the lintels, and the faces of the two buttresses which separate the three doors. These statuettes, some sitting, some standing, a few in little canopied niches of their own, are also shaped to the pilaster or column against which they lean and are dressed to the wall, a few are cross-legged. They are clothed in clinging stuffs with sharp little pleats and the wind-blown fold of the Romanesque style is occasionally seen at the base of the mantle. It is directly due to the influence of architectural necessity that sculptors abandoned little by little the archaic tradition first of the statues, then of the tympanum, and lastly of the bas-reliefs to bring in rules which are more studied and logical and truer to observation; rules, which are in fact the essence of Gothic. Archaic details can still be seen surviving in the statuettes hidden behind the larger ones and these were possibly carved by artists imbued with old-fashioned principles. Such details survive here and there in the most perfect works of the second half of the 12th century and do not completely disappear till the end of the century.

14

Like the larger statues, these statuettes do not seem to have been put up in any particular order on the new façade. The idea seems to have been simply to decorate the empty niches. Some of them are crowned with canopies, some have none and others have lost theirs through retrenchment. They are all from different workshops, and I think that some of the figures, which are bigger and heavier in style, particularly those on the right side posts of the right-hand door, were added at the end of the 12th century to fill gaps. The oldest, which are set back in deep-hollowed niches, in the manner of the big statues, have strong features, well-marked, rounded cheeks, and deep-arched brows. Among the finest I note on the upright to the left of the right door an angel bearing a soul in the hollow of his mantle, a figure of a bearded man with a strong face unrolling a scroll inscribed « Geremias [profeta] ». Other statuettes represent angels and figures in Bible history. Most of the statuettes at the head of the buttresses no longer have canopies; high up to the left is an Elder of the Apocalypse, his legs crossed, holding a viol; high up to the right a little creature with an ox at his feet, above his head the inscription « Rogerus ». This is undoubtedly a donor, who is shown at his business as a butcher, as below may be seen an armourer with his anvil; in the same way the Guilds mark the magnificent glass windows they gave to the cathedral.

Between the statues the embrasures show small columns set edgewise and entirely detached from the wall at the back of the statues. These are decorated with intertwined ribbons, and with palmettes like those on the borders of the great stained-glass windows of the 12th century.

In this stylized foliage run animals, monsters, birds and centaurs, one of whom carries behind him a woman, who grasps him by the beard; men or women pursuing each other or struggling in the fronds as on the beautiful capitals at Toulouse or Moissac, the similarity to which is here very marked. Most of these little figures have only a decorative and no iconographic value; but on one of the small columns of the embrasure to the left of the right door are represented in medallions in the same position as on Suger's façade at St.-Denis, the Occupations of the Months and the Signs of the Zodiac; January with two heads, February warming himself, March cutting trees, April picking flowers; May, a helmeted warrior on horseback, June gathering hay, July cutting corn, August threshing the grain. The last scenes of the year, the harvest, sowing, fattening of flocks and pig-killing are partially destroyed.

15

This richness of decoration which covers all the three doors of the Portail Royal is a legacy from the Romanesque, but in this case the decoration is cut away from the wall, clothes the uprights of the doors and the buttresses, and covers the columns and the pedestals of the statues; it also follows the lines of the building and becomes part of this new spirit, which was to change the heavy construction of Romanesque into a lighter fabric, the construction of Gothic. This rich decoration will appear again in the most important doorways of this group at St.-Denis, Bourges and Le Mans and will then gradually disappear, when statue-columns will form the sole decoration of the embrasures of doorways.

The columns, both large and small, on the three doors are crowned with capitals with figures, which are tucked away under the canopy and form a regular band of sculpture right across the façade. In these little scenes which form an uninterrupted series and sometimes cover two capitals with one scene, the same artists, who in the statues and on the tympana had to bow to the necessities of the proud dignity of monumental sculpture, give free rein to their

Plates 12, 14 own vigorous love of life and beauty. The movement and vitality of these little beings with clinging draperies in swirling folds at the foot of their robes, who gesticulate in so lively a manner, recall the images, carved by the school which executed the capitals of Moissac and St.-Caprais d'Agen, of St.-Etienne and La Daurade at Toulouse, but even here the influence of the master sculptor keeps the artist in check, imposes on him a certain reserve and a measure of discipline. The head of each little figure is fitted to one of the arches of the canopy and this arch rules and controls the rhythm of the design.

This carved frieze is very important in the history of the iconography of the Middle Ages. It represents with a wealth of detail seldom seen the whole history of Christ. The story begins at the central door, at the bottom of the left embrasure, and runs to the left to the very edge of the façade. It begins again at the bottom of the right embrasure and continues on to the extreme right-hand point of the right-hand door. Anna and Joachim bring their offerings

Plate 14 to the Temple; they are sent away because they have no child. Joachim goes to the fields to watch his sheep; an angel announces the future birth of the Virgin to him; he meets Anna at the Golden Gate of Jerusalem. The Virgin is born and washed in a bason by midwives. Next come scenes of the Presen-

16

tation of the Virgin in the Temple, her Marriage, the Annunciation, Visitation (left door), the Nativity, the Adoration of the Shepherds, the Arrival of the Magi at Herod's Palace, which will appear again at Notre-Dame in Paris, the Adoration of the Magi, the Flight into Egypt, full of picturesque detail and delicate feeling, and the Massacre of the Innocents, which is most movingly *Plate 12* and dramatically conceived.

To return to the central doorway. In the right embrasure we see the Presentation in the Temple, Jesus among the Doctors, the Baptism of Christ, the Temptations, the Last Supper, in which Judas, a solitary figure, sacrilegiously receives the Communion at our Lord's hands, the Kiss of Judas in the Garden of Olives (right door), the Arrest of Christ, the Entry of Christ into Jerusalem which has been delayed until now in order to give the place of honour to the Last Supper, the Laying in the Tomb — a rare scene in the 12th century, — the Resurrection, then the Washing of the feet, which should appear before the Last Supper, and lastly the appearance of Christ to the disciples at Emmaus and to the apostles.

In an abbey not far from Chartres, at Coulombs (Eure-et-Loir), the capitals of the columns also represent the history of our Lord and are in almost exactly the same style. Two of these columns are preserved in the Louvre; on *Plate 21b* the capital of one of them is represented the Nativity. [24]

The three great tympana with their arch-rims form an admirable finish to this great sculptured page of the Old and New Testament. On the right door *Plate 5* God is made Man; on the left, He ascends once more to His Father, while on the centre door He reappears at the end of the world in all the splendour of His glory and power. The perfection and nobility of this carving, the grandeur of its composition which is ruled by the most superb harmony, make it a masterpiece worthy of the great theme offered to the artist.

On the tympana of the central door is carved the scene of the Appearance of the Son of Man according to the Revelation (IV, 3-11) with the details re- *Plate 13* lated by St. Matthew (XXIV-XXV). Christ in Majesty is sitting in an elliptical glory between the symbols of the Evangelists, surrounded by the Elders of the Revelation, a popular theme in Romanesque times.

Beside Him on the lintel, as at Carennac, sit the Apostles three by three in the manner related by St. Matthew as Christ's own words. Christ holds His right hand in blessing and the Book of Life in His left; a clinging robe falls

over his breast and shoulders in stiff folds to the waist, but the proportions are good, and the easy posture is full of nobility. The head is admirable, lightly thrown back, poised upon a neck a thought too long, the oval of the face well shaped, the mouth severe and sad, the expression a little distant; the eyes with deep-cut pupils are half-closed under heavy eyelids, the forehead high and set in long, wavy curls, the moustache thick, the beard short and divided into several points. This head is set against a large cruciferous halo, imperious, remote, resolute, majestic, one of the finest creations of the Middle Ages. Around Christ are set the angel of St. Matthew, the eagle of St. John, the lion of St. Mark and the ox of St. Luke; above his head a dove and a great crown re-carved in the 19th century by Lassus, which is held up by two angels, who seem in style to be not earlier than the end of the 12th century.

On the lintel are the twelve apostles, set three by three under an arcading with slender demi-columns, each small arch framing the head of an apostle. We have already noted this arrangement on the capitals, and the figures seem to be talking to each other; their heads are bent and turned to the right or left, their gestures are varied, and they are seated, a few with crossed legs. The artist, who took his idea for them from the Romanesque doorways of Burgundy and Languedoc, which were likewise copied by the sculptors of Cahors and Collonges, was forced to give an impression of life and movement without altering the calm appropriate to monumental sculpture. The Apostles carry books and scrolls. In the middle is St. Peter with curly hair, St. Paul bald and St. John without a beard. The two figures standing at the ends are without doubt the two Evangelists who were not Apostles, St. Mark and St. Luke.

Plate 14 On the first of the arch-rims are carved angels with long wings and pleasant heads covered with curly hair; the other two rims are filled by the four-and-twenty Elders of the Revelation. They are seated, with fine faces and long beards, holding in one hand perfume jars, in the other musical instruments such as the viol, lyre, trump, rebeck or drum. The four Elders at the ends of the arch-rims are standing in attitudes of great splendour, their heads thrown back, their long beards flowing, their mien lofty, masterpieces of truth and nobility, worthy of the great sculptor who carved the Christ of the tympanum.

Plate 15 The tympanum of the left door represents the Ascension of Christ, who rises to the clouds between two angels with long wings, who assist him as deacons assist the priest at the altar and form exquisite patterns with their bodies,

18

as in the splendid representations of the same subject by Romanesque sculptors in Burgundy and Central France. Above Christ's head hovers the Dove. Four other angels with long arms and slender wings, their robes clinging to their bodies and ending in fluttering Romanesque folds, descend from the sky, which is marked with wavy lines; they show the Apostles where Christ has vanished into heaven. The Apostles, ten in number, sit on the lintel, their heads framed by the curves of small arches, as on the central door; they hold books or scrolls and raise their heads at the angels' voices. Three of them have their legs crossed; their gestures are varied as on the central doorway, but their proportions are more thickset; the robes fall in flowing folds in parallel lines. It may, perhaps, be possible to recognize St. Peter in the middle with flowing hair and St. Paul bald, with a long beard.

The tympanum is divided for reasons of symmetry into three rows, as is the right door, and the angels have been given an importance which is not generally theirs in pictures of the Ascension. Certain archaeologists have even thought that the presence of these four angels indicated not the Ascension but the second Coming of Christ at the end of the World. The absence of the symbols of the Evangelists and the Elders of the Revelation prevents my agreeing with this theory, which presents also the difficulty that it would duplicate the scene on the central door.

It is easy to recognize once more the harmony which pervades the whole door in the arrangement of the Apostles talking two by two, while the central group is shut in by two Apostles with crossed legs. This harmony of line repeats itself in the angels of the second register, carved two by two on one and the same stone, and in the top group, in which the side figures with similar but contrasted gestures arrange themselves in lines which radiate outward from the central figure.

On the arch-rims are carved delightful little figures, representing in a vivid and picturesque style, despite the stylization of trees and flowers and the stiffness of certain figures, the Occupations of the Months combined with the Signs of the Zodiac. The scenes begin on the right from the inner rim, go on to the two on the left, first the inner, then the outer, and finish by the outer rim on the right. The inner rim only contains ten scenes, while in the outer the sculptor has managed to fit in twelve; two Signs of the Zodiac have been carried over to the vaultings of the right door.

January, with two heads, is sitting at table cutting bread; above him Capricorn; then February wrapped in a cloak is warming himself in front of the fire; the Aquarius is damaged; March trims the vine; April with garlanded head holds flowering branches; the Ram; May, falcon on wrist, is about to mount a horse; the Bull; June mows the hay; July, a flowery chaplet on head, advances sickle in hand, up to his waist in the ripe corn he is cutting; Cancer; August unties the sheaves and begins to thresh; the Lion; September crushes in the vat the grapes a dresser brings him; the Virgin; October knocks down acorns to fatten the pigs; the Scales; November kills the pig, the Scorpion; December is at table; the Archer.

Plate 20b The similarity has long been noticed between this door at Chartres and that of the cathedral at Cahors, which has been transferred to the north nave and M. Mâle [25] and M. Raymond Rey with him [26] thought he had found in Cahors the original of the tympanum of Chartres. I think with C. Enlart [27] on the contrary that the Portail Royal is earlier; the style of the architecture of the Cahors door, the shape of the mouldings, must date from the last quarter of the 12th century and the arch which encloses the tympanum rises to a slight point. The Christ in glory is formed on a natural model unlike the Romanesque; the pose is elegant and supple and the body does not rest evenly on its two legs. The feet are well placed, the hands admirably carved. The fine head, in which André Michel has seen the prototype of the « Beau Dieu » of Amiens, is slightly inclined towards the right shoulder and the robe is moulded to the body and spreads out behind the legs. Below, the Virgin and the Apostles converse together in easy attitudes with measured gesture. One or two of them still have their legs crossed. They are arranged under trefoil arches carried on slender little columns ornamented with canopies as at Chartres. The south door of Cahors is also surmounted by this trefoil arch. The Christ in glory, towards whom four angels seem to drop from Heaven, is borne up by two great angels, who are placed in the background as on the doors of Burgundy. The blank spaces of the tympanum have been covered as at Conques by scenes from the life and martyrdom of St. Stephen, patron saint of the cathedral. The costume of the deacon saint and of the Jews, in particular the dalmatic with large sleeves, slit up the side, confirms our opinion that the tympanum was not carved till 1170-1180, at a date later than the Chartres tympanum, while preserving in detail and technique the

traditions of the Romanesque sculpture of Languedoc and Burgundy. The presence of the scenes of St. Stephen's martyrdom and also of the symbols of the Evangelists, the slots of which are visible round the mandorla, shows that the sculptor intended to indicate here, in addition to the Ascension of Christ, the second Coming of the Son of Man described in the Gospels of St. Luke and St. Matthew and the Revelation of St. John.

The little door at Collonges (Corrèze) recently brought to light by M. *Plate 20a*
Mayeux, is possibly a few years earlier than that at Cahors.[28] It belongs to the same group and is also carved with the Ascension; Christ rises between two fine figures of accompanying angels, while in the corners of the tympanum two other angels kneel and point to Heaven whither Christ is rising. The Virgin and the Apostles are arranged each under an arch, which is without doubt once more a copy of those at Chartres; the three Apostles at each end are placed under single arches, for lack of space.

Another Ascension at Mauriac (Cantal) is different in composition, arrangement and style; the robes with their restless folds are more agitated, the Apostles are not arranged under arches. The style is more like that of the Romanesque in Burgundy and the Brionne district; the influence of miniatures in pre-Romanesque and Syrian manuscripts is predominant, while the carving is of an earlier date than at Collonges and Cahors (it is about 1140) and cannot be associated with Northern French Art.

The tympanum of the right door of the Portail Royal is divided into *Plates 16-18*
three horizontal rows in the same manner as the left-hand one, and the Virgin seated on high between two angels in the topmost row corresponds to the Christ of the Ascension with His two supporting angels. The long slender figures bear heads which are strongly emphasized, perhaps a thought too heavily in comparison with their bodies, and the poses are rather stiff, but here and there an intimate touch appears, as in the scene of the Visitation, in which there is even emotion. The robes, clinging to the body, fall in long parallel folds, simple and restful, the fluttering folds of the Romanesque only appearing at the base of the drapery of the two angels who are censing the Virgin.

This tympanum has suffered particularly badly from the transference after the fire of 1194, the two upper registers having been cut off on the right, while the canopy over the Virgin has been shortened. On the lintel and the

second register are the usual scenes of the birth of Christ, carved in low relief, each on a single block. In the Annunciation the archangel Gabriel bows slightly to the Virgin, who is startled by his appearance. In the Visitation,

Plate 17a Elizabeth has taken Mary in her left arm and their heads bow close together in the triumphal love-song of the Magnificat. In the scene of the Nativity the Virgin lies in bed and on the dais round the bed are the Cradle and the Child; the animals are stalled; at the head of the bed is St. Joseph; at the right

Plate 17b the Shepherds hear the glad tidings from the angel who stands at the foot of the bed, opposite St. Joseph.

In the scene of the Presentation, shown above, the symmetry is even more marked. In the middle the Child Jesus stands at the altar and on either side the Virgin, the old man Simeon, Joseph, the prophetess Anna, and other figures bring offerings: a design which seems a little monotonous, as its sole object is to fill the blank space on either side of the altar evenly.

The Comte de Lasteyrie has very properly pointed out the similarity between these scenes of the Childhood of Christ and those on the side doors of

Plate 19a the west front of La Charité-sur-Loire (Nièvre); that of the left-hand door
Plate 19b is still in its original position and recently cleared, while that on the right has been relegated to the south transept. These are probably of the same date as the Portail Royal and are so similar in style to the scenes on the tympanum of the Porte de la Vierge, that they must be from the same workshop; it is interesting to notice the resemblance between these sculptures from La Charité, where the influences of Burgundy and Languedoc are visible, and the doors of the Ile-de-France. On the left door are the Annunciation, the Visitation, the Nativity and the Announcement to the Shepherds; and above, a scene which Mme. Louise Lefrançois-Pillion has shown represents Christ in glory, welcoming through the intercession of the Virgin the Order of Cluny and more particularly the priory of La Charité.[29] On the right-hand doorway, now in the transept, are the Presentation, the Adoration of the Magi, very similar in style to the representation at Bourges and above, the Transfiguration.

On the tympanum of the Porte de la Vierge at Chartres, the Virgin in Majesty is seated facing to the front, on her lap the Child, whom she holds with her right hand, while in her left is a sceptre. The Child, seated full-face, blesses with his right hand, and both have haloes. Their robes in nar-

row folds that fall a little stiffly, form at the feet the conventional pattern of Romanesque design. The group was originally set under a canopy, supported by columns the bases of which are still visible. On either side a beautiful angel with wings unfurled advances towards the Virgin, swinging a censer, which has now disappeared. In this forward movement their robes are blown back and the skirts swirl in the fluttering folds so beloved by the Romanesque sculptor, but their calm attitude and quiet gesture belong to the serene spirit of the Portail Royal. The Virgin and the angels are carved from three separate blocks, which have been set together to form the tympanum. This lovely statue of the Virgin is probably that given by Archdeacon Richer about 1150. It was formerly painted and gilded, traces of which could still be seen in the middle of the 19th century.

Descended from those Virgins in wood, painted or covered with metal plates, made in Auvergne ever since the 10th century, the Miraculous Virgin of the crypt, which was destroyed during the Revolution, seems to have resembled them. The Virgin of the door was possibly the first to be carved in stone and set in the place of honour in the tympanum of a great cathedral as a pendant to the Christ Himself. This new incident in iconography would naturally appear at Chartres, where the worship of the Virgin was especially popular and which was a pilgrimage-centre for that reason. The same type of Virgin in Majesty may be seen again in the second half of the 12th century at Notre-Dame in Paris and on the altar-piece of the little church of Carrières-Saint-Denis (Seine),[30] a dependency of the great abbey, where the *Plate 21a* Virgin is seated with the Child in her arms between the Annunciation and the Baptism of Christ which are very close in style to those of the Portail Royal. At Chartres she reappears in one of the marvellous windows of the south side-aisle of the choir, at the top of the central window of the west front, where she holds a sceptre in either hand, and again in a number of windows of the first quarter of the 13th century, where she only carries the sceptre in the right hand. A new type appears about the same time at Chartres in a window given by H. Noblet, in another high in the south transept and, a little later, on a keystone in the rood-screen; the Virgin is still a frontal seated figure, sceptre in her right hand, but she carries the Child on her left knee. Sometimes she seems to hold fruit in her hand instead of a sceptre, ceases to be the Queen of Heaven, and becomes the Mother talking to her

Child and offering him this fruit. This type appears in the windows of Nicolas li Sesne and on the central gable-end of the south transept porch.

To this latter type belongs a silver-gilt Virgin that stood behind the high altar since the middle of the 13th century, of which an early 16th century copy in wood still exists in the north side-aisle of the choir and which is called Our Lady of the Pillar. The large sharp folds of the draperies, which are in direct opposition to the stiffly-held body, and the type of the costume seem to justify the date ascribed to it by Canon Delaporte.

The arch-rims are decorated with six standing figures of angels on the inner rim, and below to the left are the signs of the Heavenly Twins and the Fish, which have been forgotten on the left-hand door. The other statuettes represent the Seven Arts, symbolized by women with the attributes given them by the commentators of the early Middle Ages from Martianus Capella in the 5th century onwards. On either side of each of them is one of the Sages of Antiquity, who was considered the inventor or the chief exponent of that art. Dialectic with a scorpion is attended by Aristotle (at the left-hand bottom corner of the outer rim); Rhetoric by Cicero; Geometry, with a compass, by Euclid; Arithmetic is with Pythagoras or Boethius; Astronomy with *Plate 18b* Ptolemy. Grammar, ferule in hand, about to correct two young children bent over a book, is attended by Priscian or Donatus. Lastly, on the inner rim, Music, attended by Pythagoras, beats three bells with a hammer and carries on her knees a dulcimer, while beside her a viol and rebeck are resting *Plate 18a* against the wall. Pythagoras, like the two companion figures, sits absorbed in his work at a carved desk; the realism of this figure, and of those of Dialectic, the Heavenly Twins, the Fishes, Music and Grammar is quite different from anything else on the door. Larger in conception, more naturalistic in drapery, more powerful in expression, these four carvings, though possibly less delicate, seem to belong to a more recent school of sculptors who were more skilful in making their figures stand out instead of leaving them sunk in the stone, and who worked in the second half of the 12th century, perhaps about 1194, when they may have been called in to complete the decoration after the removal of the porch after the fire. Such is this splendid door, executed as a whole from 1145-1155, of which some details were not finished, as I have endeavoured to show, till the second half or even the close of the 12th century. Its influence was considerable.

On the south side of the nave of Notre-Dame at *Etampes* is a doorway *Plates 22, 23* with column-statues, which seem to have been copied from those on the left-hand embrasure of the left door of the Portail Royal.

M. Lefèvre-Pontalis,[31] who has made a detailed study of the church of Notre-Dame d'Etampes, dates its nave at 1140. That is certainly the year of the completion of the building. Anthyme St.-Paul has shown, by very exact archaeological deduction, that between 1145 and 1175 [32] — in my opinion, about 1150 — a door of a style quite different from the capitals of the nave was set in the south wall of the second bay of the nave, which is certainly several years older and belongs to the style of the second workshop of the Portail Royal at Chartres. The embrasures are decorated with statue-columns under small canopies and capitals ornamented with scenes from the history of Christ, as at Chartres. But the Ascension on the tympanum and the Elders of the Apocalypse seated on the arch-rims are inspired by Moissac. The influence of the Miégeville door at Saint-Sernin in Toulouse is visible in the two great angels in low relief at the corners between the edge of the archivolt and the frieze enclosing it, which is carved with palmettes like the abaci of the pier-capitals and supported by two columns with statues. The resemblance to the doors in Languedoc, at St.-Sernin and Moissac is very remarkable in this case. Notice must be taken also of the parallel curved folds at the angles of the body, which are very close in style to Languedoc sculpture. I do not think myself that this door is earlier than the Portail Royal. The tympanum and the arch-rims are in a pointed arc, while at Chartres the curves, though pointed at the present day, were originally undoubtedly semicircular, as at St.-Denis, while the style of the capitals, the shape of the bases and the mould-ings are more advanced than at Chartres. The survival of the Romanesque of Languedoc is all that can be recognized here; for the general design has been modified to the dictation of the great workshop of Chartres.

Certain statues at Chartres on the extreme corners of the Portail Royal recall the great figures at Etampes, with their robes in strongly marked curved *Plate 23* folds at the angles of the body. These are the work of an archaistic school, which drew its inspiration from Romanesque miniatures. The statues of the central doorway, however, belong to a modernist school who followed the direction of the old workshop, while the other transferred itself to Etampes. As far as one can judge by Montfaucon's designs the column-statues of St. De-

nis belonged to the same group as those of the central doorway of Chartres.

Plate 22 On the tympanum Christ in glory is standing between two angels, while above are the twelve Apostles. It is the scene of the Ascension, as on the Miégeville door of St.-Sernin at Toulouse and on the Portail Royal at Chartres, and is carved by a sculptor who is still Romanesque; perhaps some wise old Burgundian, versed in the art of carving these bent angels, half-kneeling in adoration. It is also the second coming of Christ in Judgement, the glorious vision of the Son of Man surrounded by the Elders of the Apocalypse, here set in the arch-rims, who in great chairs of carved wood hold, as on the Portail Royal or at Moissac, instruments of music, viol, rebeck, or more rarely a small harp, in one hand, a long-necked perfume-bottle in the other. The sculptor has placed this bottle sometimes in one hand, sometimes in the other, in order to vary the pose a little. The third rim is filled with tiny figures, like the others, but holding scrolls or tablets in their hands. The edging of the archivolt is decorated with acanthus leaves, as on the Miégeville door at Toulouse, and the majority of these doorways with column-statues.

Plate 23 On either side of the door are three headless statues, two men and a woman in whom may be recognized Moses with the tables of the Law, the Queen of Sheba, David and Solomon. These figures, elongated against the column, are less stiff than those on the Portail Royal at Chartres, the modelling is more accentuated, the relief marked by the scheme of folds at the angles of the body, as at Toulouse and Vézelay and in the miniatures of the pre-Romanesque and Romanesque periods. They are the fellows of the column-statues at the extreme ends of the Portail Royal. Their feet, as at Chartres, rest on a sort of narrow, two-peaked balustrade. Above is a network of little canopies, which are destined to grow in importance and supersede the use of capitals. Inside the church are preserved two statues of St. Peter and St. Paul that possibly once adorned the jambs of the doors as at Le Mans and later at St.-Loup-de-Naud.

The capitals of the columns, with their little figures under canopies and abaci decorated with acanthus leaves, are like those at Chartres. The scenes begin from the left at the bottom corner and run to the right round the outside. To the left are the Annunciation, the Nativity, the Washing of the Child, the Adoration of the Magi and the Massacre of the Innocents; to the

right the Entry of Christ into Jerusalem, the Last Supper, the Holy Women at the Sepulchre and the Appearance of Christ to Mary Magdalen. Under the lintel the Temptation of Adam and Eve on the right balances, on the left, the Temptation of Christ.

The archivolt is framed, as at St.-Sernin, by a flat cornice emphasized by a palmette-frieze which is held up at either end by statues on columns under canopies, as on the embrasures of the door, and in the middle by heavily cut masks. The right-hand column and its statue have disappeared since the enlargement of the south transept at the end of the 12th century.

In the corners, as at Toulouse and later on the north façade of the transept of the Rheims cathedral, two great angels stand out in low relief, their draperies swirling in fluttering folds.

Of all those we have studied, this door at Etampes preserves its Romanesque character most vividly and owes the most marked debt to Languedoc, Burgundy and Aquitaine. But it belongs to the group of doors, with which Gothic begins, and is influenced by the creators of St.-Denis and Chartres; the column is the framework of the porch and its rôle is borne out by the statue against it, while a certain restraint is visible in the sculpture. The door is none the less one of the oldest of the group and must have been carved about 1150, shortly after the opening of the workshop at Chartres, possibly by artists who worked there.

At almost the same time there rose at Le Mans and Bourges extremely elaborate doors carved in imitation of St.-Denis and Chartres.

To the south of the nave of *Le Mans* is a door with statues on columns *Plates 24-26* approached by a porch, the structure and decoration of which show it to have been made at the same time as the nave, which was dedicated in 1158. The door was undoubtedly executed shortly before this and, as the restoration of the nave by the bishop Guillaume de Passavant was begun in 1145 and finished in 1158,[33] one can safely date it between 1150 and 1155, a date which moreover fits in with the position it takes stylistically in this series of doors.

The resemblance between this door and the central door of the Portail Royal at Chartres has often been noted. Eight tall column-statues recall the *Plate 25* technique, the slenderness, the attitudes and gestures, the expressions, the attributes and robes, and the drapery of the central doorway at Chartres so

closely that they seem to have been made at the same workshop. They stand, as at Chartres, on bases ornamented with zigzags, scrolls, fluting and geometric designs, while the capitals above are carved with large acanthus leaves and are separated by small columns which finish the angles of the supporting walls.

In these eight Old Testament figures can be recognized David, Solomon, whose name could still be read in 1841, on the scroll of one of the kings, the Queen of Sheba and in addition, a new point in iconography absent at Chartres and one which we shall often find later, notably at St.-Loup-de-Naud and on the St. Anne door of Notre-Dame in Paris, two figures of the New Law, St. Peter and St. Paul, who complete the series of Kings, Patriarchs and Prophets of the Old Testament. These two figures are carved in relief on the side of the door-jambs, a position and idea practised at Moissac and Souillac since the end of the 11th century and familiar in Languedoc and Provence right on to the end of the 12th. Another detail confirms the connection between this early Gothic and the Romanesque art of Languedoc, Burgundy and Provence; that is the fretwork on the inside of the right jambs, which is also found at Carennac, Charlieu or St.-Gilles.

Plate 24 The tympanum is very close to that of Chartres. It represents Christ in Majesty between the four Symbols of the Evangelists, and the shape of the body, the gesture, drapery, position of the animals and of the angel, their attitudes, and the details of the iconography mark it as a direct copy of Chartres. The Apostles, placed on the lintel, as at Chartres, are here seated under one arch instead of being grouped three by three.

The sculptures on the arch-rims differ, however, from those at Chartres, and seem to be later in date. The first rim is filled with angels, curiously and significantly like some of those at Le Mans and Chartres; but while the two other rims at Chartres are carved with the Elders of the Apocalypse, here are to be found the scenes from the life of Christ, which at Chartres decorate the pier capitals. These scenes are very interesting, iconographically, in connection with the Childhood of Christ, and they show an unusual development; certain scenes spread over three or four blocks so that the story becomes muddled and in the Miracle of Cana, for instance, Christ changing the water into wine is almost lost in the banquet-preparation scene.

Contrary to the usual arrangement of such doors with an Elder of the Apo⁄

28

calypse, a Biblical king, patriarch or prophet to each stone, as at Chartres and St.-Denis, these bas-reliefs are narrative. The style of the little figures is very vivid and sometimes astonishingly realistic. The details of robes and accoutrements agree with the date of 1150-1155 we have assigned to this door.

The order of the scenes seems very obscure, in spite of the numerous and sometimes ingenious explanations which have been put forward. The scenes begin at the bottom right-hand corner; the Annunciation, Visitation — Mary and Elizabeth embrace each other with even more freedom than at Chartres and with gestures very far removed from the restraint of Notre-Dame at Paris. To the left the Nativity and the Announcement to the Shepherds occupy six blocks, while below is the Adoration of the Magi, an admirable piece of sculpture, though badly damaged; the Virgin is sitting in a great chair holding the Child on her knee, who leans towards the Magi in the next arch-rim, the eldest of whom is half kneeling. Next one sees the three Magi sleeping at the inn and warned by the Angel not to return by the same road.

Above in the third and fourth rim is the Massacre of the Innocents told *Plate 26* with cruel realism in nine scenes; the soldiers in long coats brandish their swords or wound and kill the infants, despite the efforts of the mothers to snatch them away. One woman has just picked up the head of her child and is kissing it, a detail we shall find again at the beginning of the 13th century, in the psalter of Queen Íngeborg in the Musée Condé and also in a window of the ambulatory at Chartres; farther off two mothers give suck to infants in swaddling clothes, while Herod, stretched on his bed, is urged by horrible demons to the monstrous crime. In the meanwhile Joseph, warned by the angel, is taking the Virgin who carries the Child, far from Bethlehem on a donkey's back. Returning to the right-hand arch-rims, we find the Presentation in the Temple, the Marriage of Cana, the Preaching of John the Baptist and the Baptism of Christ. In the centre of the tympanum, above the figure of the Eternal is a Hand in blessing on a cruciferous halo, here taking the place of the Dove of the Holy Spirit, and the Lamb bearing Christ's symbol, the oriflamme.

About the middle of the long nave of *Bourges*, hidden under 13th century porches of the same date as the rest of the cathedral, are two fine doors open- *Plates 27-30* ing north and south, and little later than the middle of the 12th century.

They are the remains of a church begun in the first half of the 12th century and have been kept in the church which St. William erected at the beginning of the 13th century; only the bases have been renewed and piers added, decorated with statues: Christ on the south door, on the north the statue of a Virgin has disappeared.

P. Gauchery, who knew this cathedral down to the last detail, has shown that these two doors may well be on their original sites; the facings of the walls are intact, the formal arches which enclose them are primitive in shape and the blocks of the keystones of the south door have been reshaped in the 13th century to join on to the vaulting. The 13th century porches are joined on to those of the 12th century and not made to fit, which would have happened if the doors had been transported in the 13th century. Lastly the statuary and the rich decoration, which surrounds it, could not have been taken down and put up again in so exact a manner, without some inaccuracy or fracture, as we have seen in the Portail Royal at Chartres. These doors must have opened at the transept fronts of the old cathedral. There are none in the new cathedral and also, owing to the extension of the choir to the east, the doors would have been too far to the west, but thanks to the double side-aisles the architect has been able to include them in the new building, without displacing them.

There is a clear connection between the centre door of the Portail Royal at Chartres, the south door of the nave of Le Mans and the south door of Bourges cathedral. The composition is practically the same, the subject identical, the style and elaboration similar.

Plate 27 The south door is devoted to Christ. In the tympanum is the Son of Man in an oval glory between the four Symbols of the Evangelists. With his heavy proportions and his elaborate gadrooned halo, he appears to be a copy of some Romanesque model or even of a pre-Romanesque ivory carving.

Below, the Apostles are seated beneath little arcades. In the arch-rims, angels, somewhat crushed, and shortened at the knees to fit in a larger number, prophets and patriarchs of the Ancient Law fill the two first rows; the two others are decorated with palmettes and geometric piercings.

Plate 28 In the embrasures three figures, two men and a woman on each side stand backed to low columns with arabesque and interlaced capitals and are crowned with canopies with confronted birds, sirens, fantastic beasts and monsters

and also scenes of the Fall and Expulsion of Adam and Eve, David playing *Plate 29* his harp, Abraham's sacrifice and Samson slaying the lion. The angles of the separating walls are sharp-cut and decorated with lozenges and labels. One of the big statues must represent Moses with the tables of the Law, as at Chartres and Le Mans, while on the other two were once the names of Jonah and Sophronia. On the pier is a 13th century figure of Christ blessing.

The north door, called the door of our Lady of Grace, has the Virgin and *Plate 30* Child on the tympanum under a canopy and the Magi to the left, while to the right are the Annunciation and the Visitation. Above, two angels, unfortunately badly damaged, salute the Virgin with widely swung censers. To the right a little scene represents the Announcement to the Shepherds and is of more recent date. On the lintel are great scrolls of foliage, on which traces of green paint are still visible. The arch-rims are decorated with chequers, acanthus leaves and fretted work.

On either side of the door are two statues of women, backing on to columns; they wear haloes and are usually identified as the Queen of Sheba and a Sibyl. They stand, like figures in the South, on low columns decorated with zigzag ribbons of stone, the circular capitals of which act as pedestals. The two neighbouring columns are decorated with fretwork, knots and floral devices, like the wall-angles, and have acanthus-leaf and interlaced capitals, from which peep out masks and little playing nude figures. On the pier used to stand a statue of the Virgin, which was destroyed by the Protestants in 1562.

It has sometimes been asked whether the doors at Bourges were not earlier than the Portail Royal at Chartres, so forming the link between the South and Chartres. In spite of certain archaisms, in spite of the survival of Romanesque tradition in the iconography, as, for instance, on the north tympanum, where the Magi advance in file, as at La Charité-sur-Loire, at Moissac and on objects of pre-Romanesque date, in spite of the survival of certain decorative motifs of Romanesque character — on the bases of the statues and the capitals which they surmount — I believe the Portail Royal to be the earlier of the two. The large statues at Bourges, formed on a more careful model, are more thickset and less stiff, their gestures are easier; they stand on larger bases and are topped by canopies, which seem to be, on the side doors of Chartres, the result of a later rebuilding; lastly, they give the impression of columns in far less degree than those at Chartres or St.-Denis.

31

On the lintel of the south door, the statuettes of Apostles talking to each other are arranged two by two, as at Le Mans, under little architectural canopies, and stand on columns which are either twisted or decorated with zigzag and geometrical ornament. They are more dumpy than at Chartres; the heads are larger in relation to the body; their postures are more varied.

On the north tympanum the Virgin is seated under a canopy with crockets and pinnacles, which is borne by two little columns, like the lost canopy of the Virgin of the Portail Royal at Chartres and like that of the Virgin of the St. Anne doorway in Paris, and is less stiff in gesture than at Chartres, while the flat folds of the drapery are better arranged. The four scenes on the right representing the Annunciation and the Visitation are more lively than those at Chartres; the draperies are fuller and there is no trace of the fluttering Romanesque fold, which is still sometimes visible at Chartres. Lastly, the superb arabesques cut so boldly on the lintel of the door of the Virgin seem to me later in date than the decoration of the Portail Royal and pave the way for that of the north façade of the transept of St.-Denis or the gates of the collegiate church at Mantes.

I believe therefore that these doors were begun almost at the same time as that of Le Mans and finished a little later — between 1150 and 1160.

Plates 31, 32 The west door of *Angers* cathedral is closely connected with the preceding. To judge by the style of the statues, it must have been carved at some time between the completion of the vaulting of the nave by Bishop Normand de Doué (1149-1153) and the reconstruction of the transept, begun by Bishop Raoul de Beaumont after 1177; that is to say between 1155 and 1165.

Plate 31 The scene represented is the Son of Man in Majesty between the Symbols of the Evangelists and must have been very beautiful; but it has been mutilated in the 17th and 18th centuries.34 On Corpus Christi day in 1617, at ten o'clock at night, a thunderbolt fell on the façade and broke the head and one hand of the Christ, as well as the angel and lion Symbols of the Evangelists which surrounded it. The head of Christ was sufficiently well restored, while the angel and lion have been completely re-carved, as their style bears witness. In 1745 in order that the solid canopy used for processions might get through the door, the central pier, on which stood the statue of St. Maurice, was cut away and eight of the twelve apostles on the lintel were removed, while a granite arch was built, which defaced the tympanum, as at St.-Ayoul de

Provins and on the central doorway of Notre-Dame in Paris, before Viol-let-le-Duc's restoration. The two first arch-rims are decorated with demi-angels resting on clouds, and forming a bracket: a rare conceit, which had already been used at Chartres and Bourges and which will be found later on the door of the Virgin at Notre-Dame in Paris. In the two other arch-rims are seated the Elders of the Apocalypse holding in one hand vases, in the other instruments of music. The edge of the archivolt is decorated with flat masks, which are in the style of Norman art.

On either side of the pier-returns are four big statues, two men and two women, which are column-statues, but treated with much greater freedom than at Chartres, Le Mans or Bourges. The proportions are thicker, the shoulders and flanks wider, the gestures more supple; the ringlets of the women are no longer stiff, the robes, clinging to the body, fall more naturally, the sleeves and borders of the dresses are decorated with embroidery, while a cape is thrown over the shoulders. The head is still held upright, the body immovable, but a certain taste is seen in the gestures; one of the women, for instance, gracefully raises the front of her robe. Statues of women alternate with those of men, among which two can be identified, as at Le Mans, as David with his harp and Solomon. Moses may also be recognized by the tables of the Law, as at Chartres, Etampes and Bourges. Among the women, one with a sceptre must be the Queen of Sheba. The heads of two of the statues have been recarved in the 19th century and it is impossible to discover whom they represented before.

Plate 32

Traces of paint, some of which may be as old as the 17th century, are still visible on the pupils of the eyes, on the bottom of the tympanum and here and there on the statues.

On the borders of Champagne and the Ile-de-France are two doors belonging to the group we have just described, one, in a very damaged state, at St.-Ayoul at Provins, the other by contrast extremely well preserved, in a little church near Provins, St.-Loup-de-Naud.

The tympanum of the west door of St.-Ayoul at *Provins* has been disfigured, as has that at Angers, by cutting a big semicircular arch with a view to lowering the pier. This door was very complete, as regards sculpture, mouldings and decoration, and what is left of it is of the highest quality, as far as one can

Plate 33

33

tell from the pitiable state it is in. The scene represented was Christ in Majesty between the Symbols of the Evangelists and on the lintel were undoubtedly the Apostles, as on the door of St.-Loup-de-Naud, which seems to have taken its inspiration from it. But there remains only the torso of the Christ, the Angel of St. Matthew and the Eagle of St. John. The heads were broken during the Revolution, like those of the statues in the arch-rims and embrasures. Christ's robes have numerous parallel pleats, as at Chartres, but the freedom of the drapery indicates a period far on in the 12th century.

The first arch-rim is decorated with long-winged angels, whose clinging robes, moulded to the form of the body, and quiet, even rigid attitudes recall the St. Anne door of Notre-Dame in Paris. In the two last rims the Elders of the Apocalypse are seated, some again with the crossed legs, thickset figures and ample folded robes, which are typical of the end of the 12th century, while the musical instruments they hold are of a developed type, compared with the similar ones at Chartres. In the last arch-rim are carved scenes of Paradise and Hell, the latter to the right, the former to the left of Christ, which differs from the usual iconographic arrangement. The presence of these scenes proves that all these tympana, on which Christ is seen in Majesty with the Symbols of the Evangelists amongst the Apostles and Elders of the Apocalypse, do not represent the vision of the Eternal in glory as told by St. John, but the second Appearance of the Son of Man coming in Judgement on the last day. The iconographic details and the style of these sculptures, the shape of the mouldings and in particular the edge of the archivolt, all contribute to the belief that the tympanum and arch-rims were not carved till a date late in the 12th century, possibly between 1170 and 1180, at a period subsequent to that of the St. Anne door at Notre-Dame.

Plate 33 The large statues, on the other hand, in the embrasures of the doorway, are much closer in style to the Portail Royal and seem to me earlier than those in the neighbouring church of St.-Loup-de-Naud; in date perhaps about 1160 to 1165.[35] These column-statues are four in number, three men and a woman, and stand on either side of the door in niches hollowed in the walls. They are terribly mutilated now, but must have been as lovely as those on the centre door of the Portail Royal at Chartres, with which they have great affinities, both in general line, in gesture and attitude, and also in their extreme height, in the form of the draperies, in the set of the robes and the coiffure of the two

34

women, the one on the left with long ringlets falling down her bosom, the other on the right, without ringlets, but with ornamentation very similar to that of the queen at Chartres. Fine acanthus-leaf capitals, like those at Le Mans, top the columns. Harpies decorate the jambs of the door at their tops, and are possibly a little later in date than the completion of the door.

The little church of the Priory of *St.-Loup-de-Naud*, not far from Provins, *Plates 34-37* still preserves under an exquisite porch, at the base of the west front, a carved doorway which recalls in many details those at Le Mans and Bourges.

Certain points, like the arch over the Apostles on the lintel and other decorative motifs, are repeated here with an exactness which proves the origin of these doors in the second half of the 12th century; but the advanced style of the sculpture, the shape of the mouldings, the extremely pointed arch of the tympanum and hood — it is a semicircular one at St.-Denis, Le Mans and Bourges and pointed at Chartres after the removal of the Portail Royal, — allow us to date this door between 1165 and 1170.

As at Chartres, Le Mans and Bourges, on the tympanum Christ is seated *Plate 35* in a great Glory, his feet resting on a stool, between the four Symbols of the Evangelists. His knees are splayed, the body is long and upright, the face severe. The folds of the robes are more restless than at Chartres, where the deliberate stiffness marks the vehemence of the reaction against the art of Burgundy and Aquitaine, while, at the bottom, the fluttering fold dear to the Romanesque sculptors is noticeable. Instinct with power, his head slightly inclined, Christ gives his blessing with a spirit which contrasts strongly with the calm representations of Le Mans and Chartres. The Symbols of the Evangelists are nearer in style to those at Chartres and Le Mans, where the sculptors endeavoured to achieve true and natural poses, than to those at Bourges, where the more formalized design is closer to an oriental original.

Beneath the Son of Man, in the centre of the lintel, is seated the Virgin, a lovely figure in full relief, still a trifle stiff, but full of charm in her heavy robes, under which the shape of the body is indicated. She is crowned and wears shoes; the folds of her robe fall in numerous regular pleats, like those of the lovely Virgin of St.-Martin-des-Champs, now preserved in the choir at St.-Denis. She *Plate 44a* is outlined, like the Christ, against a great Glory, which little angels apparently bear up. The triumph of the Mother is here associated with that of the Son,

35

and this iconographic detail shows us new ideas, which point to a later date in the 12th century. The history of the Virgin is continued at the end of the arch-rims by two scenes of the Annunciation and the Visitation, the latter of which is particularly attractive. The two women embrace each other with the fervour we have already seen at Chartres; their robes fall to the ground in long parallel folds, which spread round their feet; their veils are twined round their necks. Eight Apostles with bare feet surround the Virgin on the lintel and are placed under little arcades decorated with flower-work and surmounted by canopies, like those at Le Mans and Bourges. The gestures of the Apostles are varied, their proportions slender; their feet rest on stools, as on other tympana of this type, which recall pre-Romanesque and Byzantine ivories, and one has his feet crossed.

The first rim is decorated with angels of a calm and peaceful type, represented standing. whose proportions are better than those of Bourges, less restless than those at Le Mans, which lead the way from the lovely angels of Chartres to those slender figures whose exquisite shape can be descried on the arch-rims of the St. Anne doorway of Notre-Dame at Paris. One of the angels has the legs crossed. The second arch-rim is not decorated with statuettes of Patriarchs or Prophets of the Old Testament, or with Elders of the Apocalypse, as is customary, but with little scenes as at Le Mans, which tell the story of the miracles wrought by the patron saint, St. Loup, a new idea in iconography, which is often found on doors of the 13th century; prisoners are set free by the saint, the devil shut up in a great vase, the king sends St. Loup into exile, then is smitten with remorse, falls on his knees and begs the Saint's pardon. There is also the tale of the bell of St. Etienne at Sens, which sounded such a beautiful note that Clothair ordered it to be sent to Paris, but by the intervention of the Saint it became dumb and had to be given back to St. Etienne.

Plate 37 It is St. Loup also, who is on the central pillar of the door, stiff, slender, scarcely touching the stone on which he leans as on a column. He is dressed in bishop's robes, his right hand raised in blessing, and holds in his left a cross, now broken. On the capital of the pillar is carved another miracle in which, while he is celebrating mass, a jewel falls into the chalice. It is said that the jewel was preserved in the Royal Treasury.[36] A canopy overhangs this relief, as on the Portail Royal.

36

Three column-statues are ranged on each side of the supporting walls. *Plate 36*
Though still stiff in gesture, with feet set obliquely on an inclined base, they wear robes with full folds, which are well carved, but lifeless. To the left is St. Paul, bald-headed, with the book of the Acts of the Apostles in his hands; to the right St. Peter with a long key. The two Apostles, merely indicated in the flat at Le Mans here take the same position of importance as the Old Testament figures, which have occupied this position since St.-Denis and Chartres. To the left, beside St. Paul, is a figure of a queen like that at Chartres, but more human, the face long and thin, the forehead broad, the nose well-modelled with wide nostrils, the mouth pursed, the big eyes deep under marked arched brows. The face is fine and undoubtedly copied from a model. Two long plaits fall on either side of the neck and lie in charming scrolls upon the breast. It is perhaps the Queen of Sheba who is represented. At her side is a bearded man, coiffed in a Jewish hat; opposite, a king, David or Solomon, and a man with long hair and beard with tablets in his hand, who is perhaps Moses as often found in these doorways.

The long shafts of columns, which give so peculiar a character to this type of door at Chartres, Bourges or Le Mans, have disappeared and in their place an ordinary base with a deep edge is substituted, the lower flange flat and decorated with gryphons at the corners. On top of the columns, under abaci ornamented with fine palmettes, like those at Chartres or Le Mans, which are the forerunners of those on the north transept door at St.-Denis, are capitals decorated with harpies, confronted beasts and animals, as on the doors of St.-Denis and St.-Germain-des-Prés. Between the statues appears the naked stone of the walls; the carved background of St.-Denis, Chartres and Bourges vanishes, and statuary henceforward prevails over decoration.

This door, which is in a fine state of preservation, shows us what by 1165 had become the art of the doors of St.-Denis, Chartres and Bourges, and how, in this evolution, it gave birth to the formula of the Gothic doorway, which will blossom a few years later at Senlis.

There were a great number of these doors with column-statues built in the third quarter of the 12th century in the country ruled by the Capets and in all the district north of the Loire. Many have unfortunately disappeared and we now only know of their existence by certain fragments that have endured and by engravings or old descriptions. 37

The abbey church of *Nesle-la-Reposte* (Marne) was very like St.-Ayoul and St.-Loup in general arrangement, plan, construction and façade. [38] It possessed a door with column-statues. In 1673 the monks had to abandon it owing to the dampness and moved to Villenauxe (Aube) taking the door with them. This disappeared at the Revolution and we only know it by Mabillon's engraving [39] reproduced on a small scale by Montfaucon. [40] There is a lintel with Apostles looking upwards; the Ascension was perhaps carved on

Plate 38 a the tympanum. In the embrasures on either side were three statues, standing on monsters: to the left St. Peter with a key, as at St.-Loup, Etampes and Le Mans, and two kings, to the right a bishop, whose dress has been touched up by Mabillon's engraver but who seems to resemble the statue on the door-pillar at St.-Loup, a king and a queen. The queen with a mantle thrown over her sholders, the robe outlining her breast and reaching to the ground in a long skirt with fine folds, the girdle encircling her waist and knotted in front, the two long plaits hanging on either side, must be the Queen of Sheba, whom we have seen on most of these doors, but she has one peculiarity which was discussed at considerable length by commentators of the 17th and 18th centuries and which the designer has not failed to note: one of her legs ends in a goose's foot. In a recently published book [41] M. Hourticq has put forward the theory that this monstrosity is only the result of a deformation of a costume-detail by the designer and that there is no question of a classical inspiration for it. I think, however, that it occurs too often to allow of anything as vague as this, for M. Tillet has pointed out at Sembin (Loir-et-Cher) a statue of Saint Néomoise with a goose-foot, and the Queen of Sheba is found elsewhere with the same deformity on two destroyed church doors, those of St. Benignus at Dijon and St.-Pierre at Nevers, where the Queen faces King Solomon. The abbé Lebeuf has noted it at St.-Pourçain [42] in the Bourbon district on figures of a priest, perhaps Aaron, and of Solomon, St. Paul and Moses. Scholars have identified the figure as Clothilde, the wife of Clovis, who is known to legend as « Queen Clubfoot ». But the figure represented is the Queen of Sheba, as Lebeuf points out with his usual perspicacity, and M. Mâle has indicated several parallels in the Romanesque legends of the East and West in which the lovely Queen of the East bears this deformity. [43]

At *Soissons*, the church of St.-Pierre-au-Parvis had also column-statues;

but nothing is left, unfortunately, except a carved tympanum of about the middle of the 12th century, which is now almost completely mutilated and in which may be seen the silhouette of Christ in Majesty between the Symbols of the four Evangelists and below on the lintel the Apostles. In the corners above the rim of the archivolt were carved angels with outspread wings, as at Etampes.

In the fourth bay of the south side-aisle of the nave of Notre-Dame at *Châlons* is a door with statue-columns, dreadfully mutilated, standing under a Gothic porch built in 1469; on this there was once a tympanum with Christ in glory between the Symbols of the four Evangelists. On the pier and the five columns of the splaying stand statues, now completely defaced, while on the lateral faces were two other figures in flat relief as at Le Mans. The underpart is decorated with geometric piercings and flutings as at Chartres, Nesle and St.-Germain-des-Prés. All that is left now are the capitals above the statues with fine palmettes on the left, confronted animals, lions, birds, and fantastic beasts on the right.

Inside the church or in some side chapel was a circular column with smaller columns attached on which are carved tall figures of knights in tight coats of mail, their legs crossed, protected at the back by narrow shields of the type popular in the second half of the 12th century. This fragment of a column is now in the Louvre.44a To the east of Châlons, 12th century sculpture is rare and I can only point to the late 12th century door of *Somsois* in the Marne district, which has a column-statue on either side of the door. Despite their mutilated condition it is possible to recognize in the decapitated figure on the left a bishop, giving his blessing, who is possibly St. Martin, the patron of the parish. The door of the parish church at *Château-Chalon* (Jura) once possessed eight column-statues, which were destroyed in the Revolution.44 b

To return to St.-Denis and Chartres, the centres of the group, at the church of Ste.-Madeleine at *Châteaudun* are the remains of a door, possibly one of the most ancient of the series — it seems to have been standing in 1148 when Thibaut, Count of Blois, confirmed the monks in their possessions — which according to an old engraving, was decorated with statues of the same type as at Etampes, now unfortunately destroyed; the drapery was stiff and in parallel folds with concentric curves at the angles of the body.45 There is

also at *Véreaux* in the Cher district a door without a tympanum the semicircular arches of which are held up by two column-statues which seem to have been re-used, of small size (1,33 m.) and slender proportions, representing two crowned women. Their robes fall in stiff parallel folds on to their feet.[46] M. Jean Hubert has reconstructed with accurate knowledge on the basis of documentary evidence and some fragments in the Museum at Châteauroux the superb north door of the Abbey of *Déols* near Châteauroux (Indre)[47], which was still in existence in 1830 but was then barbarously destroyed. It was an imposing work of the middle of the 12th century and of considerable importance in the history of art, for it is the meeting place of the schools of the North and the South. M. Hubert has demonstrated how the tympanum, which represented the Eternal in majesty between the Symbols of the Evangelists was made of dressed pieces carved in bas-relief, as at Moissac and Cahors, and not sculptured in high relief on a single block, as at Chartres; but the Apostles, which are on all the lintels of the group are here missing. The arch-rims were decorated with angels adoring the Pascal Lamb and figures of the Liberal Arts and the Labours of the months, as at Chartres and on several of the earliest Gothic doors. Finally, in the splayings on either side were tall column-statues, as in the group derived from St.-Denis and Chartres. Here then, as far as we can judge from the little that remains, was a door executed in the style of the South possibly by southern sculptors, but influenced by the doors with column-statues of the North.

Berry seems to have been an important centre of sculpture in the second half of the 12th century, but most of it has unfortunately been destroyed. There are fragments here and there; in the Museum at Issoudun, for instance, and in the Musée des Antiquaires at Bourges where are preserved two statues, a bishop and a queen, backed to a wall (1,15 m. in height) and coming perhaps from St.-Benoît-du-Sault (Indre).[48] The bishop's low mitre with point at the front shows that these statues must belong to the last quarter of the 12th century.

In several churches in this district, in the apse at Levroux (Indre), at Crouzille (Indre-et-Loire), at St.-Jouin-de-Marnes (Deux-Sèvres) and again at the beginning of the 13th century in the gallery of the bell-tower[49] of St.-Aignan, tall statues are to be found at the springing of the ribs of the vault, generally crowned by canopies from which these ribs sprout and set

on the capitals of the columns of the side walls, Atlas figures of which the first ideas appear in the oldest churches with pointed vaulting in the Senlis and Beauvais district, at Bury (Oise) for instance, and even south of the Loire, as at Aigue-Vive (Loir-et-Cher) in the transept; stiff figures with narrow robes scored with parallel folds, which are exact parallels of the figures on the first Gothic porches.

There was recently found at Issoudun a statuette of a woman, heavy in style, whose technique and robes with parallel folds seem to belong to the end of the 12th century; it is possible that it was originally at the springing of the vault. The same arrangement was visible in the choir of St.-Martin at Angers and will be found again later in the Sologne district in the choir of the church at Romorantin, for instance.

On the capitals of the columns of the transept of Holy Trinity at Vendôme (Loir-et-Cher) under the springing of the joists four statues were set up at the beginning of the 13th century, as at Conques in the Rouergue district; they are stiff, but of a very fine style, and they represent the Angel and the Virgin of the Annunciation, St. Peter and a bishop.

There was a door with column-statues at *Paris*, resembling those at Nesle-la-Reposte and Notre-Dame-en-Vaux at Châlons-sur-Marne, based on the tradition of St.-Denis and the Portail Royal at Chartres. It adorned the foot of the tower of the 11th century which stood at the end of the nave of *St. Germain-des-Prés* and was carved at the time of the completion of the choir in 1163. It was badly mutilated in the 17th century, when the tympanum was destroyed — traces of the Last Supper scene are still visible on the lintel — and in the Revolution, when the statues on the abutments were broken. We only have the descriptions and engravings left us by the Benedictines.50 On *Plate 38 b* the left was a bishop with a triangular mitre — if the design is correct, this is one of the earliest examples of the triangle-shaped mitre — a king, a queen and another king. The queen on the left, Bath-sheba, Esther or Judith, has two plaits, a veil on her shoulders, a robe clinging to the body and a girdle round her waist; that on the right, the Queen of Sheba, is enveloped in a big cloak brought round in front, which covers her completely without letting her robe appear.

The church of the little village of *Issy* at the gates of Paris must have had

41

a door of this nature. There remains a tympanum with Christ and the Symbols of the four Evangelists. There is the same iconographic theme with the Apostles seated below on the tympanum of St. Peter at *Compiègne,* now completely destroyed; a row of angels decorates the first arch-rim above it.[51]

The ancient abbey of *St.-Maur-des-Fossés,* also quite close to Paris, which was abandoned in the middle of the 18th century had a door with column-statues. Two of them have been found in the excavations on the site of the abbey and are preserved in the Museum of Vieux Saint-Maur[52]. They must have stood on the embrasures of the abbey door. They represent a bare-footed man with a book, an apostle perhaps an evangelist and a woman of dolorous countenance giving suck to a child on her left arm who turns from her (St. John's vision of the Woman in the Revelation, XII, 5) and are carved in one block with the column against which they lean. They are slender, their legs close together, their arms by their sides and, despite the archaic appearance of their flat robes with the swelling folds of Languedoc Romanesque, I think they cannot be dated before the last quarter of the 12th century. The body is held well and the carriage is steady, the head is no longer stiff and upright on the axis of the body, but bends to one side; the features, particularly those of the woman have a certain softness, a restraint even in her grief, which marks the « lessened strain » of the beginnings of Gothic; finally the ornamentation of the book, with its floral lozenge, which appears on the Portail Royal at Chartres, remains a common motif at the end of the 12th and the beginning of the 13th century. C. Enlart has compared this representation of the Woman of the Revelation with a statue from *Wast* now in the Boulogne Museum[53], carved perhaps in the first years of the 12th century, which represents a woman giving suck to the Child, while a wild beast bites her. This is perhaps the Woman of the Revelation also, but it is carved in a much more violent style and with much coarser technique.

There are similarities between the St.-Maur statues and three fragments from *St.-Quentin-lès-Beauvais* (Oise) now in the Museum at Beauvais, which are so damaged as to make it difficult to judge their worth, but it is possible to recognize that they were statues, backed to columns, in stiff attitudes, with flowing robes, quite like those at St.-Maur, which might date them before the middle of the 12th century. Certain details such as the head of one man, which is both bent and turned, and the elegance of the gesture of one of the

women, who lifts her skirt with one hand, make one think that they belong to the second half of the 12th century.[54]

The church of Notre-Dame at *Corbeil* (Seine-et-Oise) was built under the supervision of Suger, who took particular interest in it, as he mentions in his deposition of the 17th June 1137. The nave with its vaults on pointed arches was only finished at the end of the 12th century and was entered on the west side by a fine door with column-statues, which was carved about 1180, when three houses were pulled down to free the entrance[55]. The church was abandoned at the Revolution and destroyed by the « black bands » between 1820 and 1823. Two of the statues from the door, which were broken by municipal orders in November 1795, were preserved by Sergent-Marceau.[56] They were placed by Lenoir in the Museum of French Antiquities, where they were described as Clovis and Clothilde, and in 1816 they were transferred to St.-Denis, where they stood at the bottom of the north transept. They were restored in 1865 under the direction of Viollet-le-Duc. In 1916 they were placed in the Louvre and may be seen in the Romanesque sculpture gallery. They represent, in fact, Solomon and the Queen of Sheba. They are slender *Plate 39* statues of the height of a column, carved from one slab in the technique we have noted at Chartres, at Le Mans and at Bourges; but the sculptor, though subscribing to the principle of the column-statue, shows in his treatment of the details of robes, jewelry, coiffure and feature, so admirable a realism and observation, such care of technique, that his statues, though fixed to a column with dangling narrow, elongated feet, are freed from the stiffness, which the formula of the master sculptor prescribed.

The iconography of the tympanum and the arch-rims, as far as we can judge by old descriptions, displayed new tendencies. Besides the Elders of the Apocalypse, there were in the arch-rims several figures of saints, and in the tympanum, framed in a pointed arch, was the Last Judgement. Christ, leaning on the cross, was enthroned between angels holding instruments of the Passion, while at his feet the dead issued from their tombs. To the left of Christ the wicked were cast in chains into the mouth of Hell, to his right rose a fortress, in which were sheltered the elect. The theme may be recognized as one which appears in the centre door of St.-Denis, and which we can find again in almost exactly similar terms on the west front of *Laon* cathedral on a tympanum carved a few years before Notre-Dame de Corbeil.

Plate 40

M. Mâle, in agreement with the latest historian of Laon, M. Broche, proposes to date back to between 1165 and 1170 the door on the right of the west façade representing the Last Judgement.[57] Here as at St.-Denis, Mantes and Notre-Dame the decoration of the main façade must have started at the same time as the foundation of the apse. I am led by the difference in style between this door and the two in the middle and on the left of the west front, which were constructed at the beginning of the 13th century, to believe this theory, which assigns them to the lifetime of Gautier de Mortagne, who began the new building. The tympanum was enshrined in the new façade at the beginning of the 13th century.

Iconographically the theme is connected with the St.-Denis door with Christ enthroned in the middle of the tympanum. With palms of hands and soles of feet turned outwards he crushes the unfortunate mortals, poor cowardly insects, who at the sound of the trumpet pour forth from the graves.

Round his head angels carry instruments of the Passion, while beside him are the Apostles, assessors of the Last Judgement, and at his right hand the Virgin, who with clasped hands intercedes for the human race. For lack of room four apostles have been relegated to the ends of the two first arch-rims; above, angels carry the souls of the blessed into Abraham's bosom. In the other arch-rims are seated the Blessed, to whom an angel gives crowns, and the Wise and Foolish Virgins, the latter with overturned lamps knocking at the shut door, the former with lighted lamps entering Paradise by the open door.

The theme of the last Judgement is as complete as on the great Gothic doors at Paris and Bourges; only the Weighing of the Souls is absent and the Tortures of the Damned, which appear on the south transept at Chartres.

There was in the church of St.-Faron at *Meaux* an important monument, which in composition was attached to this group of doors, namely the tomb of Ogier the Dane. The church of St.-Faron was the most famous of the holy places at Meaux and the centre of a pilgrimage to the shrine of the Merovingian saint-bishop. There is no trace of it to-day. The tomb was « standing against the choir-wall, facing the west transept ». It was destroyed in 1751 on the rebuilding of the abbey by Tottin, the king's architect, and we only know it by Mabillon's engraving, published in 1677, and by a drawing dated 1742.[58] It was the tomb of a monk named Ogier, who was identified

44

with the celebrated Ogier the Dane, companion-in-arms of Charlemagne, who became a monk at St.-Faron after having rebelled against his king. His squire Benoît lay beside him. They were both represented in monastic habits on a great sarcophagus, the side of which was decorated with scenes relating the coming of Ogier to St.-Faron.[59] A few years ago there was found in the old mills at Meaux a head, now in the Museum,[60] which belonged to a more than life-size statue. The curly hair, like that of St. Peter at St.-Loup-de-Naud, the half-shaved beard, like that of St. Loup on the pier of the same doorway, make one think that this head was that of Ogier. In style it is more primitive than the St.-Loup figures and it is possible that the effigies were earlier in date, to judge by the mouldings and bases and the elegance of the figures; possibly about 1180, or else that they copied an old tomb that was known to have been in existence since the end of the 11th century.

The five arch-rims of the hood, of decreasing size, were decorated with figures of angels, with scenes of the Resurrection of the dead and with palmettes of very fine quality. They were upheld on either side by three column-statues, separated by ringed columns; on the right a man, a girl and a man, bearing an inscription, still legible in the 17th century, which identified him as Ogier — this was a confusion with Olivier — giving his sister, the beautiful Aude, in marriage to his friend Roland. To the left were a king with a sceptre, a woman and an archbishop, undoubtedly Charlemagne, his wife Hildegard and Archbishop Turpin, who protected Ogier against the justifiable anger of the Emperor and succeeded in obtaining his forgiveness. Mabillon's draughtsman has unfortunately invested these statues with the character, movement and poses of the 17th century, so that no one can judge of the style of the originals, though it is certain that they were column-statues, while the details of decoration and moulding, as well as the general style, as to which both Mabillon's engraving and the drawing of 1742 are in agreement, suggest a date for this magnificent monument of about the year 1180.

Despite the small inclination of sculptors for the human figure in that country, Normandy must have had doorways with column-statues, and they are found in the districts nearest to the influence of the Ile-de-France. One of these statues, the provenance of which is unfortunately unknown, is still preserved in one of the galleries of the cloister of *St.-Wandrille* (Seine-Inférieure). The head and feet are lost, but it is easy to recognize the remains of a life-size

45

statue, carved in one block with its column. The pose is stiff and the robe falls in parallel folds, but a touch of ease in the clustered pleats at the waist seems to foreshadow the accomplishment of Senlis.

One of the bays of the chapter-house of *St.-Georges-de-Boscherville* (Seine-Inférieure) is set with slender statues against columns, the robes of which recall by their folds the column-statues of our group from 1160 to 1170. The capitals of these columns, some of which are in the Museum at Rouen, are ornamented like those of the Portail Royal at Chartres, with charming scenes, including some which tell the story of the Childhood of Christ, admirably carved.

The Abbey church of *Ivry-la-Bataille* near Evreux (Eure) had a door with column-statues on the west front, now unfortunately in ruins. The tympanum and lintel have vanished and the three pointed arch-rims are decorated with arabesques and statuettes in the last stages of destruction, representing angels and the Virtues and Vices; one of them wears a long coat of mail and bears the inscription « sobrietas ». The walls on either side of the door were decorated with column-statues of which only the one on the right survives; this represents a very slender woman, unmoved, with her hands in repose, and in garments which cling in parallel folds to the body in a style very close to that of the fine figures on the centre door of the Portail Royal at Chartres. A letter dated the 6th of November 1726 from Jacques Le Gris, a religious at Ivry, to Montfaucon gives us a description of this door. On the tympanum was Christ between the Symbols of the Evangelists, on the lintel twelve little seated figures, without doubt the Apostles, as at Chartres, and on the walls to the right, a man and a woman, while the third statue had already disappeared; on the left an old man between two kings.[61a] Across the Channel several groups of sculpture, at Rochester, Lincoln, Chichester and York, prove the expansion of the new art of the Ile-de-France in the second half of the 12th century. The door of the front of Rochester copies the Portail Royal very clumsily; on the tympanum is Christ in Majesty between two angels and the Symbols of the four Evangelists, while below the Apostles are conversing. On the abutments two column-statues represent Solomon and the Queen of Sheba.

The influence of these doors with column-statues extends to the North, as far as *Honnecourt* (Nord) and *Tournai* cathedral, where the Mantile door,

erected in the third quarter of the 12th century, to the north of the nave, is adorned with little figures of the Virtues and Vices, slender, tall and set one above the other, as on some northern Italian doors and also on the old north door of the façade of Ste.-Gertrude at *Nivelle,* where the columns are decorated with statues in very low relief, representing on one side Samson with the gates of Gaza, on the other Samson pulling down the columns of the Temple. On the façade of the abbey of *St.-Trond,* near Liége, a decorated doorway was carved in 1169. On the tympanum is a Christ in Majesty, crowning St. Trond and St. Euchère who are kneeling at His feet, with two angels beside Him swinging censers, also figures of St. Stephen, St. Quentin, St. Remy and of the abbot founder. Some taller statues, undoubtedly column-statues, on either side of the door, represent David and Moses on the right, Solomon and Isaiah on the left.[61b] Madame Lefrançois-Pillion[62] has shown that at Notre-Dame at *Corbie,* a fine door was set up in the early years of the 13th century, with the arch supported by two column-statues, one of which is still standing to the right of the door, representing a prophet or a patriarch. These are in the style of those we have so far discussed, but easier in manner, more natural in pose and closer to the sculpture of the transepts than the Portail Royal at Chartres.

One of the finest of these porches and possibly the most interesting owing to the fullness of the scheme was the St. Anne door on the west front of *Notre-Dame* at *Paris,* which we are able to reconstruct before the modifications of the beginning of the 13th century and before the destruction of the large statues by order of the Commune of 1793. *Plates 41, 42*

At the time of the laying of the foundations of the choir provision was made for the site and the scheme of the façade, and shortly afterwards, about 1165-1170, the carving of the doors was executed. A large proportion of the sculpture of the St. Anne door, to the right of the western façade, dates from this period.[63] The statue of St. Marcellus on the pier, by Geoffroy-Dechaume, replaces the original, which was broken during the Revolution, put together by Romagnesi in 1818, and is now in the Musée de Cluny; the big statues have been reconstituted by the sculptors of Geoffroy-Dechaume's workshop, under the direction of Viollet-le-Duc, after Montfaucon's designs.[64] To the left is St. Peter, to the right St. Paul, and on either side three Old Testa-

ment figures, a queen between two kings; one of these latter on the right carries a viol and must be David, while the other on the same side is Solomon. According to the usual convention observed at Chartres, St.-Germain-des-Prés and several other doorways, one of the queens has long plaits; her bodice is moulded to her figure and a girdle knotted round her waist, while her dress of wrinkled material falls in fine folds to spread at her feet. The other queen is wrapped in a long mantle, which conceals the lines of her figure, as her veil does her hair; by her position, between David and Solomon, this latter undoubtedly represents the Queen of Sheba, the former being one of the famous women of the Old Testament, perhaps Bath-sheba, or Judith or Esther, who have given their names to two books in the Bible, and whose history was well known to the poets and artists of the Middle Ages.[65]

Plate 41 The second lintel on which is carved the story of the Virgin and of the Child Jesus — two scenes at the ends must be excepted — the tympanum with the Virgin in Majesty between two angels, King Louis VII, Bishop Maurice de Sully and a clerk, and a group of statuettes in the arch-rims of angels, patriarchs and prophets, elders of the Apocalypse, were incorporated about 1230 in a new door, executed on the scale of the others. The original keystones, which were copied with a different edging in the 13th century, are now in the Louvre.

These figures, so simple, calm and peaceful, do not recall in any way the restlessness of the Romanesque style except by the distorted attitudes, by the crossed legs of a few elders and by the traditional fluttering fold at the bottom of the robes blown back by the wind, which is visible on a few figures of angels, elders and patriarchs on the arch-rims and in the tympanum, on the two superb angels who support the Virgin carrying the Child. The composition is easy, though a little stiff in the balance of the groups and the pose of the figures, and in the long parallel folds of the vestments cut in stone of a heavy grain. The statues on the lintel are upright and stiff, even when in *Plate 42 a* movement, as in the Angel of the Annunciation, for instance, their heads turned to the spectator, like actors in a mystery play when they are speaking their parts, and one can imagine larger versions of them on the abutments of the door, as column-statues. This reaction against the restlessness of the older sculptors, which rather delays the action, gives to the work of the master of the St. Anne door an unusual majesty and nobility.

48

The figures on the tympanum bear witness to the efforts of the artist to create a more lively and animated scene. The Virgin sits stiff and upright, because she follows tradition, but the two angels who are censing her on either side are no longer immovable. The left-hand one, with doll-like face and curly hair, recalls the angels of Senlis; the right with longer face, gallant air, head upright, well-balanced arms, body upright on the hips, right leg almost straight, left leg slightly bent, swings his censer in a completely natural manner. The features of the other three figures, the king, the bishop and the clerk, are still more marked and their poses more varied. *Plate 42b*

This door has often been compared with the Virgin door of the Portail Royal at Chartres, [66] and it has even been suggested that the two statues of the Virgin are by the same sculptor, the « master of the two madonnas ». [67] The two Virgins have, indeed, the same gestures, poses, robes and veils, and both have a ring on the middle finger; but the Virgin in Paris is slenderer, the oval of her face longer, while the drapery on the arms is fuller and the embroidery and little folds of the robe, as well as the pierced halo, of the Virgin at Chartres are absent.

As a matter of fact the resemblance between these two doors is more apparent than real. The composition is different; there are two lintels and a tympanum at Chartres, one of each at Paris, while the iconography is not the same. It is true that on both doors are the Annunciation, the Visitation, the Nativity, the Announcement to the Shepherds, and the Virgin in Majesty, so popular a feature of 12th century doors; but there are also at Chartres scenes of the Presentation in the Temple and in Paris the Magi before Herod, while the Virgin in Majesty is attended by two angels, the founders of the cathedral and the clerk who is writing the record of the foundation.

The style itself is different; that of Paris is calmer and less familiar, less human, with a hint of the grandeur of the Bible. One has only to compare the two scenes of the Annunciation: at Chartres the angel advances to the Virgin, bows before her, while she, in astonishment, lets her book fall and clutches at her sleeve, as though to ward off the angel: little human details which are neglected by the sculptor of Notre-Dame. The latter on the other hand introduces the prophet Isaiah who foretells the scene which he is witnessing; the angel is standing upright and does not look at the Virgin and the latter is also standing in a stiff attitude, half-turned to the spectator, without

49

seeming to heed Gabriel. In the same way in the scene of the Visitation: at Chartres Elizabeth clasps the Virgin to her and their two heads are almost touching in a most moving group, while the Virgin intones the Magnificat; at Paris the two women stand side by side, at a little distance from one another, and though both figures are stiff, they have that nobility which is the mark of the sculpture of Notre-Dame. In the scene of the Nativity: at Chartres Joseph lies at the foot of the bed in a smock, his legs swathed with peasant's bands; at Paris he is seated in a high-backed chair, dressed in a long robe, dreaming, meditating, in an attitude of majesty and distinction. The same remarks could be made of the other scenes.

The drapery is also quite different. At Paris, and also at Chartres, the flowing robes are moulded to the body, the stuffs are crimped in many small folds as if by curling tongs. But many of the details of Chartres have disappeared at Paris, while the folds, which are less abundant, accentuate the shape of the body and with their long, straight lines, add to the impression of stiffness, which shows again in the poses. The fluttering fold, relic of Romanesque art, is more frequent at Chartres than at Paris. At Chartres the dresses of the Virgin and Elizabeth fall almost directly to the ground; at Paris they cling to the limbs in a very marked manner, before falling to the feet, which they cover almost entirely.

The master of Paris is inspired by the master of Chartres, but his art is entirely different: less pictorial and descriptive and more sculptural, it is also more majestic. Less restless, and possibly less monotonous, it marks a very lively reaction against Romanesque ideals and is thereby more closely allied rather to the art of the statues of the Portail Royal than to that of the capitals or even of the tympana.

The type of the Virgin in Majesty, immobile and triumphant, throne of David bearing the Divine Child, which we see at Chartres and Paris, is derived from wooden statues carved in the Auvergne district and the centre of France from the 10th century onward. It remains, sometimes with a few slight alterations, till the end of the 12th and the beginning of the 13th century upon the tympana of churches, as for instance at the Benedictine priory *Plate 43* of Notre-Dame-du-Pré at Donzy (Nièvrè), on the north door of the transept of the cathedral of Rheims, on the south door of the church at Donnemarie (Seine-et-Marne), where the donors kneel at the Virgin's feet, and at Cunault

50

(Maine-et-Loire), carved in wood, like the lovely Virgin of St.-Martin-des- *Plate 44a*
Champs now in the choir of the abbey of St.-Denis, which recalls in its pro-
portions, features, pose and drapery the statuettes of the tympanum of the
St. Anne door at Paris and the Virgin of Gassicourt (Seine-et-Oise), which *Plate 44b*
dates only from the 13th century, as is shown by the character of its features
and the style of its more ample robes, with the folds more natural and more
deeply hollowed. At Jouy-en-Josas (Seine-et-Oise) there is a lovely wooden
Virgin sitting in a chair holding the Infant Jesus before her with two little
angels to support him.[68]

II

THE SPREAD OF GOTHIC IN BURGUNDY, PROVENCE AND LANGUEDOC

FROM St.-Denis and Chartres to the St. Anne door at Paris, these doors with statues constitute a group with marked characteristics, with the same composition, iconography and technique, which represents the beginnings of Gothic sculpture formed by the new principles of Gothic architecture. The reputation of this art with its quiet majesty, which is as severe as the dogmas it transforms to stone, is destined to grow rapidly, and the same influence will even be found in Burgundy, Aquitaine and Languedoc, which supplied the models whence Suger drew and, in the western façade of St.-Denis enunciated, the new formula which is now-a-days triumphant.

We have seen that there were doors with column-statues in the north transept of *St.-Pourçain* (Allier) and at St.-Pierre at *Nevers* (Nièvre), where the Queen of Sheba wore a goose's foot, both of which are now unfortunately destroyed. We know the second of these by a drawing [69] dated 1838: on the tympanum was represented, above the Apostles, Christ in Majesty between the Symbols of the Evangelists, while in the arch-rims were the Elders of the Apocalypse.

Another door, with statues of more importance, decorated the west front of St. Benignus at *Dijon* (Côte-d'Or); it was smashed by the Revolutionaries on the 16th January 1794 to such an extent that it is impossible to recognize the composition now and we can only reconstruct it by Dom Plancher's engraving of it.[70] After the fire of the 28th June 1137 the church of St. Benignus was partially rebuilt and the door cannot have been carved before the third quarter of the 12th century. On the tympanum are Christ in Majesty between two seraphim, the four Symbols of the Evangelists and two women, who here, as at St.-Pierre at Nevers, represent the Church and the Synagogue. On the lintel as at St.-Loup-de-Naud, the Virgin sat enthroned in Majesty with the Child on her knee, to the left the Magi on horseback and the Adoration, to the right the Announcement to the Shepherds and the Nativity. On the semicircular arches were angels, Elders of the Apocalypse, scenes of the Childhood of Christ and the Massacre of the Innocents, and foliage with birds,

gryphons and winged monsters in it. The whole composition — the style of the sculpture unfortunately cannot be recognized — seems to be much closer to that of Chartres than to Burgundian Art. The presence of the column-statues confirms this. On either side, placed high under the capitals of the columns against which they stood, were ranged statues, representing figures of the Old Testament; three kings, a queen with a goose's foot, the Queen of Sheba, as at Nesle-la-Reposte, at St.-Pourçain and at St.-Pierre at Nevers, Moses with the Tables of the Law, and facing him a figure in pontifical robes, which may represent Aaron, and St. Peter and St. Paul.

Two tympana from the cloister and the refectory of St. Benignus, which were carried out at about the same period, are preserved in the Musée des Antiquités de la Côte-d'Or. One of them represents Christ in Majesty, with an aureole borne by four angels between the Symbols of the Evangelists; the other the Last Supper, as at Bellenave (Allier), at St.-Julien-de-Jonzy (Saône-et-Loire), at Déols and at St.-Germain-des-Prés at Paris.

Plate 45 At *Bourg-Argental* in the Loire district, the influence of the Ile-de-France comes into opposition with that of Cluny, as in the old door of the famous abbey, where the tympanum representing the Apocalyptic Vision under a double arch-rim, decorated with little roundels of heads or figures, is of that style, while the scenes of the Childhood of Christ on the lintel and the column-statues which receive the bends of the arches recall the art of the Ile-de-France.

Plate 46a The door of *Vermenton* (Yonne) is very closely connected with that art and dates from the third quarter of the 12th century. The tympanum is now destroyed, but an old engraving[71] shows Christ in Majesty between the Symbols of the Evangelists. In the arch-rims are figures of angels and little scenes as at Le Mans and St.-Loup-de-Naud. The statues against the columns are now much mutilated; but it is possible to recognize to the right the Virgin standing with the Child in her arms, one of the oldest representations of a theme which we find on the façades of the great 13th century cathedrals. Opposite her, according to Dom Plancher's engraving, are three kings, kings of Judah or royal Magi, and at their side a personage in episcopal robes. All the dresses fall in parallel folds to the feet and are embroidered. The statue is still attached to the column, the feet are dangling, but the proportions are good and the gestures natural, the pose less stiff; one of the figures to the left even bends slightly forward.

54

The three doors of the west front of St.-Lazare at *Avallon* were also decorated in the third quarter of the 12th century with column-statues, and on the tympanum of the centre door was Christ in glory between the Symbols of the Evangelists. [72]

The statues on the walls were prophets and figures from the Old Testament. One of them, abandoned in an upper room of the tower, after having served for many years as the mullion of the topmost window on the west side of the tower, has been recently put back in its proper place. It is a tall statue, 2 metres, 40 cm. in height, and 40 cm. in width. The costume is a robe held by a *Plate 46 c* girdle, which indicates a period far on in the 12th century, but by its technique, by the folds of the drapery and the stiff pose, the statue comes close to the style of Chartres. An investigation made at Avallon in 1482 proves that two of the large statues to the right of the central doorway were the Virgin and the Angel of the Annunciation, as shown by the inscription « Ave Maria, gratia plena ». [73] Here, as at Vermenton, the Burgundian sculptors assigned the place of honour to the Virgin on their doorways from the commencement of the 12th century.

The influence of the Ile-de-France was not felt in Burgundy merely by the introduction of column-statues at the doors of churches, but also by the quiet and restraint of an art, which accentuated its realization of life and strength by rebelling against disordered gestures and contorted attitudes. On the west door of the church of *Anzy-le-Duc* (Saône-et-Loire) is carved in a much more peaceful style an Ascension group, which also represents, as at Etampes, the second Coming of Christ, surrounded by the Elders of the Apocalypse, who appear in the arches. The restraint of the gestures, the statuettes in the arches, and the two beautiful figures of angels, which seem to copy those of Chartres or Paris, attest the influence of the Ile-de-France in this centre of Romanesque sculpture. At St.-Paul-de-Varax in the Ain district we find with the same composition the same double subject, which the recluse Honorius explains in his *Elucidarium:* « Jesus will come to judge the world in the same form in which he ascended to Heaven ».

Other proofs of the influence of the Ile-de-France on Burgundian sculpture in the second half of the 12th century can be found, and nowhere was it more strikingly shown than in a monument now destroyed, but once celebrated, that of St.-Lazare at *Autun*. Demolished in 1766 by order of the chapter, the

tomb used to stand at the end of the choir, behind the altar. It was a kind of chapel under the shelter of which was a sarcophagus; at the corners four figures of men lifted the stone cover to reveal St. Lazare's corpse, wrapped in cerecloths. At the foot of the tomb were three statues representing Christ, St. Peter and his keys on the right, and St. Andrew on the left; and at the *Plate 46b* head two figures of women, St. Mary Magdalen and St. Martha, the latter covering her mouth and nose with her robe. There were inscriptions on the tomb, and one gave us the name of the sculptor, the monk Martin, and the date of its execution, when Stephen II was bishop (1170-1189).[74] Three statues, those of St. Andrew, St. Martha and Saint Mary Magdalen are pre- *Plate 47* served in the Musée Lapidaire at Autun, while the head of St. Peter has recently found its way to the Louvre. These fine figures have oval faces, large and powerful eyes with black pupils, very bony frames, curly or ridged hair. They are the work of a Burgundian artist influenced by the Ile-de-France, and with their stiff pleated garments seem to be a kind of column-statue.

While the great Gothic sculpture is gradually developing in the Ile-de-France, and while, with the evolution of ideas and of art, aided by an ever-growing technical skill, the column-statues of St.-Denis and of the Portail Royal blossomed into those magnificent statues which we shall admire in the transept at Chartres, Romanesque traditions continued in the South of France right down to the first years of the 13th century and refused to recognize the masterpieces of northern Gothic till the very last years of the 12th century.

In his beautiful *Etudes sur la sculpture française au Moyen Age*,[75] the Comte de Lasteyrie, in opposition to the thesis of Vöge,[76] which has since been corrected by Kingsley Porter[77] and Richard Hamann,[78] on the priority of the school of Provence to any other of the Romanesque schools, and also to M. Marignan[79] who perhaps dated it too late, has established with complete proof, basing his views on style of drapery, armour, iconography and above all inscriptions and documents, that the masterpieces of Provence cannot be dated before the middle and the second half of the 12th century. I do not propose to quote this great archaeologist's arguments, most of which seem to me incontrovertible, but I am afraid that those who want to date the sculpture of Provence too far back have made too free a use of the volumes we possess upon the churches of that region.

56

The few fragments in existence of the frieze of the cathedral of Nîmes (Gard) are perhaps the first beginnings of the series, which runs through the famous frieze of Notre-Dame-des-Pommiers at Beaucaire (Gard) and a group of fragments in a chapel at St.-Guilhem-le-Désert (Hérault), recently published by R. Hamann,[80] to culminate in the frieze of the façade of St.-Gilles (Gard). The style is still heavy and coarse at Nîmes, inspired by Roman art and copied upon the Christian sarcophagi of Arles with such accuracy that it is difficult to tell which is which at St.-Guilhem; it shows that in the middle of the 12th century the sculptors were adepts at grouping and putting life into these squat little figures, with square heads and sometimes coarse features, draped in robes, whose wide sweeping folds are not without a certain grandeur. The subjects are the story of the Childhood of Christ, his public Life, Passion, Death and Resurrection.

We find this style on the façade of St.-Gilles also, which was begun in the middle of the 12th century on purely local lines, which are common among southern architects. But, except for a part of the frieze to the left of the central doorway, which is very closely connected with the bas-reliefs of St.-Guilhem and Beaucaire, there seems to be a new spirit abroad at St.-Gilles, and it is likely that the rest of the frieze and the tympana of the side doors were com- *Plate 48* pleted only after a long interval at the end of the 12th century and by artists who knew Chartres and Paris, with a more finished art and the iconography of northern French doorways. On the left-hand tympanum is the Adoration *Plate 49* of the Magi, and beside it the Angel warning Joseph to fly into Egypt, scenes which are also found on the church of Notre-Dame-des-Pommiers at Beaucaire, where the superb central group of the Virgin carrying the Child is still in existence.[81] These scenes were copied, down to the last detail, on the baptistry at Parma and are to be found on several other Italian churches: on the façade and rood-screen of the cathedral at Modena, at Verona, Parma, Como and Borgo San Donnino, where there is a very close affinity to the friezes at Beaucaire and St.-Gilles. The tympanum of the central doorway is composed of shapeless fragments restored in 1650, and it is impossible to judge the quality; but one can see a change of style and an inroad of Northern Gothic into Southern Romanesque in the arrangement of the arch-projections, which were mounted on jambs designed to carry, as at St.-Trophime at Arles, a single deep span, as was customary with the builders of the South.

57

The door of St.-Trophime at *Arles* is decorated on the tympanum with a figure of Christ in Majesty sitting between the Symbols of the Evangelists above the Apostles and, at the sides, with a broad band of sculpture repre-

Plate 51 senting on one side the elect received into the bosoms of Abraham, Isaac and Jacob, on the other the damned thrown in chains into Hell fire. Despite the very archaic nature of this sculpture, the details of the costumes, the episcopal ornaments, the armour, and coiffures, some of which are already to be seen on the Portail Royal, as Vöge has noted, as well as the style of the foliage, which is like that on the door of the church at Maguelonne (Hérault), which is dated 1178, prove that the sculptures of the door were only carved at the end of the 12th century by an archaistic school of workers, who certainly knew the Portail Royal, but who remained true to local and Romanesque tradition.

The façades of St.-Gilles and St.-Trophime, like the pillars in the cloister of St.-Trophime, are decorated with great statues; but they are not column-statues like those of the doors of the Ile-de-France, but statues backed to pilasters, deep reliefs attached to the block in which they have been carved, following the process dear to Romanesque sculptors of Languedoc — several of the Provence statues, like those of Languedoc, have their legs crossed — and carried out in the technique of the Provence sculptors, who were the heirs of the Romans, with the addition however of the fluttering folds of the Romanesque sculpture of Languedoc and Burgundy.

The statues at St.-Gilles were carved about 1160-1170, in the cloister of St.-Trophime at Arles about 1170-1190, and on the door of St.-Trophime about 1190-1200. They represent Apostles and there are in addition, at Arles, St. Trophime and St. Stephen. The style of the statues at St.-Trophime at Arles (to the left St. Peter, St. John the Evangelist, St. Trophime, St. James

Plate 51 the Less, and St. Bartholomew; to the right St. Paul, St. Andrew, St. James the Greater, and St. Philip) and the costume of the bishop-saint Trophime will not allow of a date earlier than the end of the 12th century,[82] despite certain archaisms which testify to the survival of Romanesque traditions, in execution, attitude, gesture, drapery and details of costume, such as the banded sandals of the Apostles. The conclusions of the Comte de Lasteyrie on

Plate 52 a the date of the sculptures on the north and east galleries of the cloister of St.-Trophime, based upon iconography, costumes, mouldings and inscrip-

tions engraved on the very walls of the cloister, seem to me conclusive; 1170-1180 for the north gallery, 1180-1190 for the east.

On the pillars are carved great statues, separated by bas-reliefs, some of marble, squat and coarse, others of stone, finer and more expressive, executed on Romanesque principles under Roman influence; on one of the pillars are St. John, St. Trophime and St. Peter and in bas-relief the Resurrection and the Maries at the Sepulchre; on another Christ and the Pilgrims of Emmaus; on a third Christ showing St. Thomas the wound in his side and near him St. James, and on the fourth St. Paul, St. Stephen and an apostle, perhaps St. Andrew and in bas-relief the Ascension of Christ and the stoning of St. Stephen. The statues on the façade at St.-Gilles are, with some of those in the cloister at Arles, the finest of the group, and remarkable for their *Plates 48, 50a* expression and fidelity to life. Two of them, St. Matthew and St. Bartho- lomew, are signed by the sculptor Brunus. He also seems to be the sculptor of the statues on either side of the central door, St. John and St. Peter on one side, St. James and St. Paul on the other. It also seems likely that he *Plate 50a* carved the four statues of the church door of St.-Barnard at Romans (Drôme), *Plate 50b* about 1170-1180.[83]

This same type of statue placed against a pilaster, and hollowed in bas- relief from the block which serves it as a background, with the arms flat upon the body, and the points of the feet jutting beyond the support, ap- pears on an old cloister pillar from St.-Just at Narbonne, now in the Musée des Augustins at Toulouse, and at Chamalières (Haute-Loire) on a holy-water *Plate 52d* stoup, which likewise seems to have been made in a cloister pillar, and also on the south door of St.-Jean at Perpignan (Pyrénées-Orientales) and later at Morlaas (Basses-Pyrénées) and at Mimizan (Landes), and on several doors in North Italy[84a] at Piacenza, Cremona and later at Milan — cf. the eight beautiful statues of Apostles on the north side-aisle of the cathedral — and again on the St. Gall door of Basle Cathedral. These statues belong to the art of the South and there is only a fortuitous trace of northern influence. One can follow their evolution, from Moissac to St.-Gilles, in their more close resemblance to classic works. There is a far-off recollection of northern doors in the general arrangement with statues against walls, with tympana crowned with numerous arch-rims, and also in the solemn and sometimes stiff poses of the figures. At St.-Barnard at Romans there is a more detailed

59

imitation of northern art in the more slender proportions of the figures and the many closer and finer folds of the robes.

The relations between North and South become more and more frequent after the middle of the 12th century, and if at first the South only received a gentle impulse, towards the end of the century the connection became much closer and occasionally the North even imposed its technique and form upon those of the South, without however stifling them. The political projects of Louis VII attempted to renew the relations of Paris with Provence and Toulouse which had been given up since the 10th century. As early as 1154 the King had married his sister Constance to Count Raymond V; he exercised his patronage on the bishops and abbots of the South and it is curious to note the exchange of letters between the king and some of them, as, for instance, the prior of St.-Pons at Tomières, the bishop of Maguelonne, the archbishop of Narbonne, the abbots of St.-Gilles and St.-Guilhem, and the bishop of Elne. Then there were the religious quarrels, and the struggles against heresies, which brought into the country abbots, bishops and archbishops from the North with all their suites, and the famous Crusade, which invaded the Albigenses and Languedoc, pillaging and burning towns and villages, but protecting abbeys and rebuilding churches, and it is well known what part St.-Gilles played in it, after the death of the envoy Pierre of Castelnau on the 12th January 1208.

In Provence, in Roussillon, in all the South and South-East, 12th century sculpture is based on the antique; squat figures, lifelike but rather heavy gestures, broad draperies, coarse features, hair in curls or locks on the front of the skull and round the head. At the end of the 12th century, under the influence of northern art, more mystical, less realistic, the faces become refined, the figures lengthen, robes are fine-pleated, hair parted, poses more elegant and easy while the stiffness of northern art is modified by certain bendings of the limbs and curves of the body, which recall the style of Burgundy or Languedoc.

I have noted this northern influence in the statues of St.-Barnard at Romans and on the façade of St.-Gilles in the frieze which spreads from one end to the other, especially in the beautiful scenes of the Kiss of Judas, of the Flagellation and the Bearing of the Cross — the fragment to the left of the centre door seems older — and on the tympana of the side doors, which

represent on the left the Adoration of the Magi with, below, Christ's Entry into Jerusalem, and to the right the Crucifixion with, below, the Holy Women at the Sepulchre.

I find it again in the two rims of demi-angels round the archivolt of the doors of St.-Trophime at Arles, which recall, as does also the iconography of the tympanum, the centre door of the Portail Royal at Chartres; in the statues of apostles at St.-Guilhem-le-Désert (Hérault), preserved at St.-Guilhem and in the Museum at Montpellier, tall, thin figures, closer in style to the Toulouse Apostles or the Prophets of Chartres than to the statues at St.-Gilles or Arles, and in those of the old refectory at Montmajour, which must date, like the St.-Guilhem figures, from the last quarter of the 12th century, and are even closer to the sculpture of Chartres; and finally in those long effigies with crossed hands and feet resting on an inclined plane, dressed in multifolded robes, which seem to be derived from column-statues, and are found at the end of the 12th and beginning of the 13th century, at Arles-sur-Tech, in the cloisters at Elne, and beyond the Pyrenees in Catalonia and Aragon. I find it again at *Toulouse* in a group of statues in the Musée des Augustins from the chapter-house door of the Daurade. Carved perhaps at the beginning of the 13th century only, they represent kings, queens, apostles and prophets and are set in circular niches like the old bas-reliefs of Moissac and St.-Sernin; they wear long robes with parallel folds, and dresses fitting on to the bodices, long skirts girded at the waist, as at Chartres and Corbeil; King David, his legs crossed, tunes his harp, as on the arches at Provins and Braisne; the Virgin with the Child seated on her right knee and turning himself about in the act of blessing, as in the scene of the Ado- *Plate 53 a* ration of the Magi, recalls the figures in the Virgin in Majesty at Chartres and Paris; the Child's head has been re-carved, but the Virgin's is remarkable for its powerful realism. She is seated under a crenellated canopy, supported by two columns, the base and the capitals of which are in the style of the end of the 12th or the beginning of the 13th centuries. The Musée des Augustins also shelters an Annunciation group carved in the first half of the 13th century for the Church of the Cordeliers, which shows northern influ- *Plate 53 b* ence. The Angel seems to be a copy of an ivory statuette of the beginning of the 13th century, like the beautiful angel in the Chalandon collection, now in the Louvre; the Virgin, her bosom moulded beneath a tight-fitting

bodice, her skirt falling in long thin folds and spreading about the feet, is closely connected with the statuettes of the St. Anne door at Notre-Dame.

As a last instance, this influence on the column-statues of the doorways of the Ile-de-France may be seen even more definitely on the columns with statues in the cloister of Notre-Dame-des-Doms at *Avignon*,[84b] on the cantonal pillar with its statues in the ancient cloister of *St.-Bertrand de Cominges* (Haute-Garonne) and above all on the door of the little church near by of St.-Just at *Valcabrère*. On the north side of the nave is a door with a tympanum decorated with God in Majesty between two angels, who cense Him; at the sides the four Evangelists carry their symbolic animals in the folds of their cloaks. The whole style is rather heavy, with a border of chequer-pattern and an archivolt the mouldings of which are concave. In the embrasures of the door on either side are two massive column-statues in marble, with powerful heads, broad foreheads, their bodies swathed in heavy stuffs with large folds, a Roman trick copied by the southern sculptors. These rigid statues with their constrained gestures are backed to columns, in one piece with them, and are surmounted by capitals, with scenes; they are column-statues inspired by Chartres and Bourges. The heaviness of the sculpture, accentuated even more perhaps by the material in which they are cut, the archaism of drapery and modelling, would seem to date these statues about the middle of the 12th century, but certain details, such as the costume of one of them, a queen wearing a cross upon her breast, who is possibly St. Helena, as well as the moulding of the archivolt, place them in the end of the same century. A document of the consecration of the altar found in 1886 in the stone-work of the altar,[85] which is dated in October 1200, gives us proof of our theory; it also gives us the names of the three figures on the door, three young men, whose attributes hardly allow us to identify them, who are, in fact, St. Stephen and two Christians of Spain, decapitated by the orders of Dacian, St. Justus and St. Pastor, whose relics are preserved in the church.

I could also show how even across the Pyrenees the northern doorways were known and copied, as for instance at St. James of Compostella in the Goldsmiths' door and at St.-Vincent at Avila, but I do not wish to step outside my prescribed limits. I would only point out how, beyond the sea, in Palestine, at *Nazareth,* there was a door with column-statues, surmounted

by capitals with figures of great beauty, carved by some artist of Burgundy or the South of France, sheltered beneath canopies which recall those at Chartres, Etampes or Corbeil. Father Viaud has found some of the capitals and the heads of a few statues.[86a]

The little church of *Vezzolano di Albugnano* in the province of Alessandria shows a typical instance in the closing years of the 12th century of the influence of the sculpture of the Ile-de-France. On the tympanum of the façade is the Virgin seated in Majesty between two angels, as at Chartres and Paris, and three column-statues, Christ and two angels, against the jambs of the double bay over the door. Inside, the rood-loft is decorated with a frieze of figures in double rows, below, the Ancestors of the Virgin, and above the Coronation, Death and Resurrection of the Virgin, which are copied very closely upon the tympanum at Senlis.[86b]

III

THE EXPANSION OF GOTHIC SCULPTURE

THIS rapid sketch demonstrates the considerable expansion of the new art of statuary, of which we have traced the development from St.-Denis and Chartres to Notre-Dame in Paris. This development asserts itself very strikingly, at the close of the 12th century, in a building which is as important iconographically as sculpturally, the west door at *Senlis*. Situated in the heart *Plates 55-59* of the Ile-de-France, on a hill which is covered by one of the most picturesque of old French towns, a quiet peaceful town, drowsy and charming, dominated by the cathedral, the spire of which rises lightly and joyously, like a hymn to the Virgin, opposite to the ruins of the old royal château, a masterpiece of genius was created between 1180 and 1190 — the dedication took place on the 16th June 1191, and one is justified in thinking that the porch was completed by that date[87], — by a craftsman of genius who built on to the ideas conceived by Suger at St.-Denis this flower of beauty in honour of the Virgin. Twelfth-century art had represented her with her divine Son receiving the gifts of the Magi, as at Moissac and Vézelay and St.-Bertrand de Cominges, at Mimizan (Landes) and in several Catalonian churches, at Notre-Dame de Beaucaire, where the Virgin only is left, — at Fontfroide Abbey — the group is now in the museum at Montpellier — at St.-Gilles, as at Parma and several other North Italian churches, in Burgundy, at Neuilly-en-Donjon, Anzy-le-Duc, St.-Lazare at Avallon, and St. Benignus at Dijon — the door is now destroyed, — at La Charité-sur-Loire, then at the north door of Bourges and at Loches, where the influence of the Chartres Virgin is strongly marked, and we shall find the scene again at the beginning of the 13th century on one of the tympana of Laon cathedral and on the façade of Germigny-l'Exempt (Cher). About the middle of the 12th century the scene changes; more often than not, the Magi disappear and the Virgin in Majesty alone remains, throne of David, bearing on her knees the Child Jesus, the story of whose Childhood is told upon the lintel.

At Chartres, in that basilica where she is especially honoured, the Virgin carrying the Child appears in triumph at the door of the cathedral. The master sculptor of Paris will repeat and amplify the scene on the St. Anne door

and his example will be followed everywhere. But notice that this token of love and respect offered to the Virgin seemed insufficient; the cult of Mary has grown during the whole of the 12th century; in the 13th, the Virgin takes equal place with her Son, and in the great cathedrals a whole tympanum will be devoted to her Death, Resurrection and Triumph. Senlis is the place where we first see this and we find the idea repeated at Mantes, Laon, Braisne, on the north transept at Chartres, until the time when, about 1210-1220, the master sculptor of Notre-Dame at Paris renews and simplifies it, finding in it the motif of one of the masterpieces of sculpture. The theme

Plate 56 of Christ in Majesty amid the Symbols of the Evangelists disappears entirely; and it is the triumph of the Virgin, which is now the most common on the church doors. This idea which was so successful at the beginning of the 13th century had been suggested in the 12th on stained-glass windows. Suger gave to decorate the choir of Notre-Dame a great window from his workshops of the Triumph of the Virgin, which is perhaps the original of the iconographic theme we shall find again in the 13th century; a copy of this window seems to be preserved in the nave of Angers. This has, in a series of superposed medallions, the gathering of the Apostles at Mary's bedside, the Death of Mary, her Burial, Resurrection and Coronation. The same scenes, still rather badly arranged, are to be seen on the small tympanum of St.-Pierre-le-Puellier, now in the museum at Bourges.

The sculptor of Senlis will show only three of these scenes: the Death, the Resurrection and the Coronation. On the lintel are the Death and the Resurrection, on the tympanum the Triumph, and on the arch-rims the Patriarchs and Prophets who extol her and the Kings her ancestors; in the embrasures are Patriarchs, designated by the commentators of the Middle Ages as types of Christ, and Prophets, who announced his coming, while on the pier bases are the Labours of the Months. There are many blemishes; the arch round the Coronation is not a happy shape; the face of the Virgin is stiff and unpleasant, with no expression; it is still the Temple of the Holy Spirit that is represented, rather than the Mother of Christ; the robes are conventional and the folds cling badly. Christ blessing his Mother seems to bend towards her; his face is beautiful, but the exaggerated billows of his cloak detract from the majesty of his pose. At Chartres, Christ will hold himself upright, and the Virgin on the contrary will bow before her Son,

in a gesture of submission and prayer, which will be wonderfully rendered at Notre-Dame also. Two angels on either side, who will appear again at Mantes, Laon and Braisne, overcrowd the scene. Below, the bas-relief of the Death of the Virgin — the Apostles cluster round the bed, where Mary has just breathed her last, while two angels with nimbi bear her soul to Paradise — has suffered too much for us to judge its value, but the next scene, the Resurrection of the Virgin, is very charming. The artist, who has not been restrained by a too often withering tradition, has created in a moment of inspiration a work of the greatest freshness and grace. The little angels have just alighted like a flight of swallows round the Virgin; they flutter here and there, touch her, jostle each other in order to see her, take her, and bear her to Paradise; one at the back pushes her on by her shoulder, another holds up her head, a third bears her feet, a fourth brings the crown to place on her head, while the last, in the rear, presses through the others so that he also may see his queen. It is a simple scene, full of life, showing the fertile imagination, instinct with the cleverness and observation, of artists of the end of the 12th century, who were not kept in restraint by tradition. In the arch-rims, the Patriarchs and Prophets sing the glory of the Virgin, the kingly ancestors sit on branches of the Jesse-tree, remarkable for the variety of their attitudes, their vitality and crisp execution. They fill their narrow cells, half-crouched, sitting or standing up, turned to right or left, leaning to front or back. Some of them cross their legs, a reminiscence of Languedoc sculpture transmitted by Chartres and St.-Denis; one seems to be climbing his branch. The fluttering fold of Romanesque art has vanished entirely and the draperies are logically arranged as on the statues of the doors. Adam, Noah, and Abraham clasping the elect to him, their tiny heads peeping out of his robe, are there; Moses with the tables of the Law, then a woman, Deborah or Jael, Gideon and Samson, all with haloes; Jesse, David and Solomon begin the series of Kings. Here and there are traces of paint, which shows that the whole was once painted and gilded.

Plate 57

Eight large statues stand on either side of the door and complete the arrangement. They were restored in 1846 by the sculptor Robinet, under the direction of Ramée; the attributes and grotesques under the feet have been recarved and the heads, which had disappeared, are also modern and have been restored without sufficient attention to the persons represented. They

are, to the left, St. John the Baptist, Samuel restored as Jacob, Moses restored as Melchizedek, and Abraham; on the right David, Isaiah and Jeremiah, restored as Jeremiah, Ezekiel, Daniel, and the aged Simeon. They are still column-statues, but much freer in style and closer in feeling to the art of the great cathedrals of the 12th century; David still crosses his legs, the last trace of southern influence in northern doorways, but the proportions are good, the gestures varied and true to life, the ornaments more marked, the robes less clinging, the draperies on a grander and more naturalistic scale.

Plate 59 There is preserved in the Archaeological Museum a head of a bearded man of great nobility, executed with an admirable economy of means. If it does not belong to one of the great statues of the door it is none the less the work of the same school and we can imagine, from its beauty, what the heads must have been like which unfortunately have disappeared. On the base of

Plate 58 the column-statues are carved the twelve scenes of the Calendar, the Occupations of the Months, rather clumsily executed, but each a little picture, full of life, movement and remarkable observation. Everywhere around him the sculptor found his inspiration; at the foot of the town walls Nonette slipped through the fields, where the hay was being gathered; on the slopes the vines climbed to the foot of the old château in the town; on the plain, on the plateau, the earth was tilled, the wheat sown, the harvest garnered, and far off on every side lay the forest.

The month of January is one of quiet and feasting; sitting on a chair with low rounded back, a man eats; he seizes a ewer and is about to pour its contents into a bowl. Next, February, cold and wet; a poor wretch, just returned from wood-gathering in the rain, as also represented on one of the bas-reliefs of the calendar in the Cathedral of Paris, has entered his hovel without bothering to take off his cloak and crouches before the fire, on which he has just blown till the flames roar up the chimney. At Amiens, the man has taken off his shoes and is cooking a sausage at the fire. With March we are in the fields again: the peasant is bravely digging the ground with dress tucked up. At one side a tree begins to bud; at Chartres and Semur spring is further advanced and a dresser is pruning the vine. April's sun has brought forth shoots and the peasant is cutting his trees. Bare-headed and bare-armed, his short cloak thrown over his shoulders, he bestrides a branch; at Rheims he prunes a vine, at Paris and Chartres he holds ears of corn in his arms to

68

show that already the expected harvest is appearing. With May the scene changes to one of gaiety and amusement; at Amiens the peasant lies amidst flowers. Here a lordling, a falcon on his outstretched left wrist, holding in his hand the reins of his richly-caparisoned horse, leaves his castle to hunt. At Chartres and Semur he is already on horseback, at Paris on foot, the falcon and the decoy on his wrist, and hanging from his arm a branch of flowering eglantine: it is the bursting forth of spring, whose blossoms embalm nature. At Amiens, he is in mid-country, under trees that form a bower round him. In June the peasant is at work again garnering the sheaves, his arms extended, wielding the scythe vigorously. In July, it is the harvest; the peasant is cutting the corn with a sickle. In August the harvest continues at Chartres, Paris, and Rheims, while at Senlis, as at Semur and Amiens, the peasant, bare to the waist, threshes the grain on the floor. In September, the vintager gathers the grapes from bunches that weigh down the plants. In October, at Semur and Rheims, in the great wine country, the vintage goes on; at Paris and Chartres, the peasant sows his grain; here, he seems occupied in getting in the harvest. In November the peasant, as at Chartres and Semur, kills the pig, which only happens in December at Paris and Rheims. Lastly, in December cakes are put in the oven. The cycle ends, and the year is fulfilled as it began, in joy.

It was perhaps a few years before Senlis that the north door of the abbey of *St.-Denis* was carved, which Pierre de Montreuil embodied in the north façade of the transept he erected in the 13th century. In the tympanum are the Arrest, Last Communion and Martyrdom of St. Denis and his companions; in the arch-rims three rows of kings, and in the embrasures, on either side three kings, tall column-statues in varied attitudes, the heads more or less inclined, the upper half of the body detached from the column, from which the statue thus gradually separates itself. The curve of the arch-rims is a pointed one, the piers are decorated with superb foliage of a broad, bold type, while the columns, with their acanthus-leaf capitals bent in spirals under the angles of the abacus, are of the finest. The whole may be dated *Plate 54* at about 1170-1180.

The capitals and bases and perhaps the monsters on them and the superb foliage round the door, which is copied exactly at the collegiate church at

Mantes and is the forerunner of that on the Virgin door at Notre-Dame, seem to have survived untouched; but such is not the case with the statuary, the pier-figures, the statuettes on the arch-rims and the tympanum, which have been scraped, re-cut and even finished since the 18th century, as has been suggested by the last chroniclers of St.-Denis, M. Vitry and M. Brière, who have had access to the documents of the early 19th century, before Debret's restorations, and notably to Lenoir's drawings of the Kings in the Musée des Monuments Français[88] which prove that the door was not originally the same as it now appears. The dryness of the sculpture, the falling folds of the draperies, the arrangement of the Kings in the arch-rims and the figures on the tympanum, which seem to have no relation to it, are met

Plate 60 a with again on the left door of the collegiate church at Mantes, which has undeniable affinities with the north door of St.-Denis. As for the large statues on the embrasures, despite the fact that they are obviously not original, they are nevertheless by their attitudes and general outline witnesses to the evolution of the column-statues from St.-Loup-de-Naud or Corbeil to those of Senlis, which follow immediately after.

The influence of the Senlis door, and that as early as the end of the 12th century, is first noticeable in the central doorway of the west front of the

Plate 60 b collegiate church of *Mantes*. We do not know the date of the construction of this façade, but the composition of the door, the character of the beautiful foliage round it, the bases and pedestals, which once bore the column-statues ranged in front of the abutments, the outline of the mouldings and the very style of the statuary on the tympanum and arch-rims, place it right at the end of the 12th century, or shortly after, somewhere between 1190 and 1205.

The door is dedicated to the Virgin, as at Senlis. The scenes of the Death and Resurrection of the Virgin on the lintel are slightly different from those at Senlis. The sculptor wished to vary his design in these, and, to give more life to the composition, he has put on the left an exceedingly rare scene which is nevertheless also found on the tympanum of St.-Pierre-le-Puellier at Bourges, the Arrival of the Apostles, miraculously transported, from all corners of the globe where they were preaching the Gospel, to the Virgin's bedside.

Plate 61 b The central scene, much damaged, represents the Apostles round the Virgin on her deathbed, and to the right the Angels transporting their queen to Paradise. The scene unfortunately has not the freshness and spirit of Senlis, but the

70

artist has made a charming discovery. Between the two scenes of the Death and the Resurrection, Christ, recognizable by his cruciferous halo, gives to an angel, who receives it reverently in a fold of his robe, the Soul of the Virgin, conceived as a small naked child.

The Coronation of the Virgin recalls that at Senlis in general composition, but the Virgin and Christ are seated under a trefoiled arch, borne by two pillars, which is more graceful than the arch which frames the Senlis group, though it is much damaged. The heads of the Virgin and Christ are lost, but the drapery of the robes is more delicate and Christ no longer wears the great cope of Senlis which enveloped his arms and shoulders and added so much dignity and essential width to the gesture of blessing; the pose of Christ at Mantes, seated to the front, his hand raised in benediction, is already that which will appear at Braisnes, Laon and Chartres. The Virgin on the other hand is still stiff and upright as at Senlis, and the mark on the transom shows that the head was upright, and not bent as at Braisne and Chartres, a feature which gives such charm to those representations. Two angels on either side, the first standing with a censer, the second seated on a little stool with a candlestick, exactly as at Senlis, prove that the sculptor of Mantes knew the tympanum at Senlis.

The statuettes on the arch-rims, Ancestors of the Virgin, Patriarchs and *Plate 61a* Prophets, arranged in four rows, repeat the style of Senlis with remarkable precision in the composition of the Jesse-tree, the branches of which form niches in the figure of eight, and in the poses, some sitting cross-legged facing the front, others half-turned, as though better to see the scene upon the tympanum, their legs bent ready to kneel or to walk, their robes in flowing, swirling folds without a trace of the fluttering Romanesque fold. A few variants may be observed: a scene with two figures near the top of the outer rim, and the gesture of David playing his harp, his left leg crossed over his right, show that the statuettes of Mantes, the heads of which are all unfortunately broken, are more advanced in style than those of Senlis.

The jambs on either side of the door are decorated with superb foliage, exactly like that on the north door of the abbey of St.-Denis and the St. John door of the west front of Rouen cathedral.

In the embrasures on either side of the door, there were once five great statues backing on to columns, like those at Senlis and anticipating those in

the north transept of Chartres. They were damaged in the Revolution and have been replaced by plain columns; it is possible that some fragments exist among the debris preserved in the choir galleries.[89]

Plate 60 a

The door on the right of the façade was re-carved at the beginning of the 14th century. That on the left belongs to the same school as the centre door and may even be a little older. In the construction of the collegiate church the lateral walls of the side-aisles seem to have been built before the nave walls, and the side door was undoubtedly begun a little before the centre door about 1180-1195, at the moment when the north door of St.-Denis was being carved; it is therefore quite remote from any influence from Senlis, the new style of which was not known till the carving of the central door was started. The sculpture is treated as on the north door at St.-Denis, with a certain dryness, and the unique scene on the tympanum is stretched out in a somewhat naïve manner to fill the space. It is a Resurrection according to Romanesque rules with a certain archaism, not merely in the composition, but in the poses of the soldiers round the tomb and in their costumes; they wear the helmet with the nose-piece which was in use from the 11th to the 12th century. To the left of the empty grave without its stone, from which issues the shroud, is seated the angel who tells the news to the Holy Women, who have come, as though in procession, with their spices. The first bows, the second seems already about to depart; all three are dressed in long robes which fall to the ground, and great cloaks, as in a mystery play. Above, the risen Christ is seated in Majesty between angels who bend towards him and swing censers, a little like those in attendance on the Virgin at the Portail Royal and the St. Anne door. In the arch, which is pointed, eight small figures of Prophets stand out in a groove, some with crossed legs, with slender proportions and stiff folded robes, as at the St. Anne door at Notre-Dame.

On either side of the door are three column-statues. The jambs are decorated with foliage of very good style, possibly less rich than that of the centre doorway, but nevertheless nearer in form to that than to the flat foliage of the St. Anne door. The capitals of the pier-columns with fine acanthus-leaves, the claw-foot bases, the pedestal with geometric piercing and fluting, as at St.-Germain-des-Prés, and the outline of the abaci, all confirm the date of 1180-1195, which must be the period of this door.

About the time of the completion of the Senlis door and the central door of the collegiate church of Mantes, but a little before the decoration of the front of Laon and the doors of the transept of Chartres, appears on the west front of *Sens* an entirely different kind of sculpture, heavier, firmer and more powerful, in the true Burgundian tradition, but without a trace of Romanesque in composition, attitudes or drapery. On the 23rd of June 1184 a terrible fire swept through Sens; the cathedral did not escape, and Canon Chartraire has shown the effects of its ravages.[90] A few years after, about 1195-1220, when the most pressing needs of restoration had been fulfilled, the decoration of the façade was taken in hand. The collapse of the south tower on the 5th of April, 1268, destroyed part of it; but the left-hand door remains and a part of the centre door.

The left-hand door, dedicated to St. John the Baptist, is possibly the older *Plate 62a* of the two. On the tympanum is the Baptism of Christ by St. John, assisted by two angels, and the death of the Saint, and in the middle Herod's feast. Salome, her robust body moulded beneath her flowing robe, her plaits hanging down, advances bearing the Baptist's head on a dish. Above, a bust of the Christ, between two angels, blesses the saint.

The scenes in the arch-rims complete the story of John the Baptist. In the middle rim is the appearance of the angel to Zacharias, the Meeting of Zacharias, smitten dumb, with Elizabeth, the Conception of John, the Visitation, the Nativity and the Washing of the Child; in the inner rims, John named by Zacharias, the Circumcision of John, then the Preaching of the Saint and the Visit of the Disciples. The outer rim is devoted to the story of the relics of the saint. Despite Julian's orders to burn the bones of John the Baptist, the faithful of Sebaste collect the fragments and after his victory Theodosius bears them in triumph back to Constantinople, where he places them in a church built to receive them.

On the lower part of the embrasures are two great medallions carved with, on the left, Avarice with a shut coffer, on the right Liberality opening a box *Plate 62b* wide with either hand. The large statues sheltered under canopies which crown the capitals of the columns against which they leaned, as will become the usual disposition, have unfortunately disappeared. The shape of the bases, astragals and abaci, and the style of the capitals, prove that the work may be dated from about 1200.

On the pier of the centre door is the statue of the patron saint of the cathedral, St. Stephen, happily preserved. It is a fine column-statue of the first years of the 13th century, the counterpart of that desperately damaged St. Stephen by the pier of the north door of Meaux cathedral with a Book of the Gospels in his hand, on which is carved Christ on the cross between the Virgin and St. John,[91a] and of the lovely figures of deacons on the left door of the south porch of Chartres. Tall, thin, well-balanced, the feet inclined upon their pedestal, the young deacon holds the Book of the Gospels clasped to his breast. His long pliable dalmatic with rich embroideries falls in natural folds, well planned and skilfully rendered; round his neck the collar of his amice falls back on to the embroidery of the apparel of the dalmatic; his face, young and pure, with delicate features and of a slightly elongated oval, framed in curls, is one of the most delightful creations of mediaeval art. On the side of the pier, vine-tendrils with large leaves and rich bunches of grapes are entwined together; birds are pecking in them and little figures climb up to pluck the fruit. It is the first time that plants, fruits and leaves are observed with such care and so carefully reproduced: it is the natural foliage we are to find so soon on the Virgin door of Notre-Dame, which replaces the conventional foliage of early Gothic. The same remark applies to the birds who hide under the leaves or flit from branch to branch stretching out their necks to peck; every attitude is admirably observed and rendered. The other statues on the door-embrasure have disappeared; they represented the apostles and one of them is possibly preserved in the diocesan museum.

Plate 78a

Plate 63

On the pier-bases is carved the Mirror of Nature with animals and fabulous beings that were believed to inhabit the tropics and the Far East, and the Mirror of Vices and Virtues, now much mutilated; and above, on the left, the Mirror of Science, the Liberal Arts, the Trivium, the Quadrivium and Philosophy, represented by graceful maidens, and to the right the Occupations of the Months, rather like the set at Senlis. Janus, an old man warming himself, the pruning of the vine, the sower, the hunt, the harvest, the hay-gathering, the threshing of the grain, the vintage, the bottling of the wine, the acorn-harvest and the pig-killing.

On the jambs of the door are carved the Wise Virgins with lamps erect and the Foolish with lamps overturned, charming young women in graceful dresses with full skirts, which they lift elegantly to let them fall in folds; clinging

dresses in the case of the Foolish Virgins, moulding their bodies and defining their shape; capes and mantles in the case of the Wise Virgins, enveloping them in great folds. Above the Wise Virgins in the corner of the archivolt is the open door of the heavenly Jerusalem; above the Foolish Virgins the door that is closed to their loud knocking. This parable reappears at Auxerre, Notre-Dame and many other 13th century doors, and seems to show, like the little pictures carved on the embrasures and like the small figures of the arch-rims, that the scene originally carved on the tympanum was the Last Judgement. The tympanum was broken by the collapse of the south tower in 1268 and the Last Judgement replaced by the story of St. Stephen. The shallow arch-rims are decorated with seventy statuettes, arranged in five rows. Finely proportioned, beautifully draped in wide mantles in natural folds, they preserve not a vestige of Romanesque conventions, except in the occasional crossing of legs, which will soon disappear altogether.

With no canopies or pedestals they are somewhat like the figures of the arch-rims of the collegiate church at Mantes and of the north door of St.-Denis, but their poses, gestures and draperies are more natural. All have lost their heads, like unhappily nearly every statue on this door. They represent saints of Paradise, the holy angels, deacon martyrs, saintly confessors with palm and crown — four are in knight's armour, and lean on great shields of the time of Philip Augustus — holy doctors and saintly women, with the Paradise arranged in concentric circles, as later at Paris and Amiens.

In the ambulatory, under an arch of the third bay to the north, is a statue found in 1897 in a house in the cloister square, which represents a bishop in his robes, seated, his hand raised in blessing. This is without doubt St. Thomas à Becket, who stayed several times in Sens between 1166 and 1170 at the abbey of St. Colombe, and who on a previous visit in 1164, when he went to plead his cause before Pope Alexander the Third, may have stayed in the house where the statue was found. By the style of robes, architecture and of the sculpture itself this statue must date from about 1200.

The bas-reliefs of Sens can be compared with four little scenes carved on the sides of the buttresses of the centre door of the west front of Notre-Dame in *Paris,* the remains perhaps of a series of medallions of the Virtues and Vices illustrated by Bible stories, begun about 1200-1210 and probably abandoned or another series of Virtues and Vices of quite a different character.

75

Plate 64a

Plate 64b

I shall bring into connection with the doors of Sens two others of the first years of the 13th century, in which this Burgundian strength, this ebullition of life is plain, and scarcely modified by the influence of Chartres and Bourges though it appears in some details, notably the angel-figures; these are the doors of *St.-Pierre-le-Moutier* (Nièvre) and *St.-Benoît-sur-Loire* (Loiret). On the tympanum of these two doors, which are inspired and possibly carved by the same workshop, is Christ in Majesty seated on a throne between the four Evangelists, who write at the dictation of their symbolic animals, who, from the niches of the many-lobed arch round the tympanum, seem to inspire them; in the arch-rims are charming figures of angels. The lintel at St.-Benoît is also decorated with little scenes full of life, representing the finding and exposition of St. Benoît's relics and their solemn transportation to the great abbey. Miracles occur as the cortège passes with clerics in front of it. In the embrasures are column-statues, much mutilated, the character of which is still plainly seen, while the gesture, attitudes, the arms clasped to the body, the feet resting on animals with supporting grotesques, draperies with stiff folds, and sometimes gathered up round the body, all show the connection with the statues of Senlis, which is some years before it, and with those of the transept at Chartres which is a little later.

The same iconographic theme as on the tympana of St.-Pierre-le-Moutier and St.-Benoît-sur-Loire, is to be found on the front of *Donnemarie* (Seine-et-Marne), where the door is still decorated with a figure of Christ on the pier and statues, unhappily much mutilated.[91b]

We have now arrived at the beginning of the 13th century, a period when there will be at Chartres for almost half a century workshops busy with the façades of the transepts of the new cathedral. But before describing this marvellous group, which shows Gothic art in all its splendour, I must study two doorways executed at almost the same time as the beginning of the work at Chartres and directly connected with Senlis,[92] the inspirer already of the sculpture of the collegiate church at Mantes; those of the cathedral of Laon and the church of St.-Yved at Braisne (Aisne).

In 1205 the chapter of the cathedral of *Laon* bought the quarry at Chermizy, 17 kilometres from Laon, to cut stone from it to build their new choir. It may be supposed therefore that at the moment when the chapter undertook work as considerable as this, the immediate necessity for which does

76

not seem apparent, the façade of the cathedral was already under way and the carving far advanced. Between 1200 and 1210 the sculpture on the left and central doors was carved and the tympanum and the right door, which had been finished more than thirty years before, set up. The shape of the mouldings, the style of the bases and capitals, and also the iconography and scheme of the draperies is in agreement with these dates, which is a little later than the Senlis door, slightly earlier than the Virgin door at Notre-Dame and almost exactly at the same time as the central door of the north transept of Chartres. The comparison of these different compositions must be made with great discernment, remembering that at Chartres, the dominating influence exercised by the Portail Royal on the statuary of the cathedral continued right on to the first quarter of the 13th century, affecting pose, gesture, and the folds of the drapery, while at Paris the sculpture advancing in a great blaze of glory will soon outstrip the other schools, though always preserving the grandeur and distinction, which is a feature of Notre-Dame throughout the Middle Ages. 93

All the large statuary at Laon as at Notre-Dame is unfortunately destroyed; the figures on the tympana and the arch-rims have been heavily restored, on the central door above all, and almost all of the heads re-carved; a few scenes are completely new.

The central door is dedicated to the Triumph of the Virgin, as at Senlis. *Plate 65* The statues on the pier and embrasures are new, as are the bas-reliefs on the lintel, which are copied from the Death and Resurrection of the Virgin at Chartres. The Triumph of the Virgin, though much restored, is old, and recalls that of Senlis. The Virgin is stiff and seated close to Christ, between four angels, the first two standing swinging censers, the others kneeling with torches. In the arch-rims are arranged angels with attributes symbolical of the Virgin's virtues, the Kings and Patriarchs, ancestors of the Virgin, seated in a Jesse-tree, and fourteen Prophets, also sitting, with scrolls in their hands, on which are written their prophecies. Two great bearded figures are preserved in the museum and seem to have come from this door, or from the door of the church of St.-Vincent, which was carried out at the same period; their robes are somewhat stiff, but well-observed and draped with feeling. The arms are close to the body, but the pose is natural; as a whole they are closer to the great figures at Senlis than to those of the transepts at Chartres.

77

The left-hand door is also dedicated to the Virgin, but the Virgin as Mother of the Child Jesus, and, as at the Portail Royal at Chartres, as at Bourges or the St. Anne Gate, the scenes of the Childhood of Christ are carved at the base of the tympanum as well as those from the Life of the Virgin: the Annunciation, the Nativity, and the Announcement to the Shepherds. Above is the Adoration of the Magi, an arrangement introduced from the South and Burgundy, which we have already seen at Bourges and St.-Gilles and which will be copied at Germigny-l'Exempt (Cher) and later at Freiberg (Saxony). It was popular throughout the Middle Ages, particularly on ivories, where it is very common. The Virgin is seated to the front, as if in Majesty, under a canopy, upheld by two columns; the Child Jesus, seated on her knees, turns towards the Magi, who offer their gifts in rich cups.

As a pendant to the Magi group, the Angel holds in his hand the star, which has guided them to the cradle, while behind Joseph sits and ponders. In spite of a certain clumsiness, the sculptor has succeeded in creating natural groups; the poses and gestures are true to life, the draperies fall easily, the trees, as for instance in the scene of the Announcement to the Shepherds, are treated naturalistically. It is very noticeable how the influence of the symbolism that the clergy had introduced into the cathedral schools, predominates in these reliefs, as well as on the whole façade of the Cathedral at Laon; in the Nativity scene, for instance, the Child Jesus lies not in a cradle but upon an altar and the Virgin and Joseph seem to meditate on the destiny of him, who is to be crucified on Calvary.

The scenes in the arches are particularly interesting from an iconographic point of view. In the first two are six angels with censers, chalices and crowns, and eight women represent the Virtues triumphant over Vice: Sobriety, Chastity, Patience, Charity, Faith, Humility, Good-Temper, Liberality, the names being engraved under those of their corresponding vices on the edge of the arch, as in the churches of Poitou and Angoulême, where this theme is elaborated. The meaning of the figures on the two outer arch-rims was obscure until M. Mâle gave a clear explanation of it.[94]

The clerics who ordered these figures were inspired by the sermons of the recluse Honorius, which were dedicated to the Virgin and preserved in the *Speculum ecclesiae,* in which Honorius notes the prophecies of the Old Testament and the types of the Virginal Conception of Mary. In the third arch-

rim Daniel in the den of Lions is fed miraculously by the prophet Habakkuk, who is transported into Judea by an angel and puts a basket of food in the den without breaking the seal on the door; Gideon prays to the Lord, who lets fall dew from heaven upon the fleece, though the ground on every side is dry; then the burning Bush, which the flames cannot consume, the Ark of the Covenant, in which, Aaron places the rod, which, though, withered bursts forth into fruit; and lastly the door, through which the King of kings passed. The last rim contains symbols also of the Virginity of Mary and types of the birth of Christ, the Virgin with a unicorn, blind Isaac sending his son to Mesopotamia, Balaam announcing to the Israelites that a star will be born of Jacob, the dream of Nebuchadnezzar and the three young Hebrews protected by the Lord who walked with them in the furnace; lastly, two charming figures, a man who has not been identified, with floating mantle behind him, and the Erythraean sibyl, standing, holding tablets in one hand and lifting her robe in the other in fine folds.

The iconography of these doors overflows with great richness, and is continued in the arch-rims of the two windows which flank the great rose-window.

To the left between two rows of dragons, whose fine style is the last remnant of an oriental influence, nine statuettes of seated women represent, as on the Portail Royal at Chartres, the seven liberal arts, Philosophy and Medicine; a tenth statuette of a man drawing a plan on a board, represents Architecture. Round the companion window are ten scenes of the Creation of the World, set in garlands of fruit and flowers with birds pecking at them. Thus is brought to a close on the façade at Laon the sum of mediaeval knowledge: the Old and New Testaments, the Mirrors of Science and Morals and the Last End of mankind, the Judgement.

Not far off, at *Braisne* (Aisne), the Church of St.-Yved possessed a door likewise of the Triumph of the Virgin, carved a few years later than the Laon and Chartres doors, which reproduces the scenes originated at Senlis in a superb style, as finished as that of Chartres and possibly freer. The façade at Braisne was constructed at the beginning of the 13th century—the church, begun towards 1180, was finished[95] and dedicated on the 31st August 1216— it was demolished in 1832, but the principal items of the central doorway were put back in the new façade or preserved in the interior; a few were sent to the museum at Soissons.

Plates 72, 73

79

On the lower half of the tympanum was carved the Death of the Virgin, now much restored and touched up to make an altar-piece for one of the side-chapels of the church. The Apostles crowd round the bed, on which the Virgin has just drawn her last breath; two of them, one of whom is St. John, lean towards her; Christ who at Chartres stands by and at Mantes receives his mother's soul, is absent altogether in this representation, while the scene of the Resurrection has vanished. Above was the Coronation of the Virgin with four standing angels separated by small columns. One of these is preserved in the

Plate 72 museum at Soissons. The Virgin and Christ, happily saved from destruction, are two magnificent fragments. The Virgin, turning towards Christ, bows slightly as at Chartres, with clasped hands; her long cloak falls in great folds from the shoulder over her dress, which spreads out on the ground. Christ is also seated, three-quarter face, his left hand resting on the Book of Life, his right raised to bless; his body is upright and his head, unfortunately damaged, portrays a majestic carriage, which is absent from the figure at Chartres, whose head, sad and stiff, is supported by a neck too long for it. The well-designed folds of the robes are freer than at Chartres and nearly approach those of the statues at Laon.

The same remarks apply to the figures in arch-rims which must formerly have been arranged in four rows, as at Senlis; of these twenty-two still exist, twenty in the actual doorway and two, perhaps the best, in the south transept.

Plate 73 These delightful figures of kings and queens, Christ's ancestors, personages of the Old Testament, are seated, as at Mantes, Senlis and later at Amiens, on branches of a Jesse-tree, which form figures of eight around them. At Chartres and Laon the branches form an oval frame, like a glory. Men and women are carved with clean, deft cutting; their robes, gathered by a girdle at the waist and covered with a mantle, fall in wide deep folds of well-studied effect.

On the gable is a seated Virgin with a Child on her knees; she is heavily restored and the heads and parts of the arms and hands have been re-carved. The pose is still the same as the St. Anne Virgin, but the drapery is much freer and falls in full folds to spread at the feet, like those of the Virgin of the Adoration of the Magi at Chartres, with which this presents a number of affinities.

The style of these different fragments, as well as that of the base and capital of the column in the museum at Soissons, lead one to think that the door-

way at Braisne was carved in the years immediately before the dedication, that is to say between 1205 and 1216.

The new schools at *Chartres* had already been open several years, when the sculptors of Braisne began their work.

Soon after the fire, which in the night of the 9th and 10th of June, 1194, destroyed the Romanesque cathedral of Bishop Fulbert, only sparing the crypt, façade, door and towers which were still separate from the main building, the construction of the new cathedral was undertaken. In response to the appeal of Cardinal Melior, the legate of Pope Celestine III, the people assembled and organized themselves into brotherhoods, with the same enthusiasm as in 1145, to help the workmen reconstruct their beloved sanctuary. Guillaume le Breton, in his *Philippide,* dated by Delaborde the 14th July of some year between 1218 and 1224, and in his *Gesta Philippi Augusti,* finished about 1220, sings the praises of the great vaults, which henceforward were to protect the cathedral against fire, and in January 1221 the dean, Barthélemy, issued a regulation regarding the positions of the dignitaries in the choir-stalls. The labours of Canon Delaporte have proved moreover that the stained glass was finished between 1230 and 1235, and we know that in 1247 the apse chapels received their altars. The work therefore advanced rapidly and, as the festival of the dedication was postponed till October 24th 1260, it was undoubtedly because they wished to wait for the completion of the porches of the transept. The nave was constructed first, then the lower part of the transept and the choir, and the transept clerestories were finished last.

The tops of the abutments of the flying-buttresses of the nave are decorated with niches let into the masonry and finished with trefoiled arches, an arrangement which will be reproduced in all cathedrals of the 13th century. In these niches are statues of bishops, still in good state of preservation. Well proportioned, immobile and stiff in their heavy vestments, with carefully arranged folds, wearing chasuble, dalmatic, stole, maniple and low-crowned mitre, these bishops hold in their hands crosses with ball or tau-heads, and crush beneath their feet devils or monsters or figures symbolical of the Vices, as, for instance, the miser with a cord round his neck, whom a devil is clasping to him. The sculptor has taken pains to vary the poses and expressions; some hold the cross in both hands, others in one hand only, while

81

the other is raised in blessing. Some are chubby, others thin, with bony heads. These statues, rather older in date than those on the transept doors, must have been put in hand soon after the fire of 1194.

The decision to keep the Portail Royal in the west front of the new cathedral induced the master sculptor and the chapter to transfer the iconographic scheme usually employed on the front of a cathedral to the side doors of the transept, which consequently became very important. On the north the central door is dedicated to the Triumph of the Virgin, the left to scenes of the Childhood of Christ, the right to heroes of the Bible. On the south reigns the New Testament; on the centre door the Last Judgement, the glorious cohort of Martyrs on the door to the left, that of Confessors on that to the right. This fine composition, the greatest of all the concepts of the Middle Ages, was not completed in one moment; its full richness of development would even seem not to have been provided for in the beginning. The study of the statues and decoration of these doorways and of the two great porches which introduce them, allows us to catch a glimpse of the progress of the work and to follow the evolution of the artists who worked on these façades almost continuously for more than fifty years, from about 1200 to 1260.

The two centre doors with the Triumph of the Virgin on the north and the Last Judgement on the south are the oldest, and I incline to think the northern door was begun first. In both the great statues of the embrasures, Patriarchs and Prophets on the north, Apostles on the south, are still stiff against their columns, their feet tilted forward on a low base, supported by a monster, a devil, a human figure or some floral motif. They are still column-statues, carved in one block, but they have been given life by the sculptor. The proportions are good, the heads are turned to right or left, bent forward or thrown back, the hair and beard treated differently for each; but the gestures are still stiff, the arms cling to the body, the robes fall straight in parallel folds, the feet are still slanting, while the statues remain hung on to their columns and do not yet carry the weight upon their legs. The numerous fine folds are characteristic of the art of Chartres even in the 13th century, a survival of the great tradition of the school of the Portail Royal, which still imposed its rules on the sons and grandsons of the sculptors of 1150. The folds here are less deeply cut and a soft, radiant light seems to envelop the figures carved in the fine lias-stone of Senlis.

On the north door are the Patriarchs and Prophets, as at Senlis and former- *Plates 68-70*
ly at Mantes, types of Christ whom they announce by word and deed; to the
left David, Samuel, Moses, Abraham, Melchizedek; to the right Isaiah, Jere-
miah, the old man Simeon, St. John the Baptist and St. Peter in pontifical
robes, with high tiara, on his breast Aaron's ephod, in his hand the keys.
Their faces, of a long oval with sharply-defined features and eyes but slightly
marked within orbits that are round and without much projection, their ex-
pression that of wonder and severity, are perhaps the most beautiful of all
mediaeval creations of the figures of the Old Testament, who shine through
all the storm and tribulations of God's people, like a ray of peace and light,
with a certainty of power that is calm and austere rather than terrible, un-
changeable in will or in their faith in the sacred mission of the chosen peo-
ple and of submission to the orders of the God of Israel. Never perhaps till
the creation of the Sistine Chapel by Michael Angelo, who has much in com-
mon with the sculptors of Chartres, has imagination produced more moving
and superhuman figures than these giants of God's will. They will be imita- *Plate 71*
ted; at Rheims, for instance, several upright statues in the embrasure to the
right of the right-hand door of the façade, prove that their conception was
imagined in the first quarter of the 13th century, doubtless soon after the
fire of 1210, which caused the reconstruction of the cathedral, in a door in
the style of Chartres, though these statues have not the incomparable gran-
deur of the Chartres figures.

The figures of Apostles on the south door are of the same type, but in the *Plate 77*
faces the features are more marked, which inclines me to the belief that they
were executed later than the Patriarchs and Prophets. The eyebrows are more
marked, the sockets of the eyes are deeper and fall into hollows on either
cheek, as though to shade the eye, giving to the face an anxious and restless
character; the expression, instead of gazing into eternity far beyond mortal
coils, as on the north door, seems fixed; the beard, moustache and hair are
treated with more precision and begin to stand out from the head. The
Apostles are nevertheless from the same workshop as the Prophets and the
character of the column-statue remains clearly marked in the somewhat mo-
notonous immobility, which the sculptor has endeavoured to vary by group-
ing the figures two by two as though talking together. The most beautiful of
these figures, that of Christ teaching, on the pier, seems to be derived from *Plate 76*

83

some statue on the north door, possibly that of Jeremiah, but it is treated with greater dexterity by an artist who is technically more accomplished. Christ holds in his left hand the Book of Life and lifts the right in benediction; his face, regular and slightly bent, is framed in long, flowing hair and a two-pointed beard with which his moustache mingles. The eyes are shallow, the nose rather thick, the lips thick, the cheeks prominent, and there is none of the beauty, simple grandeur or majesty of the « Beau Dieu » of Amiens who reigns high above the crowds of earth, far from their ills and pettinesses. His sweet, calm, sensitive face, its mouth a little sad and full of pity, brings him nearer to humanity towards which he seems to bend his head.

These statues are sheltered under high, towered canopies, and the columns against which they lean are topped by capitals with natural foliage and prolonged to the ground by short pillars, decorated with clusters of leaves and flowers which copy nature. The bases with flattened moulding and deep hollows, the astragals with almond-shaped or hollow edging mark here once again a more advanced stage in 13th century architecture than that of the north door.

Plate 67 The statue of St. Anne carrying the Virgin, which decorates the pier of the north door is possibly the most recent in this group of large statues. Her robes fall in long folds, which spread at her feet, her majestic visage with full, even oval, well-marked features and tiny mouth, is set off by a light veil, which covers the head and falls on to the shoulders, a close stylistic parallel to classic models of which she seems to be a memory, as does the Virgin of the Visitation at Rheims. This figure would seem to be closer in style to the statues on the side doors and slightly later in date than those of the centre door, if one did not find in the tympanum above, and in the figure of the Virgin stretched on her funeral couch, almost similar features.

Plate 66 The tympanum of the north door represents the Death, Resurrection and Triumph of the Virgin, as at Senlis. Below, to the left, the Virgin is stretched on her bed, surrounded by Apostles who stand aside at the arrival of Christ, recognizable by his cruciferous halo. In the next scene, Angels hasten to take out of the coffin the body of Mary, whom God has just restored to life. There is no longer the spirit, the freshness, the charming invention of the master who, at Senlis, imagined the scenes; the Resurrection of the Virgin has become a regular scene in iconography and the sculptor can no longer escape

84

the prescribed formula. Almost the same thing will happen at Amiens, as at Longpont in the second quarter of the 13th century.

The scene of the Coronation, by contrast, is better than that at Senlis; the trefoiled arch which frames Christ and his Mother is better arranged and supported by graceful little columns with crockets, surmounted by crenellations, like those on the canopies of the great statues on the abutments; these symbolize the heavenly Jerusalem in the same way that the wavy clouds round the tympanum symbolize the heavens. The Virgin is no longer the stiff, rough figure of Senlis, but bends her head gently in acquiescence to the will of Christ, who is blessing her; while on her head is the crown which marks her Queen of angels and of men. She is seated in a great chair with a high back; Christ, with majestic mien, sits on a bench of plain stone. Each figure is carved from a single block from which it stands out in relief. Two little angels with long wings swing censers above them and, at the side, two kneeling angels, almost as large as the principal figures, carry candelabra. The theme of Senlis is ordered, simplified, and assumes the majesty which will distinguish its conception throughout France in the 13th century. The folds of the robes are still numerous, narrow and a little stiff, as on all the sculpture of Chartres in the first third of the 13th century.

The first arch-rim is ornamented with twelve standing figures of angels with censers or candlesticks, the second and fifth with ten Patriarchs and sixteen Prophets; in the two others is a Jesse-tree, the trunk of which springs from between the feet of a Patriarch, below on the left, while its strong and flexible branches embrace and frame the Ancestors of Mary, as in a Glory.

On the tympanum of the south door is carved the Last Judgement. This *Plate 74* theme, which we have already discussed at St.-Denis, Corbeil and Laon, is here represented in all its details: the Resurrection of the dead, the Weighing of souls, Separation of the elect and the damned, rewards and punishments; but the sculptor did not know how to get everything into the tympanum and it overflows on to the base of the arches, where are the Resurrection of the dead, the Tortures of the damned and the Rewards of the elect. The unity of the composition thus suffers, and the scene has none of the grandeur of the Judgement scenes at Notre-Dame, Amiens, and Bourges.

Christ as Judge is seated, showing his wounds, between the Virgin and St. John, both seated with joined hands in the attitude of prayer. Two

85

kneeling angels on either side and others round Christ's head bear the instruments of the Passion.

This scene stretches right across the tympanum, and the sculptor has been forced to put the Weighing of souls on the lintel, as well as the Dividing of the good from the bad, and he has tried to vary the monotony by putting them in two rows. A frieze of angels, as is often found in the sculpture at Chartres, separates the lintel from the tympanum. At the base of the arch-rims are, to
Plate 75 a the left, the blessed received into Abraham's bosom and crowned by angels, and to the right the cursed, misers and immoral women, dragged away by
Plate 75 b grinning demons; some of the women are already dressed in the little hat and wimple, which will become the fashion in St. Louis' reign. Below is carved the Resurrection of the dead, and in the five arch-rims, the nine angel choirs, Seraphim and Cherubim with six wings and swinging globes of fiery flame, Thrones, Powers, Dominions and Virtues, Principalities carrying books, Archangels with warriors' symbols, and Angels with censers, torches and trumpets. The triumphal Court of Heaven is seldom shown in such detail. In all this sculpture, which is still somewhat stiff, the robes are worn more naturally, but the folds are still numerous and narrow and fall with a parallelism which is a trifle monotonous. Nevertheless the tympanum and arch-rims, as well as the wall-statues, seem to me slightly later in date than the sculpture on the north door.

The two central doors of the cathedral transept were set up before the side doors and I think that very possibly only they were included in the original scheme.

If one looks at the 13th century foundations of the crossings of the transept, it is noticeable that, to east and west of the great blocks from which start the intersections, two great passages had been left leading from Fulbert's crypt to the ground level, on either side of the flight of steps leading to the centre door; there can originally have been no thought therefore of side doors. These passages are now enclosed at their extremities and debouch to east and west by little passages at right angles to the axis of the large ones. If this arrangement was the original one, there would have been no necessity to dig the big passages so deep.[96] An examination of the inside wall of the north transept façade confirms our theory; the side doors have been cut subsequently in a wall, where only a plain window was at first intended, a point

86

made quite clear by the defects in the dressing, the differences in the ground level, the underpinning, and the marks of the cutting which are clearly visible.

In the course of the work, the bad effect of this plan was realized and the original design was modified by giving the façades that breadth of treatment we admire so much to-day.

The two side doors on the south side were undoubtedly the first to be carried out. They were possibly cut at the same time as the central door, after it had been decided to modify the arrangements on the north; there are not indeed the same irregularities in the piercing of these doors as on the north.

The study of the statuary will lead us to the same conclusions as the study of the architecture.

The side doors of the south doorway are older than the side doors on the north; the left-hand door, dedicated to the Holy Martyrs, is the older of the two; the righ-thand, dedicated to the Confessors, is of more recent date. *Plates 78b, 79*

The three first statues on either side of the left-hand door, in quite a different style to the two statues of warriors, St. Theodore and St. George, are still column-statues, leaning against the pillar, the stiffness and length of which they adopt. The shoulders and flanks are still narrow, the gestures stiff, the head erect on the axis of the body, and the folds of the stuffs fall in crisp, parallel folds without any deep shadows, enveloping the figure in an atmosphere of calm and sweetness. The legs are long, the tilted feet inclined on their pedestals, which stand on little shrines with grotesques of men or animals carried out on a large scale. The dresses are decorated with loving care, and the embroideries of chasuble, dalmatic, stole, maniple or amice-collar, the chasing on tiara, mitre, cross or binding, show the skill and careful observation and accuracy of the artist. To the left the pope, St. Clement, in his pontifical robes, tiara on head, triple cross in hand, blesses the people; his feet stand on the cresting of the little chapel, which sheltered his body at the bottom of the sea, where he was thrown at the Emperor's orders. To his right St. Stephen, to his left St. Lawrence, both wearing deacon's costume, alb, *Plate 78b* stole, and long dalmatic with wide sleeves open at the side, and carrying richly-bound books. Under St. Stephen's feet is Saul, who was to become Paul, imploring forgiveness; under St. Lawrence's, the Emperor Valerian, who ordered his death, is clutched by a little devil at the throat. To the right, St. Vincent, also in deacon's costume, has at his feet the wolf and crow, which

watched over his body. Next, St. Denis, who was torn to pieces by lions, has one beneath his feet and is dressed like St. Clement, except that his pallium is not fastened to his chasuble and that he wears a high pointed mitre like all the Chartres bishops, while at Rheims and Amiens, even at a much later date, all the mitres are low. To his left, a priest, much honoured in the district, Saint Piat in alb, stole, chasuble, amice, and maniple, with a book in his hands; he is bearded, like St. Denis, and beneath his feet his executioner, Rictius Varus.

Plates 82-85 The six great statues of the embrasures of the right hand door belong to the same series, but are more finished in execution. The faces are better built, the features more individual, the eyes deeper in their sockets, the chin more marked, the ears more carved, the hair better planned. The costume is also *Plates 82, 85d* later in date. To the left a pope, an archbishop and a bishop: St. Leon, St. Ambrose, and St. Nicholas, are superbly carved, like the companion figures on the right, which are possibly even finer; tall, large, with similar gestures, their heads erect, almost haughty in their heavy ornaments, they are invested with all the dignity and somewhat remote nobility of princes of the Church. The pope, St. Leon, wears the conical tiara, already slightly convex, and the pallium; St. Nicholas, bishop of Myra, a mitre. Under the dalmatic appears the lower fringe of the tunicle, a feature which will often be seen in bishops' costumes of the second half of the 13th century; the amice-collar is stiffer than on the Martyr door, and is turned down upon the neck, and at the front is a streamer of fine material.

Plate 83 The three statues on the right are among the most beautiful of any on mediaeval doors. They represent St. Martin, St. Jerome and St. Gregory; the last with inspired face and great steady eyes, a little dim and introspective, *Plate 84* with upright head, filled with the intensity of his inner life, listens to the dove, which dictates to him the words of the Holy Spirit; at his feet, his amanuensis. The two next statues are admirable contrasts in proportion, gesture, attitudes, features and personality. To the left the bishop, St. Martin, his body erect and strained, larger than the others, head full of self-assurance and slightly turned to the left, eyes deep in their sockets, nose prominent, mouth strong, almost violent, seems to command the world and its elements; worker of miracles and apostle, he goes all over Gaul, dispelling devils, overturning idols, baptizing crowds, overcoming without stopping the obstacles

88

placed in his path by the powers of evil, and seeing from afar the people who come to hear him preach. The sculptor has succeeded in giving to his work this energy, this power, this spirit, without departing from the vertical plan appointed to him by the master sculptor, or from the rigidity imposed upon the statue by the column against which it rests. Next him, small, timid, almost trembling, and appearing to hide under his protection, is St. Jerome, *Plate 85 c* the scholar, the writer who translated the Bible into Latin from the Hebrew, who gave to the world the manuscript of the Vulgate, which he holds in his hand; his face is calm and peaceful, and it is certainly not that of the real St. Jerome, whose austerity, whose whims, whose violence and harshness even, are known to us, but rather symbolizes the savant: it is not a portrait of St. Jerome, it is the type of the savant that St. Jerome was.

The marked character of these figures in features, carriage, elegance of gesture — cf. St. Jerome's right hand — and the details of their dress, shows that their date is later than those of the left door. We have arrived at the limit we set ourselves in this study of the beginnings of Gothic sculpture. After the rapid evolution which we have traced up to this point Gothic sculpture attains its complete fruition on the transept doors at Chartres. A typical detail is shown on these two statues of St. Nicholas and St. Jerome; they are no longer attached to their columns, their feet resting slantwise on the inclined plane of the socle, but stand upright on a horizontal block, balanced on their legs. The whole pose is altered, and the statue comes out from the pedestal where it had been imprisoned by its function of column-statue, and lives. But the sculptor has seen the danger involved in this innovation and has remembered that if a figure is detached from the column, it must soon become independent, and that treated by itself its relation with other figures must remove its architectural value and transform it into a separate piece of sculpture, beautiful perhaps, but not in accordance with the rules of architecture. During St. Louis' reign, here as at Paris, Amiens or Rheims, the sculptors will avoid their danger, but their successors rapidly lose the calm simplicity necessary to monumental sculpture and, absorbed in realism and picturesque detail, make their statues gesticulate at the doors of the cathedrals.

The study of the tympana and arch-rims of these two doors leads us to the same conclusions. On the left-hand tympanum the story of St. Stephen, a

little dry and monotonous, preserves some of the austerity and rigidity of the Presentation on the Virgin Door of the Portail Royal; above, Christ between two angels carries the martyr's palm. The scene of the martyrdom of St. Stephen continues in the arch-rims, where the Jews bring stones and throw their garments at Saul's feet. In the first rim ten statuettes of children carry palms, representing the Holy Innocents; the two other rims are filled with martyrs seeking the blood of the sacrificial Lamb, whose head is carved on the keystone: «They have washed their robes in the blood of the Lamb» following the mighty words of the Apocalypse (VII, 14).

Plate 80 The tympanum of the right door is more advanced in style. On the left is St. Martin parting his mantle with a beggar, and his dream of Christ wearing it. To the right St. Nicholas gives marriage portions to three poor girls. Above, the saint is shown extended on his tomb in episcopal garments; the sick watch at the tomb and pray to him. On high, Christ between two angels raises his hand in blessing. The gestures are still angular, the materials dryly treated, and there is none of that suppleness and fullness and freedom in the sleeping figures, for instance, which are seen on the fragments of the rood-loft; but the search for the picturesque in the treatment of the scenes, the forced realism of the figures, of the sick folk, for instance, at the tomb of St. Nicholas, connect this tympanum with the side doors of the north transept much more than with the tympanum of the Martyr door. The same remarks *Plate 81* apply to the figures of holy bishops, kings, monks and warriors, carved in the arch-rims, and to the picturesque scene of the hunt of St. Gilles which unrolls itself below the arch-rims; the doe, pursued by the king, takes refuge in the hermit's hut, who gives it his protection.

If we had to continue the history of the Chartres workshops in the second quarter of the 13th century, we should follow it to the two side doors of the north porch, where the tall and lifelike statues, still a little stiff and some of them very narrow, for lack of sufficient space, stand by their own weight on bases carved with attributes vividly rendered by the sculptor, such as the dragon whispering impure thoughts into the ears of Potiphar's wife, beneath Joseph's feet, which may be compared with the fine, free dragon under St. John the Baptist on the centre door. The proportions of the statues are more squat, the robes of the women fall to the ground to spread around their feet, those of the men finish horizontally above the instep, while the heads are of

90

an advanced type; the figures have no longer the stiffness of the column-statue, they bend forward, turn and converse together. The tympana also are in a more advanced style, as are the statuettes on the arch-rims, notably the figures of kings on the right-hand door, which are already so sharply realistic, so striking in character.

The north door, provided for at the same time as the two side doors, cannot have been executed much after them. The dressing of the stone shows the continuity of the work without pause or faltering. The north door with its triple arcade within borders adorned with delightful statues, as well as the pillars which carry them and the column-statues which lean against them, of which some were perhaps finished later, or have even since been modified, was therefore constructed and carved soon after the side doors. It must have undergone numerous re-carvings after the subsidences at the beginning of the 14th century, which necessitated a careful overhauling in 1316 by Pierre de Chelles, the master sculptor of Notre-Dame.

On the south side, it is quite different. The south porch had not been envisaged when this door was erected and decorated. The arch-stone of the porch had to be refitted into the wall of the façade, the mouldings cut, the dressing of the wall interrupted and a fifth arch-rim set up in front of the two side doors, separated from the others by a rim of foliage and carried by two abutments with columns against which two statues rested. Upon this arch-rim bears the pointed vaulting of the two side bays of the porch. In the centre it was necessary to level the canopy, which covered the figure of the last apostle on either side, and let the lintel of the arch rest on the columns against which these statues lean. The resumption of the sculpture is clearly marked; the statuettes of the outer arch of each of the side doors are much easier in style, poses and gestures are freer, while the folds of the robes are deeper and fall less stiffly. The canopy over each of the new figures is quite different, much more voluminous and more richly decorated. The architecture is more elaborate, the lobes of the arches are trefoiled, except above St. Theodore, whose coping has possibly fallen, and surmounted with little gables and canopies. The capitals of the columns against which they lean and the short columns on which they stand are ornamented with foliage, which is in deeper relief, more detached from the stone and more delicately carved than those of the other columns of the two central doors north and south, which are

however in a style which is already far advanced and astonishingly naturalistic. The mouldings of the astragals, of the bases, and of the ring which encircles the columns are more delicate, slightly flatter, and the hollow mouldings are deeper. The consoles supporting tablets on which they stand are different from all the others. Instead of being ornamented with one or two figures on a fairly large scale and connected with the statues, which stand above them and form one piece with them, they are carved with little scenes on smaller scale and of quite different character, with some incident from the life or martyrdom of the saint. Lastly, the four statues, St. Theodore and St. George on the left, St. Laumer and St. Avit on the right, are much later in style than their neighbours. With feet set firmly on a horizontal tablet, well planted on their legs, of good proportions, with straight shoulders and arms longer than in the statues near by, these four saints are dressed in shorter robes with deeper folds which fall squarely; even the cut of the dress and the shape of the armour has advanced. From the same workshop come the eighteen fine statues of kings which crown the porch, recalling that figure of Childebert, which Pierre de Montreuil ordered to be carved for the refectory of St.-Germain-des-Prés at Paris, which is now in the Louvre. Possibly from the same workshop, and but little later, was the rood-loft, of which several fragments are still preserved in the crypt.

Such is the evolution of the statuary on the transept façades at Chartres. What dates can we assign to them?

We know that after the fire of 1194, which destroyed Bishop Fulbert's cathedral, restoration went on apace and that the nave was finished in 1220; the following year the choir was sufficiently advanced for it to be necessary to arrange the order of precedence of canons and dignitaries during the ceremonies. It must therefore be admitted that towards 1200 the cathedral workshops, after completing the erection of the Portail Royal on its new site, and doubtless carving the great statues of bishops destined for the niches at the head of the buttresses, were now preparing to decorate the façade of the new transept.

The work began with the centre door of the north doorway, as I have shown, the decoration of which must be dated about 1200 to 1210. It is dedicated to the Triumph of the Virgin and the types of the Old Testament, and it is possible that a statue of the Virgin and Child was projected for the cen-

tral pier, when in 1205, the cathedral having received the precious relics of St. Anne, it was decided to decorate the pier with the lovely figure of St. Anne carrying the Virgin, a work rather more advanced perhaps than the other great statues of this doorway.

At the same moment, or perhaps a few years later, the other great statues were carved, and also the tympanum and the statuettes in the arch-rims of the centre door of the south façade. At the feet of Christ teaching, upright on the pier is a figure of a donor, who is traditionally said to be Pierre Mau-clerc, Comte de Dreux et Duc de Bretagne, accompanied by his wife Alix de Thouars, both also represented with their coats of arms in the windows of this same south façade. The scene possibly represents the donors distribut-ing alms on the occasion of their marriage in 1212; in any case it must be before 1221, the year of Alix's death. I propose to date the door at about 1205 to 1215. It was approached by a flight of steps, the existence of which from 1210 to 1214 we know of by the cathedral records.

The carving of the sculpture of these two south doors then, was in course of execution, first on the left door of the Martyrs and next on the right-hand door of the Confessors, and we may approximately date the former between the years 1215 and 1220 and the latter between 1220 and 1225.

The side doors of the north façade, begun towards 1220 or 1225, were finished in 1230 or 1235, while the decoration of the porch, which stands before the door, continued on to perhaps the middle of the 13th century; its construction took place at the same time as the doors on either side of the centre door, which were not in the original scheme.

As regards the south porch we possess a text mentioned by all the histo-rians of the cathedral, from which M. Merlet in his little monograph seems to me to have drawn a perfectly correct conclusion. An edict of the Chapter[97] dated 26th May 1224 orders all merchants to take their stalls from the gallery in front of the façade into the cloister. The conclusion is that they wished to free the façade of encumbrances in order to construct the porch. I shall put the carving of the four great statues, the statuettes of the two arch-rims added on to the side doors and the decoration of the porch, works of a totally differ-ent school to that of the north porch, at between 1230 and 1250. All these undertakings were finished or very advanced — the north porch in my opin-ion never has been finished — at the dedication on the 24th October 1260.

93

While the walls of the nave of the new cathedral at Chartres were rising from the ground, the great shell at Notre-Dame in *Paris,* with its double side-aisles, galleries and high narrow windows, was completed. At the beginning of the 13th century the foundations of the façade were laid, and in 1208 some houses belonging to the Hôtel-Dieu were destroyed to clear the ground in the south-east corner of the forecourt. A few years later, when the building had begun to rise, the sculpture and bas-reliefs were carved in a style midway between that of the front at Laon and the transepts at Chartres on one side, and the façade of Amiens on the other, a style less sober and more charming than at Chartres, more delicate and less realistic, less commonplace than at Amiens.

Plates 86-88 The work began with the Virgin door on the left of the façade, where the sculpture was carved between 1210 and 1220. It is unquestionably the best-known of the doors at Notre-Dame and one of the most beautiful of those executed in the Middle Ages. It is dedicated to Mary and her Triumph in Paradise, and is the most splendid paean in praise of the Virgin conceived by the 13th century.

This lovely theme, originated as we have seen at Senlis in 1185, repeated at Mantes, Laon, Braisne and Chartres from 1200 to 1215, and later at the priory of Longpont (Seine-et-Oise) and on the façade of Amiens, is here set out in a new way.

The traditional scenes of the Death, Resurrection and Coronation of Mary, with their picturesque and moving detail, their crowds of people, could not have originated with the master sculptor who had designed the majestic façade of which the main characteristics are nobility, balance and strength combined with simplicity, and who would not have wished to break the august lines of his concept by overloaded doors or restless tympana with numberless figures on too small a scale for the rest of the edifice. No other façade but this has the unity of conception and execution or gives the same impression of force, nobility and calm durable strength designed to endure through the centuries.

Plate 86 Everything in the door of the Virgin, composition, ensemble, details, is on this grand scale. On the lintel six great seated figures, three kingly ancestors of the Virgin and three Prophets announcing her coming, the Patriarchs and Prophets of the Old Testament, who at Senlis and Chartres watched on

94

the piers of the doors, now sit on the lintel and play their rôle in the mystery carved on the tympanum. Above, a single scene, is the Resurrection; two great angels, lightly bent and forming as it were a frame for the scene which unrolls itself below, lift the Virgin from her coffin; she lies stretched on the shroud with hands joined and wakes to life at the call of her Son who stands beside her. Behind, forming a background to this scene of simplicity full of nobleness, the twelve Apostles meditate on the mystery unrolled before them in which they have no part, which they hardly see. This peaceful calm, this profound meditation, this gaze lost in the beyond, lend an unwonted grandeur to the scene.

The Coronation splendidy dominates the tympanum. The Virgin, quite young, her hair down her back, as on the day of her betrothal, sits on the right of her Son, her hands joined, her body bent towards him in love and submission. Christ, his head and body erect, slightly withdrawn to the rear, blesses her with an attitude of kingly authority and gives her the sceptre that makes her Queen of Earth and Sky, while an angel places the crown upon her head. At Senlis, the Virgin was already crowned; later, atA uxerre and Rheims Christ will crown his Mother. Two kneeling angels, instead of four, as at Senlis and Braisne, almost as large as the Mother of God, wait on the central group. The beauty of the composition, so light and airy, the simplicity and nobility of the attitudes, the calm and gravity, the elegance of the draperies, the bold and powerful modelling of the heads, make this one of the masterpieces of the Middle Ages and of all time.

The whole of the sculpture on this tympanum is in high relief, almost in the round, but nevertheless contained within the thickness of the stones which cover the foundations; it seems to stand out from the building, but is still a part of it, and this restraint contributes in no small degree to retaining the lines of the construction and the dignity of the architecture.

In the arch-rims angels with candlesticks or censers, Kings of Judah, Patriarchs and Prophets who announce her coming, — the descriptions still legible on some of the Jesse-figures at Braisne read Eliud, Achim, Sadoc, Joatham, Jacob, Bath-sheba — are arranged under canopies and not on branches of the tree, as at Senlis, Mantes, and Braisne, or in the midst of branches which frame them in a sort of glory, as at Chartres and at Laon, where they break the harmony and thus spoil the magnificent proportions

95

of the rest of the door. The number of them had been fixed, and could not be diminished. To get over the difficulty, the master sculptor has represented them half-length, a scheme almost unique at this period and one which is only found in a few figures on the west door at Angers and the south door at Bourges. Only the statuettes at the lower ends of the arches are full-length. A border of foliage frames the tympanum and the arch-rims and these, by way of extra precaution, are enclosed by a gable.

This tympanum is important iconographically and artistically. After Senlis, where about 1185 for the first time a whole door was dedicated to the Death, Resurrection and Triumph of the Virgin, the theme was repeated between 1200 and 1215 at Mantes, Braisne, Laon and Chartres.[98] At Mantes, as at Senlis, two angels on either side, one standing, one sitting, flank Christ and the Virgin, who sit under an arch of more pleasing design than at Senlis; the arch-rims are identical in each case. At Laon, the scene of the Coronation, much restored, is presented as at Senlis, between two angels on either side, one standing and the other kneeling; at Braisne, the two angels are separated by a column, as at Senlis. On the north door at Chartres, a little later than the Laon door, the scene is more beautiful and more simple; the Virgin bows before her Son, an angel kneeling at either side. It is almost the composition which the master of Notre-Dame of Paris will adopt, carved with consummate genius as regards the mass and with remarkable skill in the arrangement of the drapery.

While at Senlis in 1185 the Virgin was already crowned, at Paris an angel comes to place the crown on her head. Later, at Mouzon (Ardennes), at Strasburg, Sens and Auxerre, Christ crowns his Mother; later still, at La Ferté-Milon, the Virgin kneels at the feet of three divine beings, who crown her, and it is thus also that the theme of the Coronation will be represented in the charming miniature in the *Heures d'Etienne Chevalier,* at the Musée Condé at Chantilly.

The group on the Virgin door at Notre-Dame, which is repeated with slight alterations on the Porte Rouge, has been copied by the ivory sculptors of the Parisian workshops at the end of the 13th century and in the 14th century, and also by the sculptors of the façade at Longpont and Amiens, of the south door at Rampillon (Seine-et-Marne), on the tympanum of the Commanderie de l'Hopiteau (Aube) in the middle of the 13th century, which is now in the

museum at Troyes, at Notre-Dame at Dijon, at Villeneuve-l'Archevêque (Yonne), on the tympanum of the Church at Longpré on the Somme, as also at Bazas Cathedral, on the left door of Poitiers cathedral, the style of which already announces the 14th century, and even in Spain at Burgos and León at the end of the 13th century.

As for the scene of the Resurrection of the Virgin, no sculptor can compete with the master sculptor of Notre-Dame, and if a detail here and there as, for instance, the design of the stone sarcophagus, is repeated as at Longpont (Seine-et-Oise), it is the iconography of Senlis and Chartres and not that of Paris which is copied with more or less success at Longpont, as at Amiens and Longpré (Somme). These scenes will still be found at the end of the 13th century on the west front at Sens, for instance, but decked with realistic and picturesque detail. There is the Death of the Virgin on a bed surrounded by Apostles, as in the bas-reliefs of the chapels north of the choir of Notre-Dame in Paris at the beginning of the 14th century, then the Resurrection from the tomb and the Assumption of the Virgin in a Glory borne by angels. The Assumption, a rare scene in the 12th and 13th century, has already appeared on the stained glass at Angers and the tympanum of St.-Pierre-le-Puellier, and since the 13th century at Pontaubert (Yonne), Sens, and St.-Thibault (Côte-d'Or) as at the beginning of the 14th century in the bas-reliefs on the north of the choir of Notre-Dame in Paris; during the latter part of the Middle Ages it replaces the scene of the Resurrection of the Virgin.

The great statues have unfortunately disappeared, but we can imagine them from the figure of St. Geneviève carved on the pier of the door of Ste.-Geneviève at Paris about 1220-1225 and now preserved in the Louvre, which is of a type midway between the statues of the central doors of the Chartres transept and those of the west door at Amiens, more human than the Apostles and Patriarchs of Chartres, but finer and more remote perhaps and less commonplace than the Saints at Amiens. The Virgin on the pier, crushing a serpent beneath her feet and bearing the Child Jesus on her left arm, must have been from what we know of it the counterpart of the lovely Virgin of the « Porte de la Mère-Dieu » at Amiens, which seems to have been copied line for line in almost all its details from the Virgin door at Notre-Dame. Though the sculptor of Amiens has abandoned the majestic compo-

sition of Paris for that of Senlis and restored the two scenes of the Death and Resurrection which moreover correspond to each other in an outline almost identical, he at least reproduces, in the Resurrection scene, the poses and gestures of the Paris tympanum and of the Coronation scene and has attempted, without achieving the same beauty, to copy the superb group of Notre-Dame, which he has encumbered with two additional angels, as at Senlis and Laon. Above the Virgin of the pier, still immobile according to the traditions of the beginning of the 13th century, he has placed in a niche the Ark of the Covenant with six figures of Kings and Prophets on either side as at Notre-Dame. This composition is repeated on the St. Firmin door, which acts as a pendant to the latter. On the centre door many details recall the Last Judgement at Paris.

Plate 88

Plate 87

The small reliefs on the lower part with scenes from the lives, the martyrdoms or the triumphs of figures decorating the embrasures, and those on the abutments of the door and on each side of the pier, with the Occupations of the Months, the Signs of the Zodiac, the Seasons and the Ages of Man are as grand and strong in their small way as the figures on the tympanum. The Occupations of the Months which were often represented on Romanesque churches, reappear on the abutments of the right door of St.-Denis and in the arch-rims of the Portail Royal at Chartres, at Senlis, Sens, and Laon; again later in the realistic and familiar medallions at Amiens, on the west front of Rheims, on the north porch of Chartres, and in the arch-rims of the north door of Semur-en-Auxois. Though the scenes at Paris may lack the wit or the humour of some of these representations, they gain an undeniable grandeur by their simplicity and their calm. It is difficult to forget the beauty

Plate 87 b

of the peasant-figure sharpening his scythe or of that other, who follows the furrows with measured stride, and with sweeping gesture scatters the fecund seed. The little bas-reliefs under the arches of the lower part are equally remarkable, carved with an accuracy of observation and a suppleness and precision of execution, which were not attained by the sculptors of the south door at Chartres, who copied them on a larger scale, a process by which some of these little scenes, of a grandeur all antique, can rival the great compositions of the tympanum: to take an example, the triumph of the good angels, where against the starry heavens the figure of the Good Angel flies upward

Plate 88 a

in a great sweep of drapery, spurning beneath his feet the Evil Angel.

98

The sense of realism and truth and direct observation shines forth in this door, not only in the figures and scenes, but in the flowers, living, blooming, which the artist has scattered over the whole door, on the tympanum, as in the scenes on the abutments and bases, or on the wall round about the great statues of the embrasures[99]; but this realism is always tempered by the willingness of the sculptor to remain true to his architectural ideal with the taste and restraint which is as it were the distinguishing mark of the art of Notre-Dame.

Like the great figures of the Confessors' door at Chartres, the Virgin door at Notre-Dame marks the full flowering of Gothic sculpture.

CONCLUSION

GOTHIC sculpture appeared about 1140-1150 at St.-Denis and Chartres as a reaction against the pictorial and decorative style of the Romanesque. With its combination of symmetry, rhythm and method, which conformed to the needs of men of the 12th and 13th centuries, with its inspiration of restraint and repose, the new style created under the impulse of the clergy, within the limits imposed by the master sculptor, compositions of admirable arrangement, clearly and logically set forth, of a splendour and majesty rarely achieved.

At St.-Denis artists, gathered from all France, built under the stern guidance of Suger the Gothic door with its lintel, sometimes in more than one register, and its tympanum framed in arch-rims standing on column-statues, tall, severe and immobile. The Master of the Portail Royal copies it very soon at Chartres; and others, with a few recollections of Romanesque here and there, at Etampes, Bourges, Le Mans, Provins, St.-Loup-de-Naud, Notre-Dame, and many other churches in the Ile-de-France and the royal dominions, whence in the second half of the 12th century it spread its noble ideals over the whole of France, even to Burgundy, Languedoc and Aquitaine, whence Suger had drawn his sculptors for St.-Denis.

About 1185, at Senlis, the Gothic door takes definite form. On the tympanum appears a new iconographic theme, the arch-rims, fitted with statuettes, are held up by columns against which are set statues which gradually lose their stiffness and come to life, while on the lower part are carved little medallions. The art of Senlis, descended directly from that of St.-Denis and Chartres, but freed to some extent from the restraint in which it was held by the reaction against Romanesque, developed, through the doors of Sens, Mantes, Laon, and Braisne, to the traverses of Chartres and the Virgin door at Notre-Dame.

After an evolution of nearly 75 years Gothic sculpture attains its full flower and brings forth those statues at Chartres and the tympanum at Paris, which are among the masterpieces of the world. It is a moment when the artist, master of his chisel and having nothing more to learn, has not yet forgotten the lofty lessons of idealism, nobility, and obedience to the great principles of architectural composition which his predecessors had taught him.

NOTES

1] *Notre-Dame de Paris, sa place dans l'histoire de l'architecture du XIIe au XIVe siècle*, Paris, 1920, in-4to. 224 pp., 16 pl.; 2nd ed. 1929.

2] *Sugerii abbatis sancti Dionysii liber de rebus in administratione sua gestis*, and *Libellus de consecratione ecclesiae sancti Dionysii*, in *Œuvres complètes de Suger*, ed. Lecoy de La Marche, pp. 155 and 213.

3] *Œuvres de Suger*, ed. Lecoy de La Marche, p. 189.

4] Ibid., p. 320: «ad introitum monasterii Beati Dionysii renovandum et decorandum».

5] Papiers du BARON DE GUILHERMY, Bibl. Nat., Dép. des Mss., Nouv. acq. françaises, Nos. 6121-6122.

6] *Monumens de la Monarchie françoise*, pl. XVI, XVII, XVIII.

7] Bibliothèque Nationale, Dép. des Mss. fr. 15634, fol. 33 and following pp. It is obvious that at the time these drawings were made, some heads were already missing and others out of place; one male head seems to me to be on a female body.

8] The tall statues carved on the sides of the centre pillars of the doors at Moissac and Beaulieu, which seem to support the lintel, are survivals of the antique caryatides. There are also on the upper part of the façade at Civray (Vienne) under the arcade to the right in the place of columns, two statuettes, on one side a slender caryatid stiff and upright, fixed in a sort of casing, and carrying the capital on its head, the other an Atlas figure weighed down by the capital, which rests on its shoulders, also an imitation of the antique.

9] *Monumens de la Monarchie françoise*, t. I, pl. X, p. 58.

10] As early as the beginning of the 12th century, there was found, as in the cloister of Moissac, a figure of Christ on the jamb of the old door of the Church of La Couture at Le Mans, a barbaric figure imported from the South, which had no influence upon the art of that district.

11] *Moyen Age*, 1898, p. 341.

12] *Monographie de la cathédrale de Chartres*, Ist ed., p.50: 1170; 2nd ed., p.34: 1110-1149.

13] In the *Monuments Piot*, t. VIII.

14] *Die Anfänge des monumentalen Stiles im Mittelalter*, p. 122.

15] *Dictionnaire*, t. VIII, p. 208.

16] *La façade de la cathédrale de Chartres du Xe au XIIIe siècle*, 1900.

17] *Revue de l'Art Chrétien*, 1899, p. 328 and 1900, pp. 32 and 137.

18] *Les façades successives de la cathédrale de Chartres au XIe et au XIIe siècle*, in *Congrès Archéol. Chartres*, 1900. — *Les Architectes et la construction de la cathédrale de Chartres*, in *Mém. Soc. Nat. Ant. de France*, t. LXIV, and *Revue des Archives hist. du dioc. de Chartres*, 1906.

19] De Lépinois and L. Merlet, *Cart. de N.-D. de Chartres*, III, 19-20: «Decoravit etiam introitum hujus ecclesie imagine beate Marie auro decenter ornata».

20] *Mémoires de la Soc. Archéol. d'Eure-et-Loir*, 1902 and 1904.

21] *Les Miracles de N.-D. de Chartres*, in *Bibl. Ec. des Chartes*, 1881, pp. 508.

22] The site proved too narrow for the three windows over the door and the southernmost of the three had to be cut and the borders removed.

23] *La Vie des images*, 1927, p. 31 and foll.

24] Musée du Louvre, *Catalogue des Sculptures*, 1922, Nos. 48-49.

25] *L'Art religieux du XIIe siècle en France*, pp. 402-404.

26] *La Cathédrale de Cahors*, p. 115.

27] *Gazette des Beaux-Arts*, 1926, I, p. 132.

28] This tympanum has been studied by M. Fages, *Bull. de la Soc. Scient. et Archéol. de la Corrèze*, 1923, pp. 164-178, and M. Mayeux, *ibid*, pp. 209-217.

29] *Un Tympan sculpté du XIIe siècle récemment découvert à La Charité-sur-Loire*, in *Beaux-Arts*, 15th July 1924, pp. 212-214.

30] This retable is now in the Louvre, *Catalogue des Sculptures*, 1922, N. 50.

31] *Congrès archéologique de Paris*, 1919, p. 6 and foll.

32] *Gazette archéologique*, 1884, p. 215.

33] These dates have been established very accurately by Eug. Lefèvre-Pontalis (*Etude hist. et archéol. sur la nef de la cathédrale du Mans*, 1889, p. 37) and Gabriel Fleury, *La Cathédrale du Mans*, p. 86, in the *Petites Monographies*.

34] *Notice sur la Cathédrale d'Angers*, by Canon Urseau, in *Congrès Archéol. Angers*, 1910, pp. 166 and foll.

35] Bourquelot has proved that the Church of St.-Ayoul was rebuilt after a fire which must have occurred later than 1153 and before 1164 (*Hist. de Provins*, t. II, pp. 380-386).

36] Emile Mâle, *L'Art religieux du XIIe siècle en France*, pp. 223-224.

37] Gabriel Fleury has studied and reproduced a certain number of them in *Etudes sur les portails images du XIIe siècle*, Mamers, 1904, in-fol; 294 p. and fig. Some fragments still preserved show that there was at Lagny (Seine-et-Marne), a doorway with column-statues, which may be dated between 1160 and 1170.

38] Jules Tillet, *Les Ruines de l'abbaye de Nesle-la-Reposte*, in *Congrès archéol. Troyes-Provins*, 1902. pp. 514-528. Maurice Jacob has recently announced the discovery at Villenauxe of fragments from the ancient doorway of Nesle.

39] *Annales ordinis Sancti Benedicti*, f. I, pp. 50-51.

40] *Monumens de la Monarchie françoise*, t. I, pl. XV, p. 192 and the drawing in Bibl. Nat., Ms. Lat. 15634, fol. 22.

41] *La Vie des Images*, Paris, Hachette, 1927, p. 182.

42] Discours à la Séance publique de l'Académie des Inscriptions du 12 novembre 1751; extract in the *Mercure de France*, December 1751.

43] *L'Art religieux du XIIIe siècle*, pp. 394-396. The Queen of Sheba is still represented like this in 15th century German art. Cf. JEANNE HERR, *La Reine de Saba et la Légende de la Croix*, in *Revue archéologique*, 1911.

44] A. *Catalogue des Sculptures*, 1922, n. 47.

B. Indicated by J. DUNOD in his *Histoire des Séquanois*, 1735.

45] An 18th century drawing by LANCELOT in *Mémoires de l'Acad. des inscript. et belles lettres*, IX, 185. The statues were perhaps originally on the embrasures of the door, but were later dispersed over the façade and on the buttresses, as in the churches of Aquitaine.

46] Reprod. in GABRIEL FLEURY, *Études sur les portails imagés du XIIe siècle*, p. 143. They come perhaps, from the neighbouring church of Germigny-L'Exempt, the column-statues of which have now disappeared, but are reproduced by ACHILLE ALLIER (*L'Ancien Bourbonnais*, 1838, p. 63). They were restored in the 19th century.

47] JEAN HUBERT, *L'Abbatiale Notre-Dame de Déols*, in the *Bulletin Monumental*, 1927, p. 46 and foll.

48] They were presented to the Bourges Museum in 1845, Nos. 129-130.

49] Repr. in *Congrès archéol. Blois.* 1925, p. 405.

50] DOM BOUILLART, *Histoire de l'Abbaye de Saint-Germain-des-Prés*, p. 309; MABILLON, *Annales ordinis Sancti Benedicti*, t. I, p. 169; B. DE MONTFAUCON, *Monumens de la Monarchie françoise*, t. I, pl. VII, pp. 54-55.

51] Published by E. LEFÈVRE-PONTALIS, in *Bull. mon.*, 1922 pp. 208-209.

52] Published by M. H. ROSSEAU, in *Le Vieux Saint-Maur*, November 1924, fig. 9-10.

53] C. ENLART, *L'Église du Wast en Boulonnais et son portail arabe*, in *Gazette des Beaux-Arts*, July-August 1927, pp. 1-11. I have already drawn attention to this statue as among the most ancient column-statues.

54] They are reproduced in A. KINGSLEY PORTER, *Romanesque Sculpture*, t. X, fig. 1431-1433.

55] PINARD, in *Revue archéol.* I, 165 and 643, and *Monogr. de N.-D. de Corbeil*, p. 32 and fig. 3.

56] DUFOUR, *Commission des Antiquités et des Arts de Seine-et-Oise*, 1896, t. XVL, pp. 28-29.

57] E. MÂLE, *l'Art religieux du XIIe siècle*, p. 410; LUCIEN BROCHE, *La Cathédrale de Laon (Petites Monographies)*, p. 74.

58] MABILLON, *Acta Sanctor. ord. S. Bened., Saecul. IV, pars prima*, p. 664. - The drawing, dated 1742 and noted as being drawn on the spot, on the whole confirms MABILLON's engraving; my attention was drawn to it by M. JEAN HUBERT, the keeper of the Seine-et-Marne archives; it is preserved in the Bibiothèque Nationale, Dép. des Mss., Collect. de Champagne, t. 19, fol. 127.

59] Cf. E. MÂLE, *L'Art religieux du XIIe siècle*, pp. 306-308, and F. DESHOULIÈRES,

La Cathédrale de Meaux (Petites Monographies), pp. 102-103. The letter of Brother John of St. Faron dated the 20th May 1742, which accompanies the drawing mentioned here, explains the meaning of the scenes in which Ogier is represented holding in his hands a stick with bells on it: «You should know (thus runs the tradition of the monastery) that this Ogier when he wished to embrace the monastic state went through all the provinces seeking a monastery where the rule and modesty were rigorously observed: and, to test this, when the monks were in choir he would throw his stick into the middle of them so that the bells made a tremendous noise. He would then watch to see whether the monks raised their eyes, and from this he judged whether the rule was rigorously kept or not. He made the experiment in many places, but his wretched rattle always distracted the attention of the monks, and so off he went. He did the same thing in the monastery of St. Faron, but they all controlled themselves with great modesty except one little novice, who was at once reproved by the novice-master.» So Ogier took the robe at the Abbey of St. Faron.

60] It gives me great pleasure to thank M. JEAN HUBERT, keeper of the archives of Seine-et-Marne, at this point, who gave me very precise information on this subject. The reproduction is in M. GASSIES' article in *Bulletin Archéol.*, 1905, pp. 40-45, pl. 6.

61] A. GABRIEL FLEURY, *Études sur les portails imagés du XIIe siècle*, 1904, pp. 138-142. A. KINGSLEY PORTER has published good photographs of the remains of this door in his volume *Romanesque Sculpture*, t. X, nos. 1474-1478.
B. M. Paul Deschamps has called my attention to the *Gesta abbatum Trudenensium* published by SCHLOSSER, *Quellenbuch zur Kunstgeschichte des abendländischen Mittelalters*, *Mon. Germ. Hist.*, *Script. X*, p. 395, where this door is described by the chronicler: «Quatuor nichilominus alias ymagines longiori de lapide sculptas operi ipsi inseruit... singula brevia sanctorum meritis testimonium perhibentia in manibus habentes», obviously a description of column-statues.

62] L. LEFRANÇOIS-PILLION, *Le Portail de l'église Notre-Dame de Corbie*, in *Bulletin monumental*, 1925, pp. 131-146, pl. and fig.

63] COMTE DE LASTEYRIE thought it might be possible to date the St. Anne door as far back as 1180-1190 (*Mémoires Soc. Hist. de Paris*, t. 29, 1902; *Études sur la sculpture française*, pp. 36-39). His proofs do not seem sufficient grounds for bracketing the St. Anne door with the Virgin door and separating it at such a distance from the Portail Royal at Chartres. Cf. E. MÂLE, *Art et Artistes du Moyen Age*, p. 208.

64] *Monumens de la Monarchie françoise*, t. I, pl. VIII, p. 56. Two fragments of column-statues of the third quarter of the 12th century are in the Cluny Museum (Nos. 89 and 90 in Montremy's catalogue). They are possibly from Notre-Dame,

which is their traditional provenance, or St.-Germain-des-Prés or even St.-Denis. It is impossible to identify them.

65] The story is represented on the north door of the transept at Chartres and very frequently on the windows. It is interesting to compare the Chartres figure as we saw it on the Portail Royal with the initials in the Stephen Harding Bible, representing Esther, reproduced in M. OURSEL, *La Miniature du XIIe siècle à l'abbaye de Citeaux*, pl. XI.

66] VIOLLET-LE-DUC is said to have discovered in the foundations of the chapels north of the nave, in the course of restoration work, the fragments of a colossal Christ with Evangelist Symbols which must have come from a destroyed tympanum, possibly intended for the centre of the great façade, like that on the Portail Royal. Undoubtedly the figures of Elders of the Apocalypse round the Virgin tympanum, an arrangement contrary to the usual iconographic rules, must have been intended to accompany a Last Judgement in the mind of the sculptor who planned the original façade between 1165 and 1170.

67] W. VÖGE, *Die Anfänge des monumentalen Stiles im Mittelalter*, Strasburg, 1894, in 8vo, pp. 135-165; E. MÂLE, *Le Portail Sainte-Anne à Notre-Dame de Paris*, in *Revue de l'Art ancien et moderne*, 1897, p. 231 and *Arts et Artistes du Moyen Age*, pp. 188-208.

68] It was found in 1858 in a farm wall near the old priory of Viltain.

69] In *Le Nivernais, album historique*, by MORELLET, BARAT and BUSSIÈRE, 1838, p. 125, pl. 7.

70] *Hist. génér. et part. de Bourgogne*, t. I, p. 498.

71] DOM PLANCHER, *Hist. génér. et part. de Bourgogne*, t. I, p. 514.

72] DOM PLANCHER, *Histoire génér. et part. de Bourgogne*, t. I, p. 515.

73] A study of these researches has been published by M. A. DE CHARMASSE, n *Bull. de la Soc. d'études d'Avallon*, 1865, pp. 72-87.

74] FÉLIX THIOLLIER, *Les débris du tombeau de saint Lazare*, in *Bulletin archéologique du Comité*, 1894, pp. 445-457, pl. Cf. MARCEL AUBERT, *Une Nouvelle sculpture bourguignonne au Musée du Louvre*, in *Bulletin monumental* 1924, pp. 127-132, pl., and PAUL VITRY, *Un Fragment du tombeau de saint Lazare d'Autun au Musée du Louvre*, in *Monuments Piot*, t. XXVI, 1923, p. 165 and foll.

75] *Monuments Piot*, t. VIII, 1902, p. 45 and foll.

76] *Die Anfänge des monumentalen Stiles im Mittelalter*, Strasburg, 1894, in 8vo.

77] *Romanesque Sculpture*, Boston, 1923, 1 vol. text and 9 vols. plates. See also GEORGIANA GODDARD KING, *Tact and inference in the matter of jamb sculpture* in *Art Studies*, 1926, pp. 113-146, pl.

78] *Deutsche und französische Kunst im Mittelalter, I. Südfranzösische Protorenaissance*, Marburg, 2nd ed. 1923.

79] *Moyen Age*, 1898-1899, t. XI-XII.

80] R. Hamann, *Ein unbekannter Figurenzyklus in St.-Guilhem-le-Désert*, in *Marburger Jahrbuch für Kunstwissenschaft*, t. II, 1926.

81] The inscription on the base of this Virgin cannot be older, according to M. Paul Deschamps, who made a detailed study of it, than 1165-1170, from which it may be concluded that the whole tympanum of Notre-Dame at Beaucaire was twenty years later than the frieze on the side of the doors, which was imitated, like the tympanum, at St.-Gilles in the last quarter of the 12th century in a quite different style, heavily influenced by the art of Burgundy and the Ile-de-France.

82] Brutails (*Monuments Piot*, XXVI, 1923), and Labande (*Congrès archéologique*, Avignon 1909) have arrived at the same conclusions.

83] The choir and transept of St.-Barnard at Romans, constructed in the first half of the 13th century, are undoubtedly several years later than the doorway.

84] A. Italy also knew, through Languedoc, the apostles of Toulouse, and possibly those of St.-Denis as well, the doors of which present so many resemblances to some of the doors in Lombardy, with their small statues, isolated or placed one above another, carved in low relief at the abutment angle or on the columns between, in the style of Modena (for instance), or Ferrara or Cremona which are closely related to Honnecourt (Nord) or even the Mantile door at Tournai.
B. One of these statues, preserved in the Garcin collection at Apt, was published by M. M. Labande in the *Bull. archéol.*, 1926, pl. 75. Purchased by M. Martin Le Roy, it was subsequently presented by him to the Louvre Museum.

85] *Bulletin monumental*, 1886 pp. 501-508, fig. and pl.

86] A. R. P. Viaud, *Nazareth*, pp. 149-163, fig.; C. Enlart, *Les Monuments des Croisés*, t. I, pp. 129-132, pl.
B. Reproduced by A. Kingsley Porter, *Lombard Architecture*, pl. 235-237.

87] Marcel Aubert, *Monographie de la cathédrale de Senlis*, 1910, pp. 13-14 and 99. Cf. E. Mâle, *Le Portail de Senlis et son influence*, in *Revue de l'Art ancien et moderne*. 1911, and *Art et artistes du moyen âge*, 1927, p. 209 and foll.

88] Watercolours and drawings by Lenoir, kept in the Print Room in the Louvre, t. III, fol. 67. Engraved by Alexandre Lenoir in his *Atlas des Monuments de la France*, 1828, pl. 20.

89] An engraving by Ransonnette in Millin, *Antiquités nationales* 1791, t. II, pl. 19, gives us the appearance of these doors with their column-statues.

90] *La Cathédrale de Sens* (Petites Monographies). *La Sculpture du grand portail de la Cathédrale de Sens*, in *Bulletin archéologique*, 1914. M. L. Bégule has given some beautiful reproductions of this statuary in his *Cathédrale de Sens*, Lyon, 1929.

91] A. Repr. in *Revue de l'Art chrétien*, 1912, p. 94.
B. Repr. by Mme De Maillé in *Bulletin monumental*, 1928, pp. 22-26.

92] The door of St. Nicholas at Amiens, which was in ruins at the end of the 18th

century and is preserved to us in an engraving published by MILLIN in his *Antiquités nationales (an VII)*, seems to have been a replica in its tympanum, its arch-rims, and great statues against the walls, of the doorway of Senlis.

93] MARCEL AUBERT, *Notre-Dame de Paris, architecture et sculpture*, Paris, Morancé, 1928, in-fol.

94] *L'Art religieux du XIIIe siècle en France*, pp. 179-182.

95] AMÉDÉE BOINET, *L'Ancien portail de l'église Saint-Yved de Braisne*, in *Congrès archéologique de Reims*, 1911, t. II, pp. 259-278.

96] This arrangement can be found in the plan of the crypt and foundations of Chartres given by M. RENÉ MERLET at the beginning of his *Petite Monographie*, Paris, Laurens.

97] *Cartulaire de la Cathédrale de Chartres*, II, 103.

98] At Corbie, at the end of the 12th century, the Coronation of Senlis is surrounded by the Symbols of the Evangelists, a curious survival of Romanesque traditions with a new theme.

99] Cf. MARCEL AUBERT, *La Flore de la porte de la Vierge à Notre-Dame de Paris* in *La Renaissance*, December 1927.

INDICES

GENERAL INDEX

Aaron, 38, 54, 79.

Abraham, 31, 44, 58, 67f, 83, 86.

Adam, 31, 67.

Albigenses, 60.

Alexander III, Pope, 75.

Allier, Achille, 105.

Anna and Joachim, 16.

Anna, prophetess, 22.

Announcement to shepherds, 22, 29, 31, 49, 53, 78.

Annunciation, The, 17, 22f, 26, 29, 31f, 36, 41, 48f, 55, 61, 78.

Apocalypse, Elders of the, 5, 15, 17ff, 25f, 28, 33, 36, 43, 48, 53, 55, 107.

Apostles, 5ff, 17, 19ff, 26, 28, 30, 32, 34ff, 38f, 44, 46, 58f, 70, 82f, 95, 108.

Apulia, 6.

Aquitaine, 6, 11, 27, 35, 53, 101, 105.

Aragon, 61.

Archaism, 3, 14, 25, 31, 42, 58, 62, 72.

Ardennes, 96.

Aristotle, 24.

Ark of the Covenant, 79, 98.

Arts, figures of the, 24, 40, 74, 79.

Ascension, The, 3, 17ff, 21, 25f, 38, 55, 59.

Atlas figures, 6, 41, 103.

Aubert, Marcel, 107ff.

Auvergne, 23, 50.

Avarice, 73.

Balaam, 79.

Barat, 107.

Bath-sheba, 41, 48, 95.

«Beau Dieu» (Amiens), 20, 84.

Bégule, M. L., 108.

Berry, 40.

Bible, The, 107.

Bibliothèque Nationale, 4f, 103, 105.

Boethius, 24.

Boinet, Amédée, 109.

Bouillart, Dom, 105.

Bourbon district, 38.

Bourquelot, 104.

Brière, M., 70.

Brionne, 21.

Broche, M. Lucien, 44, 105.

Brunus (Brun), 5, 59.

Brutails, 108.

Bulteau, Abbé, 8f.

Burgundy, 1f, 11, 18ff, 27f, 35, 53ff, 58, 60, 63, 65, 73, 76, 78, 101, 108.

Bush, The burning, 79.

Bussière, 107.

Cana, Marriage at, 28f.

Catalonia, 61, 65.

Celestine III, Pope, 81.

Chalandon collection, 61.

Champagne, 33.

Charlemagne, 45.

Charmasse, M. A. de, 107.

Chartraire, Canon, 73.

Chelles, Pierre de, 91.

Childebert, 92.

Christ, among the Doctors, 17 - ancestors of, 14 - and the Apostles, 9 - as Judge 5, 85 (*see also* Last Judgement) - Baptism of, 17, 23, 29, 73 - childhood of, 3, 22, 28, 46, 53f, 57, 65, 78, 82 - death of, 57 - forerunners of, 6 - in glory, 20, 26, 39, 55 - in majesty, 17, 28, 32, 34, 39, 46f, 53f, 58, 66, 72, 76 - Life of, 1, 16, 28, 57 - on tympana, 42, 46 - raising Lazarus, 56 - teaching, 93 - types of, 66, 83.

III

Herod, 29, 49, 73.
Herr, Jeanne, 105.
Heures d'Etienne Chevalier, 96.
Hildegard, 45.
Holy Women at the Sepulchre, The, 27, 61, 72.
Honorius, 55, 78.
Horace, 6.
Hourticq, M. L., 10, 38.
Hubert, M. Jean, 40, 105f.
Hugues of Amiens, 8.

Ile-de-France, 1, 3, 8, 22, 33, 45f, 54ff, 58, 62f, 65, 101, 108.
Incarnation, The, 17.
Ingeborg, Psalter of Queen, 29.
Innocents, Massacre of the, 17, 26, 29, 53, 90.
Isaac, 58.
Isaiah, 47, 49, 68, 83.
Italy, 6f, 59, 65, 108.
Ivory, 2, 30, 36, 96.

Jacob, 58, 68.
Jacob, Maurice, 104.
Jael (?), 67.
Jeremiah, 68, 83, 84.
Jerusalem, Entry into, 61.
Jerusalem, The heavenly, 75, 85.
Jesse, 67.
Jesse-trees, 14, 67, 71, 77, 80, 85, 95.
Joachim, 16.
John of St.-Faron, Brother, 106.
Jonah, 31.
Joseph (O.T.), 90.
Joseph (N.T.), 78.
Judah, Kings of, 54.
Judas, 17.
Judas, Kiss of, 60.
Judith, 41, 48.

Julian, Emperor, 73.
Juvenal, 6.

King, Georgiana Goddard, 107.
Kings, 6, 28f, 66, 77.

Labande, M. M., 108.
Labours of the Months (*see* Months).
Lancelot, 105.
Languedoc, 1f, 5f, 11, 18, 21f, 25, 27f, 42, 53, 58, 60, 67, 101, 108.
Lanore, 8.
Lassus, 18.
Lasteyrie, Comte de, 8, 22, 56, 58, 106.
Last Judgement, The, 3ff, 43f, 75, 79, 82, 85, 98, 107.
Last Supper, The, 17, 27, 41, 54.
Lebeuf, Abbé, 38.
Lefèvre-Pontalis, Eugène, 8f, 25, 104f.
Lefrançois-Pillion, Mme Louise, 22, 47, 106.
Lenoir, Alexandre, 43, 70, 108.
Lépinois, De, 104.
Le Roy, M. Martin, 108.
Loire, The, 11, 37, 41, 54.
Lombardy, 108.
Louis VII, King, 48, 60, 86.
Lucan, 6.

Mabillon, 38, 44f, 105.
Madonnas, Master of the two, 49.
Magi, The, 3, 17, 22, 26, 29, 31, 49, 53f, 57, 61, 65, 78, 80.
Magnificat, The, 22, 50.
Maillé, Mme De, 108.
Mâle, M. Emile, 5, 20, 38, 44, 78, 104f, 107f.
Manuscripts, influence of, 1, 21.
Maries at the Sepulchre, 59.
Marignan, M., 8, 56.

INDEX OF PLACE NAMES

PLATES 1-88

I

SAINT-DENIS (Seine). ABBEY CHURCH
West Front. Central Door

Tympanum: Last Judgment. *Arch-rim:* Scenes from Hell and Paradise. Elders of the Apocalypse. *Jambs:* Wise and foolish Virgins.
Numerous restorations.

1135-1140
Photo Giraudon

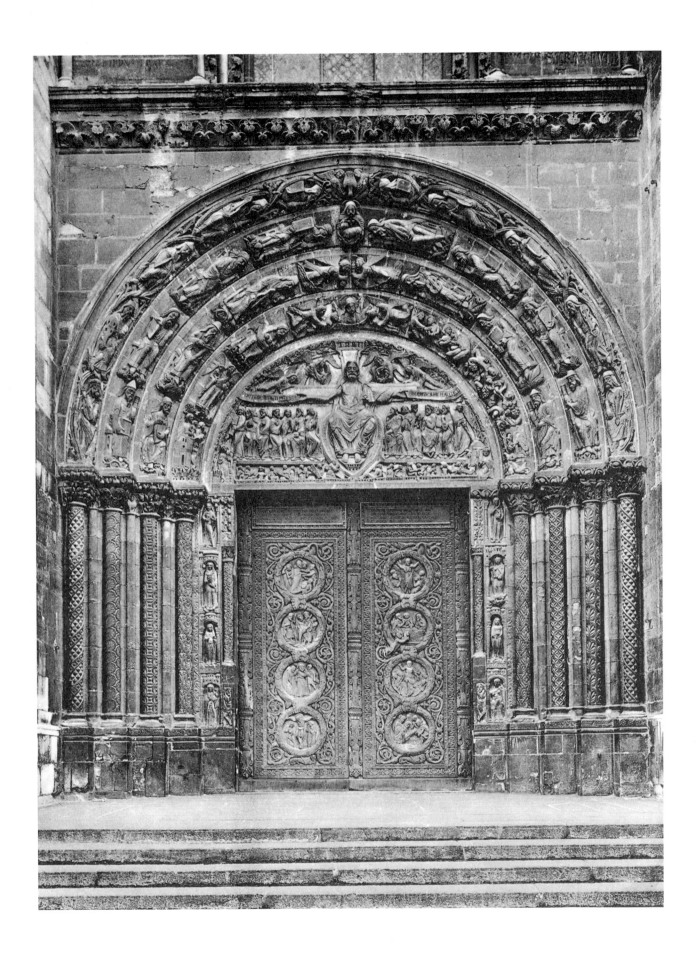

2

SAINT-DENIS (Seine). ABBEY CHURCH
West Front

Pillar statues: Designs executed for B. de Montfaucon and preserved in the Bibliothèque Nationale (Dép. des Mss. fr. 15.634): Personages from the Old Testament.

1135-1140

Photo Marcel Aubert

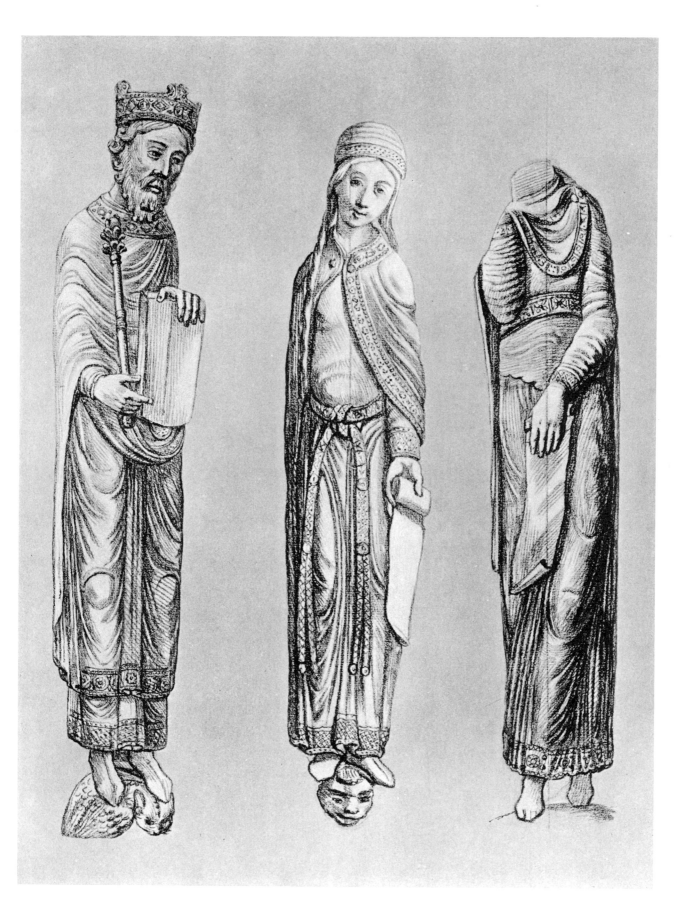

3

SAINT-DENIS (SEINE). ABBEY CHURCH
WEST FRONT. DOOR TO THE LEFT
Details of pillars: Signs of the Zodiac. Atlantes.
1135-1140
Photo E. Lefèvre-Pontalis

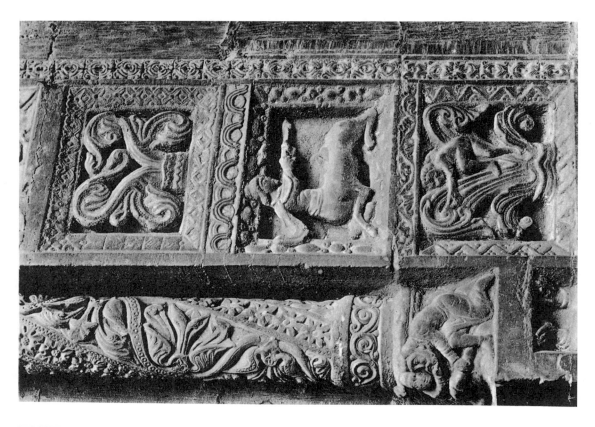

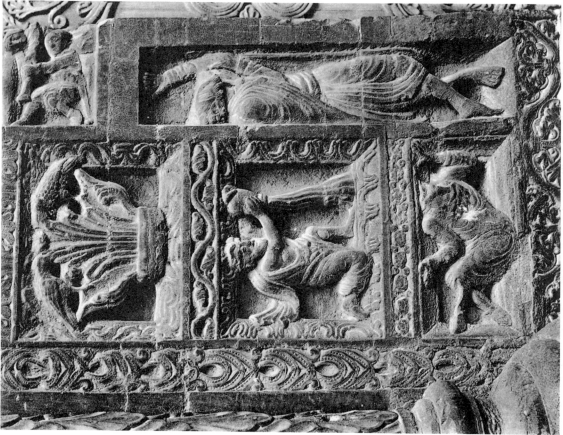

4

SAINT-DENIS (Seine). ABBEY CHURCH
West Front. Door to the right
Details of pillars: Occupations of the Months.
A. December, January. B. February, March.
1135-1140
Photo E. Lefèvre-Pontalis

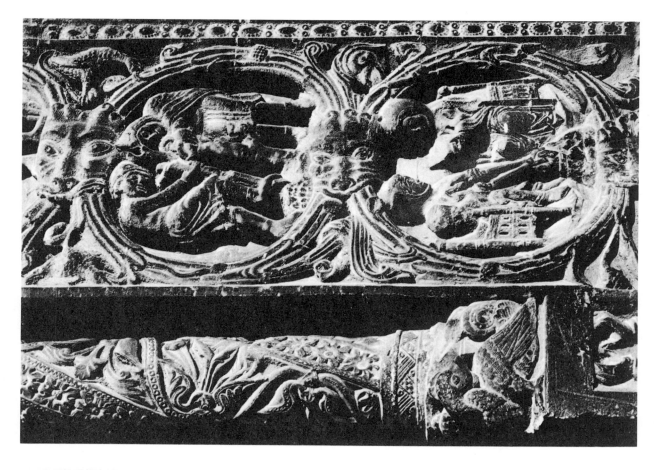

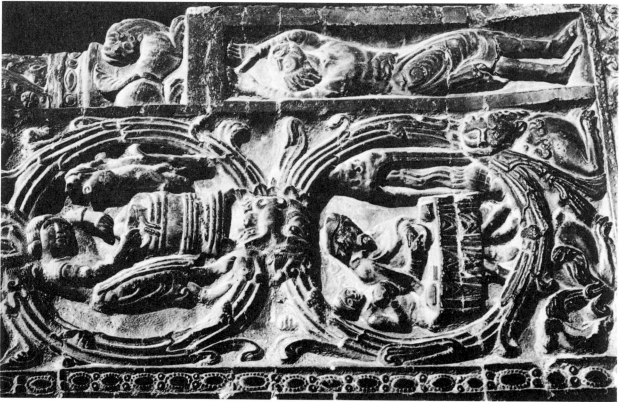

5

CHARTRES (Eure-et-Loir). CATHEDRAL
West Front. Portail Royal

Central door: Christ in Majesty between the Symbols of the
Evangelists. Apostles. *Arch-rims:* Angels, Elders of the Apoca-
lypse. *Left door:* Ascension. *Arch-rims:* Occupations of the Months.
Right door: Scenes from the Childhood of Christ; Virgin in
Majesty. *Arch-rims:* Signs of the Zodiac, Liberal Arts.

1145-1155
Photo Houvet

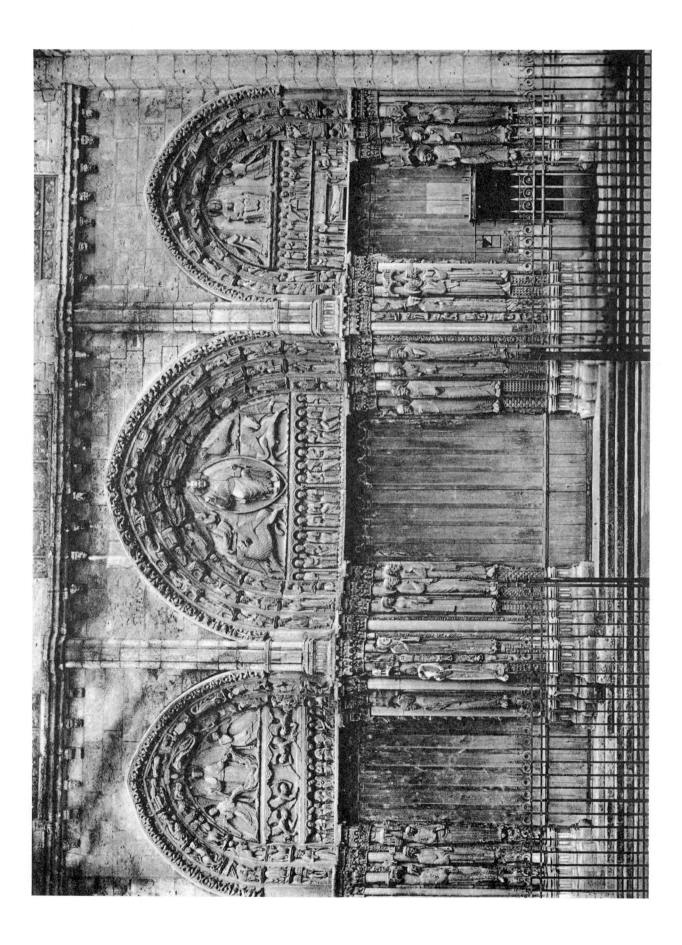

6

CHARTRES (Eure-et-Loir). CATHEDRAL
Portail Royal. Central Door
Splaying to the left: Personages from the Old Testament.
1145-1155
Photo Houvet

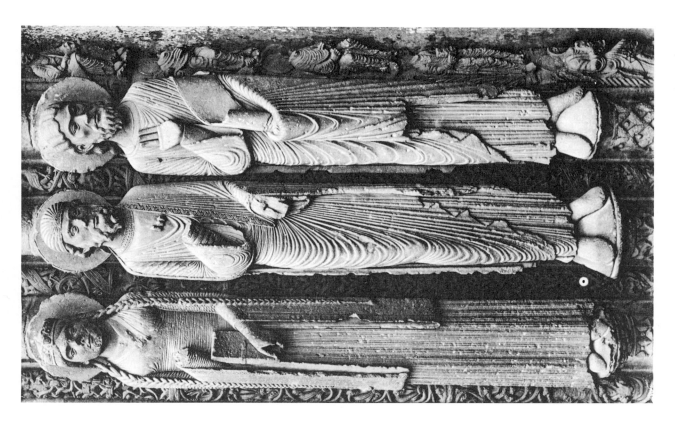

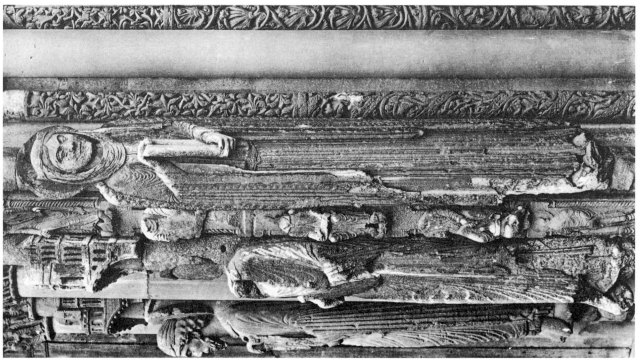

7

CHARTRES (Eure-et-Loir). CATHEDRAL
Portail Royal. Central Door
Splaying to the left, Details:
Head of a personage from the Old Testament.
1145-1155
Photo Houvet

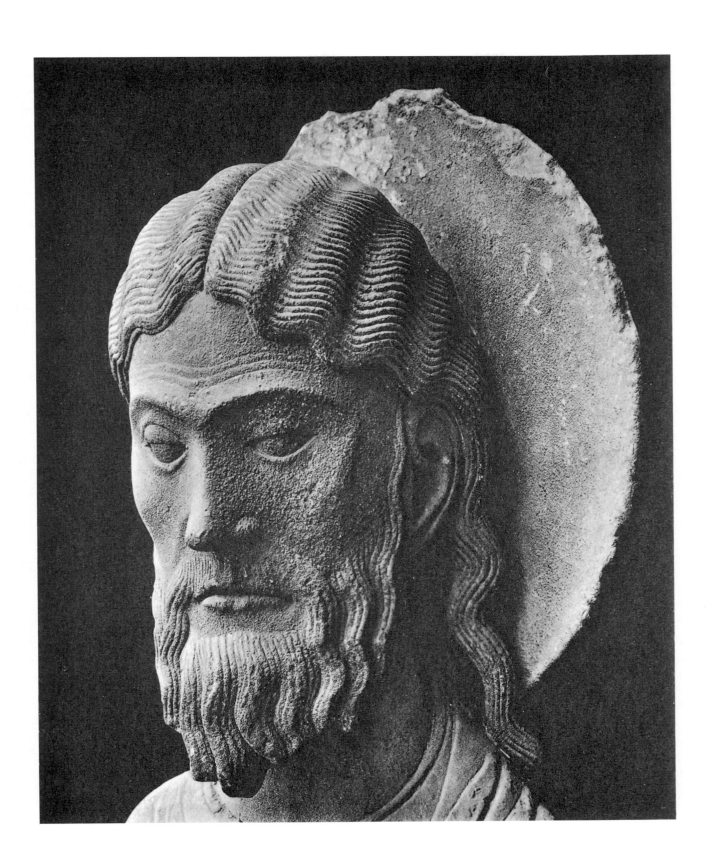

8

CHARTRES E(URE-ET-LOIR). CATHEDRAL
PORTAIL ROYAL. CENTRAL DOOR
Splaying to the right: Personages from the Old Testament.
1145-1155
Photo Houvet

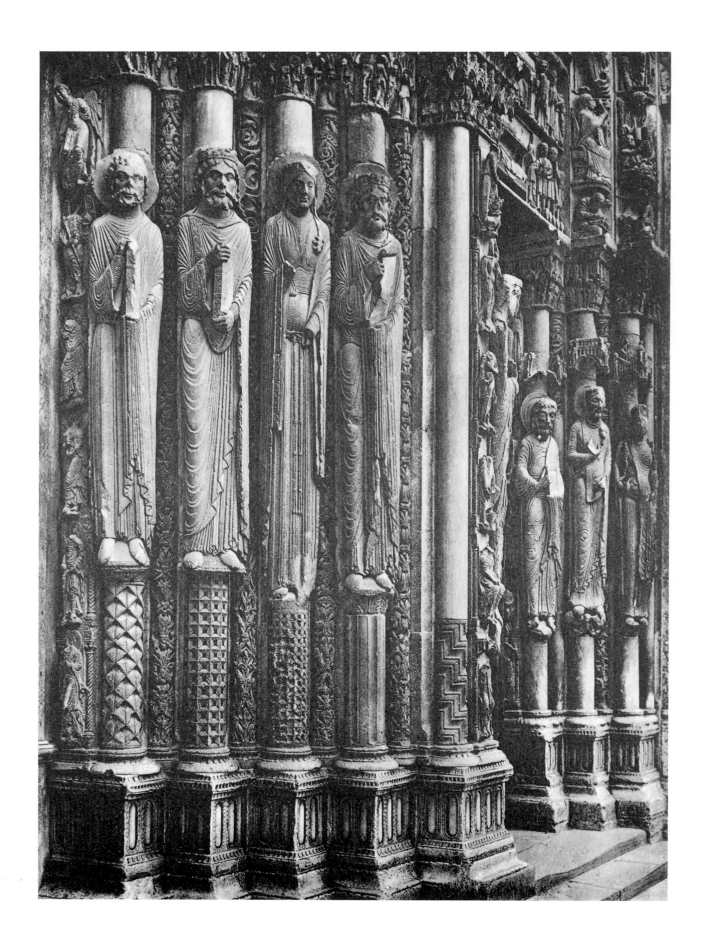

9

CHARTRES (Eure-et-Loir). CATHEDRAL
Portail Royal. Left Door
Splaying, Details: Personages from the Old Testament.
A. Splaying to the left. B. Splaying to the right.
1145-1155
Photo Houvet

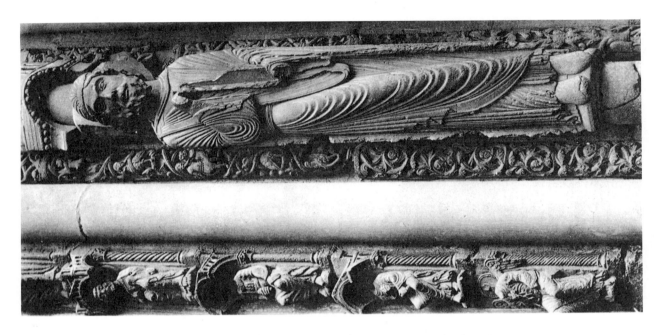

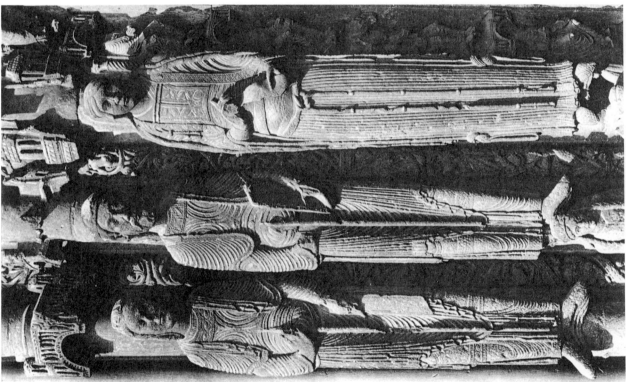

IO

CHARTRES (Eure-et-Loir). CATHEDRAL
Portail Royal. Door to the right
Splaying to the left: Personages from the Old Testament.
1145-1155
Photo Houvet

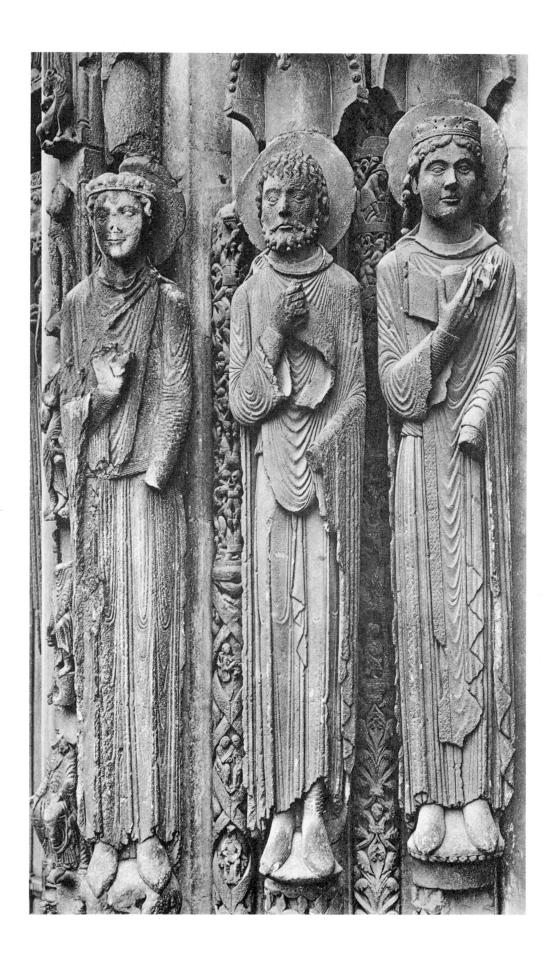

II

CHARTRES (Eure-et-Loir). CATHEDRAL
Portail Royal. Door to the right
Splaying to the right: Personages from the Old Testament.
1145-1155
Photo Houvet

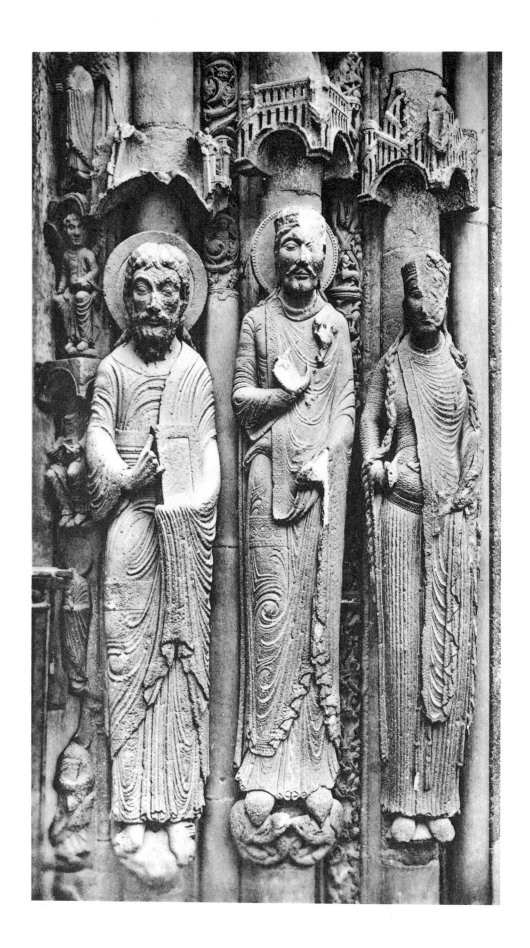

12

CHARTRES (Eure-et-Loir). CATHEDRAL
Portail Royal. Left Door
Splaying to the left, cornice:
Massacre of the Innocents and Flight into Egypt.
1145-1155
Photo E. Lefèvre-Pontalis

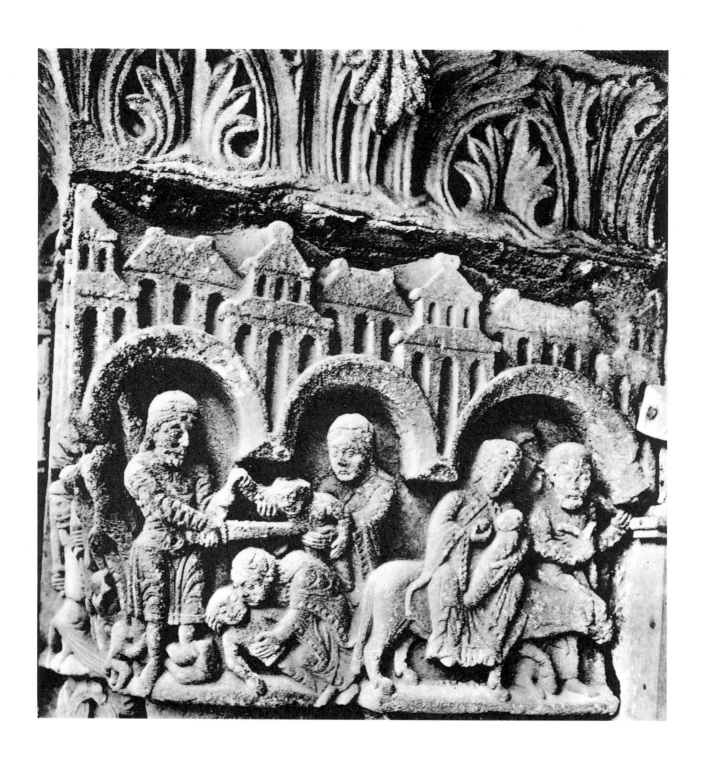

13

CHARTRES (Eure-et-Loir). CATHEDRAL
Portail Royal. Central Door

Tympanum: Christ in Majesty between the Symbols of the
Evangelists.
Lintel: Apostles. *Arch-rims:* Angels, Elders of the Apocalypse.

1145-1155
Photo E. Lefèvre-Pontalis

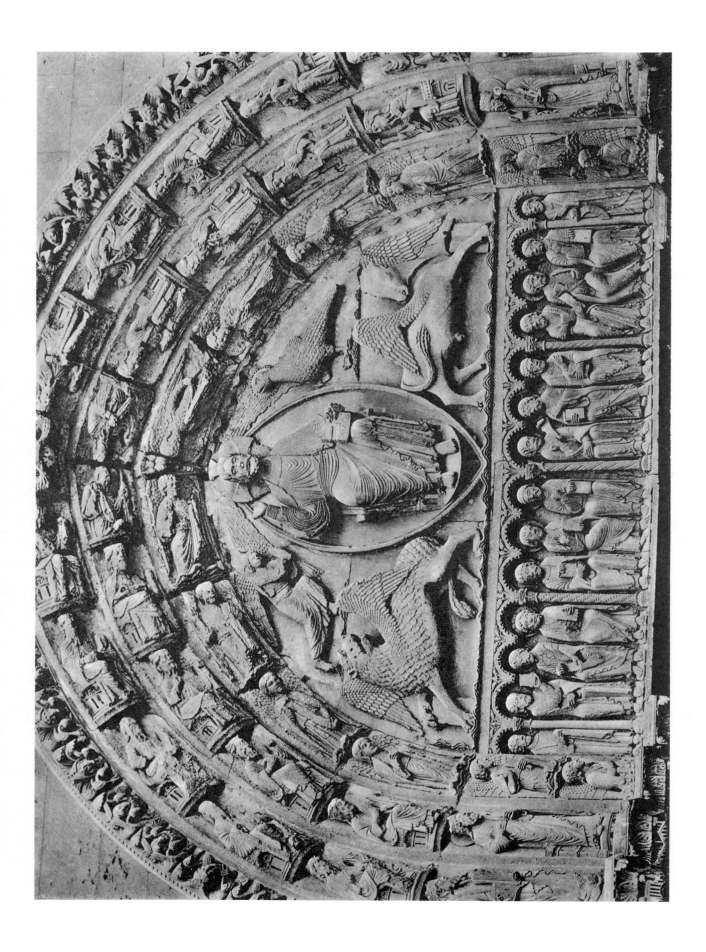

14

CHARTRES (Eure-et-Loir). CATHEDRAL
Portail Royal. Central Door. Left Side

Capitals: Anne and Joachim in the Temple. Golden Gate. The birth of the Virgin. Her Presentation in the Temple. Her marriage. *Arch-rims:* Angels. Elders of the Apocalypse.

1145-1155

Photo E. Lefèvre-Pontalis

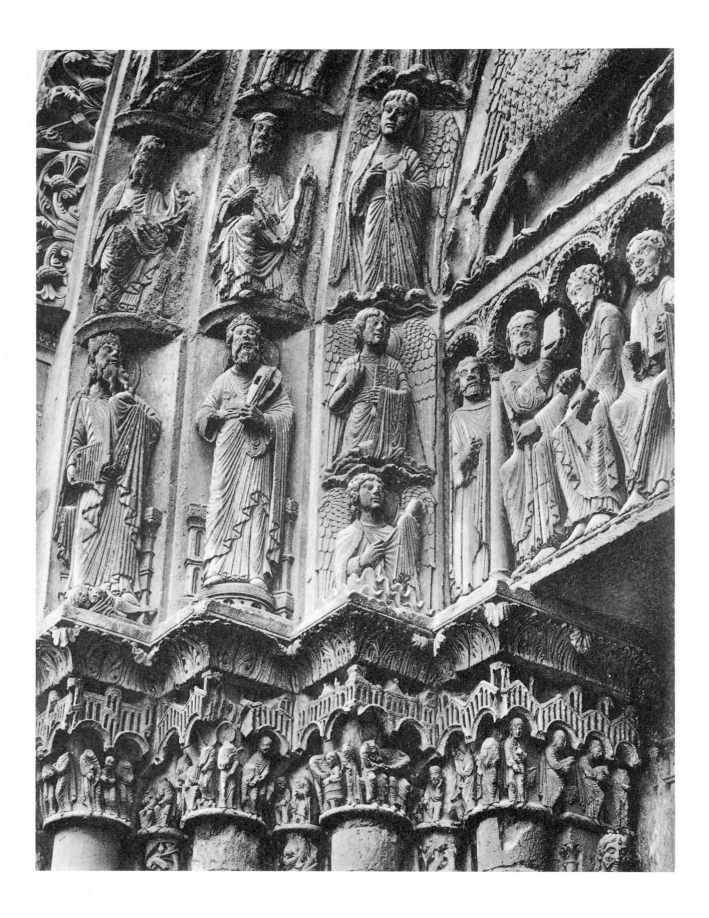

15

CHARTRES (Eure-et-Loir). CATHEDRAL
Portail Royal. Left Door

Tympanum: Ascension. *Arch-rims:* Signs of the Zodiac and
Occupations of the Months.

1145-1155
Photo E. Lefèvre-Pontalis

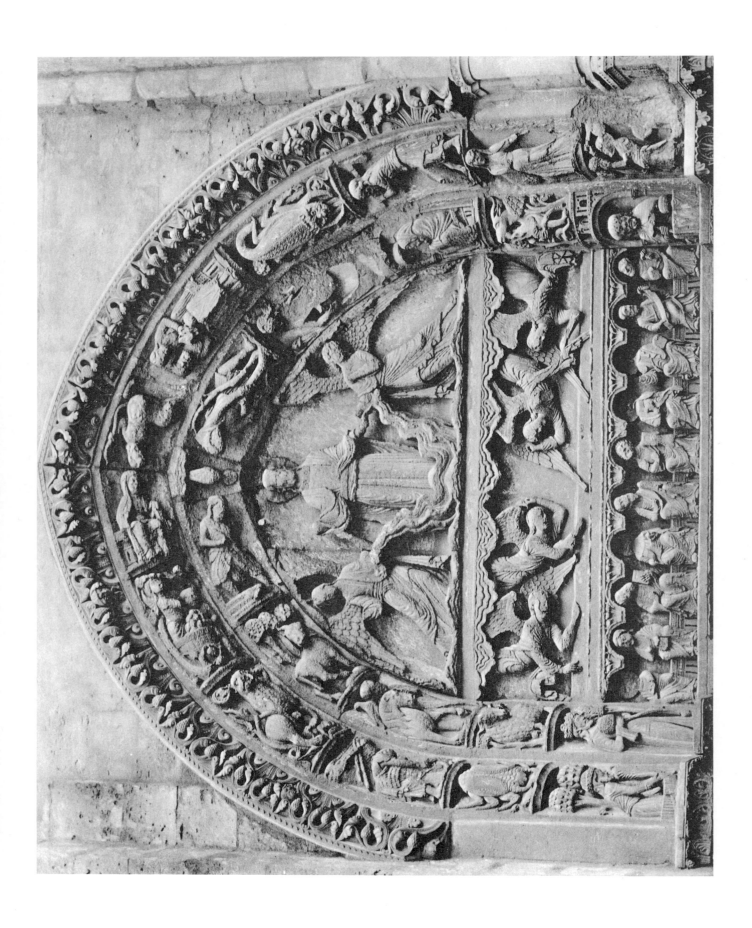

16

CHARTRES (EURE-ET-LOIR). CATHEDRAL
PORTAIL ROYAL. DOOR TO THE RIGHT

Tympanum, first register: Annunciation, Visitation, Nativity, Annunciation to the Shepherds. *Second register:* Presentation in the Temple. *Third register:* Virgin in Majesty between two Angels. *Arch-rims:* Signs of the Zodiac. Angels. Liberal Arts.

1145-1155
Photo Houvet

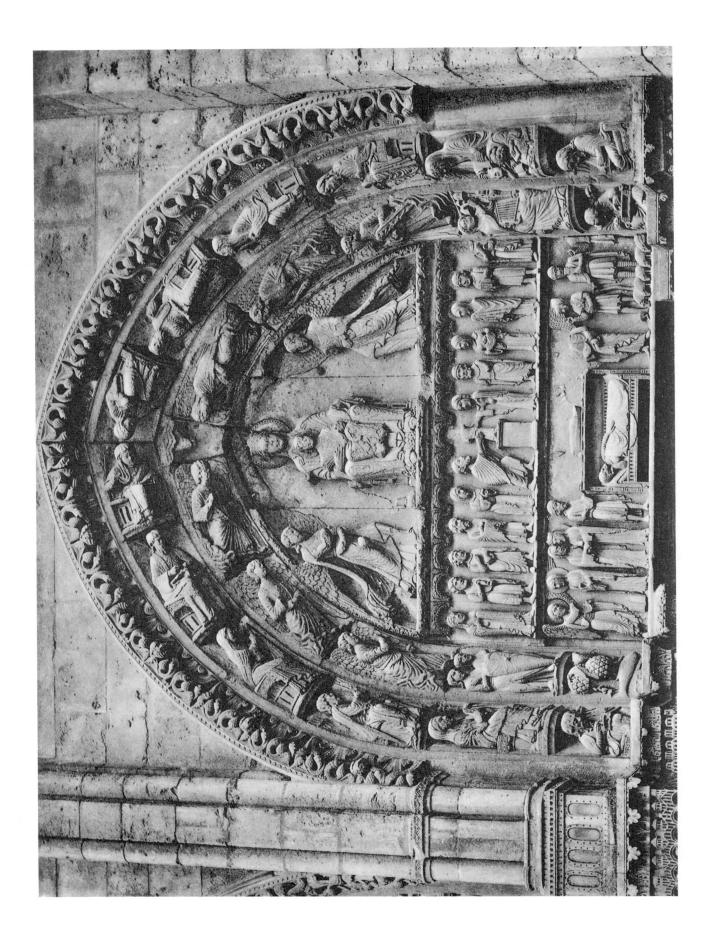

17

CHARTRES (Eure-et-Loir). CATHEDRAL
Portail Royal

Right door: Tympanum, details.
A. Visitation. B. Shepherds.

1145-1155
Photo Houvet

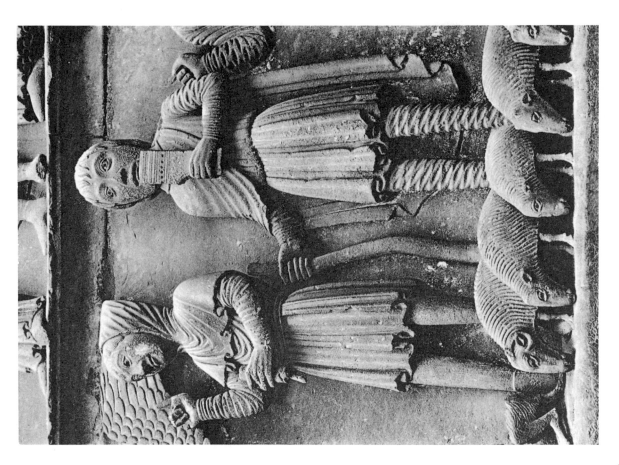

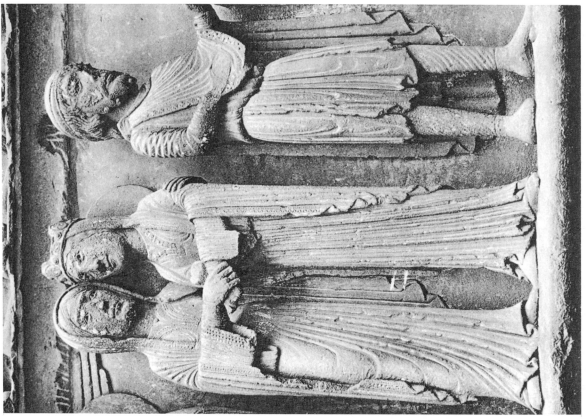

18

CHARTRES (Eure-et-Loir). CATHEDRAL
Portail Royal

Right door. Arch-rims, details:
A. Pythagoras. B. Grammar.
1145-1155
Photo Houvet

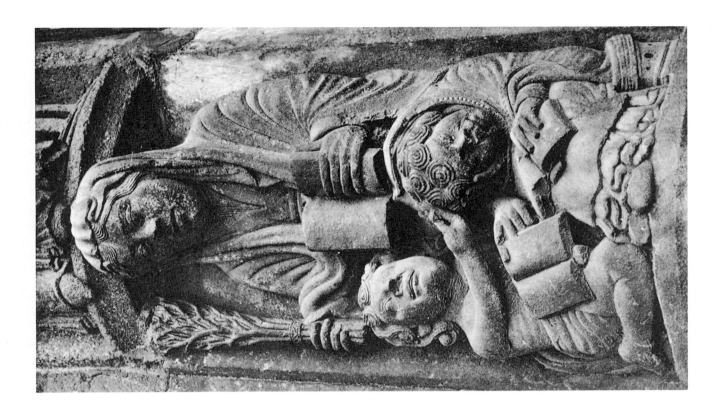

19

LA CHARITÉ-SUR-LOIRE (Nièvre). ABBEY CHURCH
West Front

A. Left side door. *Lintel:* Annunciation, Visitation, Nativity, Shepherds. *Tympanum:* Christ of the Ascension taking under his protection the Order of Cluny at the intercession of the Virgin.

B. Right side door: Tympanum, to-day at the base of the southern wall of the transept.
Lintel: Adoration of the Magi, Presentation in the Temple.
Tympanum: Transfiguration.

MIDDLE OF XII CENTURY
Photo Monuments historiques

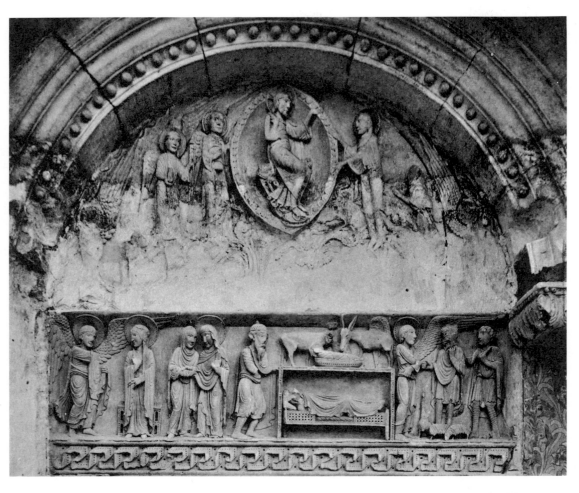

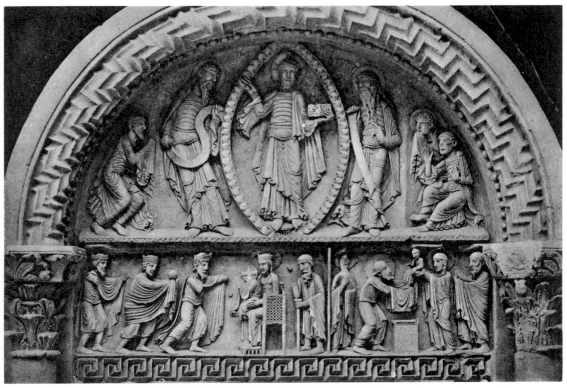

20

A. COLLONGES (Corrèze). PARISH CHURCH
West Door

Tympanum: Ascension.
THIRD QUARTER OF XII CENTURY
Photo Monuments historiques

B. CAHORS (Lot). CATHEDRAL
North Door

Tympanum: Ascension and Second Advent of the Son of Man.
History of St. Stephen.
ABOUT 1170-1180
Photo Monuments historiques

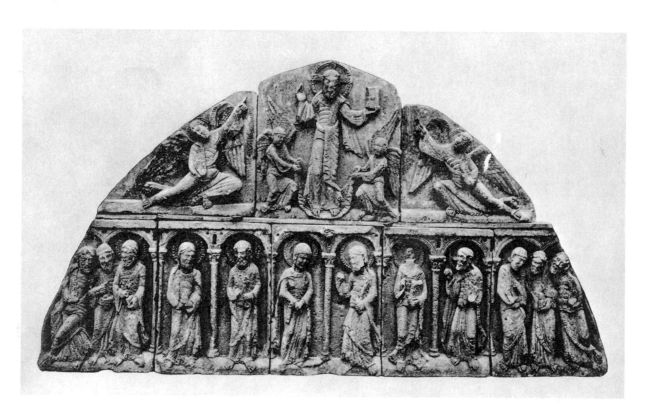

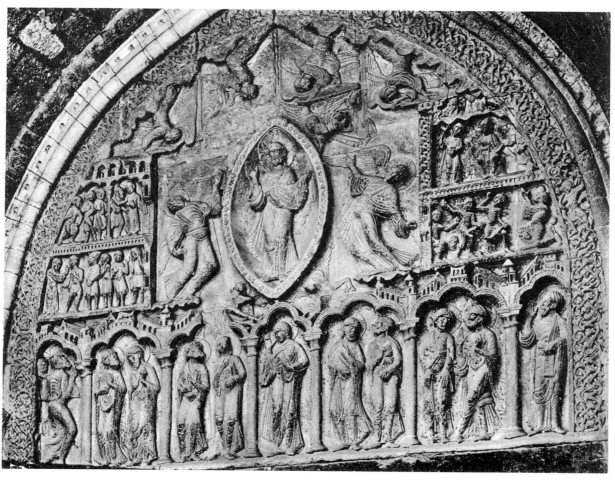

21

A. CARRIÈRES-SAINT-DENIS (Seine-et-Oise)

Retable, now in the Louvre, Paris (Catal. 1922, N. 52).
In the middle, the Virgin in Majesty; to the left, Annunciation;
to the right, the Baptism of Christ.

Length 1,84; height 0,86 m.

THIRD QUARTER OF XII CENTURY
Photo Archives d'Art et d'Histoire

B. COULOMBS (Eure-et-Loir). ABBEY CHURCH

Details of columns, now in the Louvre Museum, Paris
(Catal. 1922 N. 48-49).

Capital: The tidings brought to the Magi at the Inn.

Total height of the column 1,95 m.

THIRD QUARTER OF XII CENTURY
Photo Archives d'Art et d'Histoire

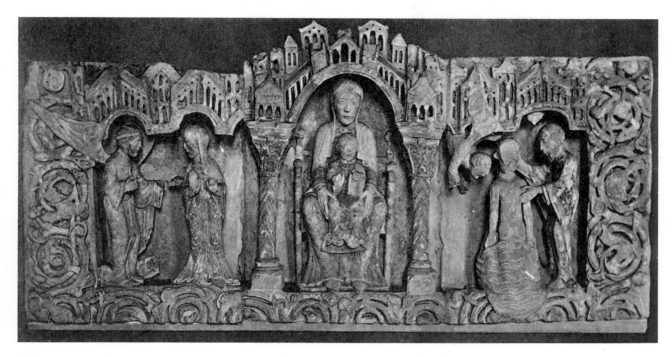

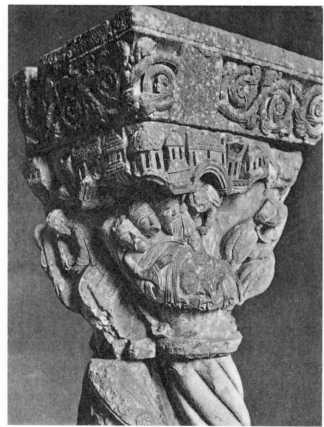

22

ETAMPES (Seine-et-Oise). CHURCH
South Door

Tympanum: Ascension and Second Advent of the Son of Man.
Arch-rims: Elders of the Apocalypse and personages from the
Old Testament. *Capitals:* Life of Christ.

ABOUT 1150
Photo Monuments historiques

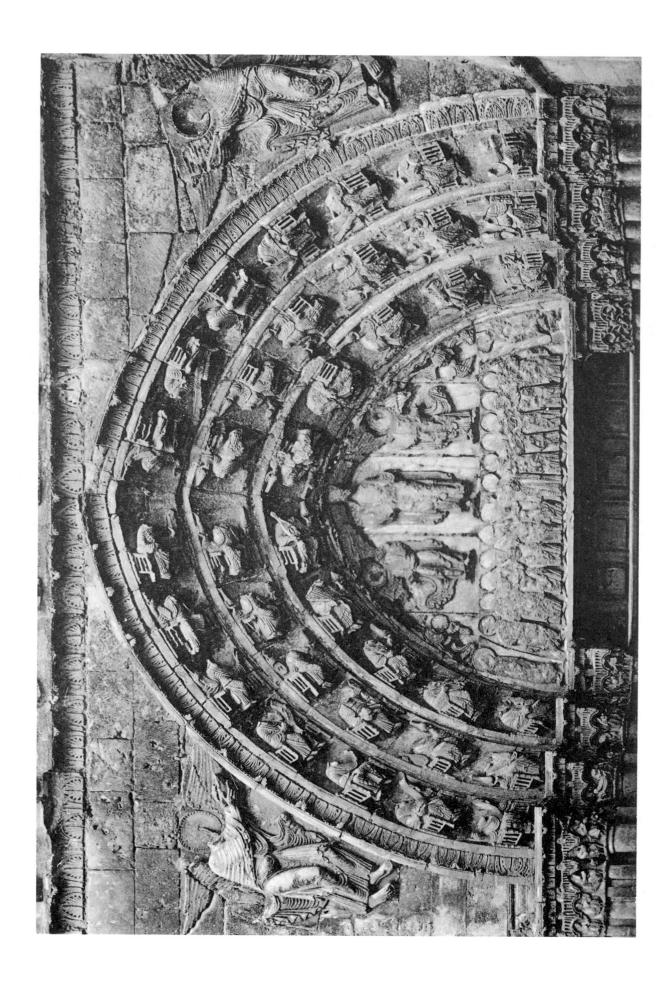

23

ETAMPES (Seine-et-Oise). CHURCH
South Door
Left Splaying: Personages from the Old Testament.
ABOUT 1150
Photo Monuments historiques

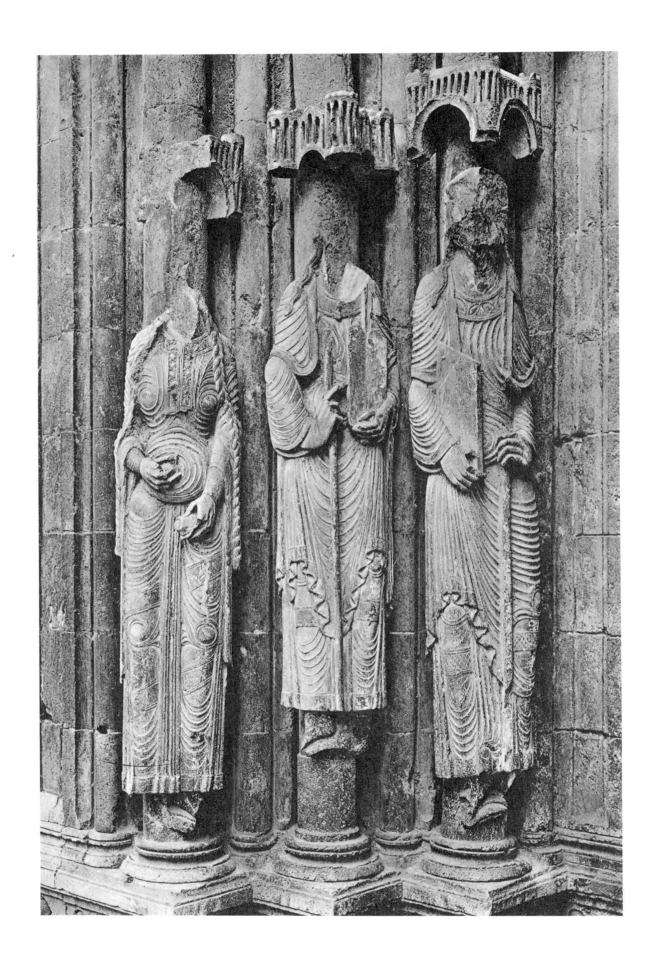

24

LE MANS (Sarthe). CATHEDRAL
South Door

Tympanum: Christ in Majesty between the Symbols of the Evangelists. *Lintel:* Apostles. *Arch-rims:* Scenes from the Life of Christ. *Pillars:* Personages from the Old Testament. *Jambs:* St. Peter and St. Paul.

1150-1155
Photo Monuments historiques

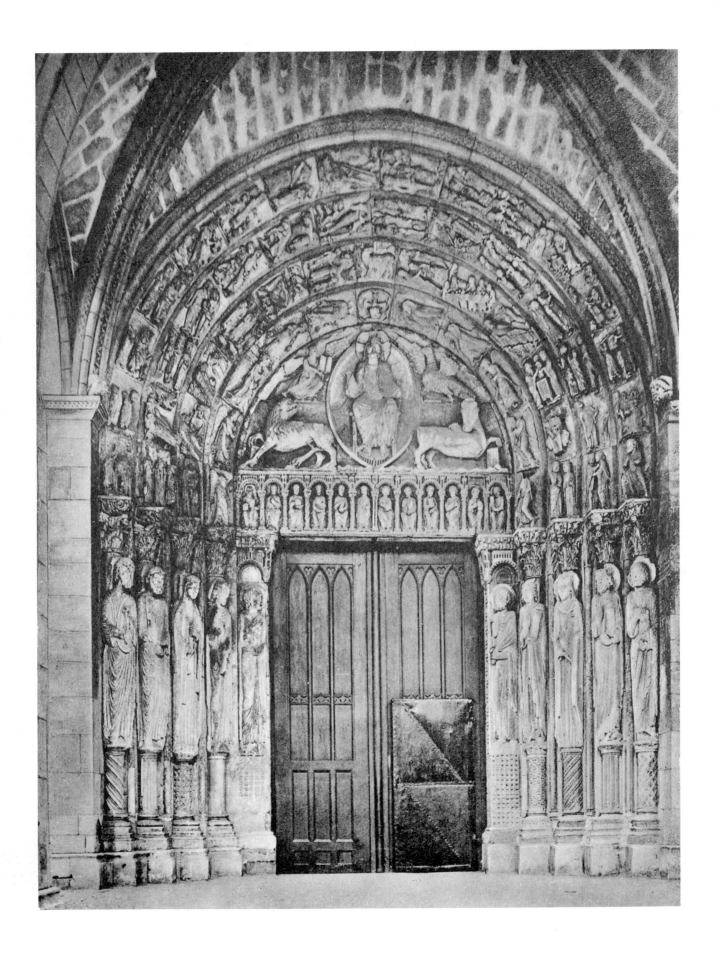

25

LE MANS (Sarthe). CATHEDRAL
South Door

Right Splaying: Personages from the Old Testament; St. Peter.

1150-1155
Photo Monuments historiques

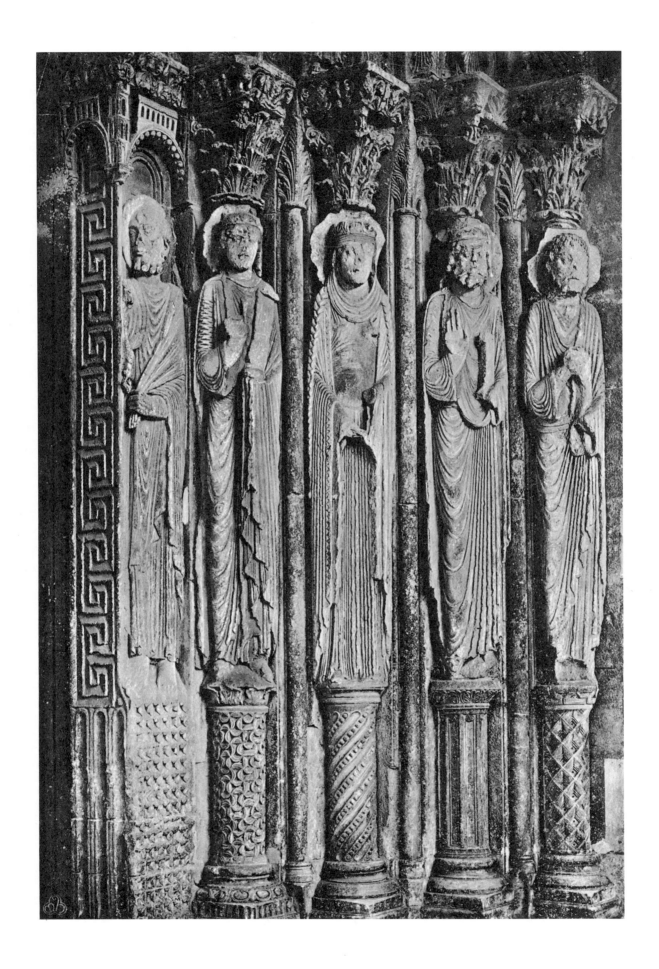

26

LE MANS (Sarthe). CATHEDRAL
South Door

Arch-rims to the left: Angels, Nativity, Massacre of the Innocents.
1150-1155
Photo E. Lefèvre-Pontalis

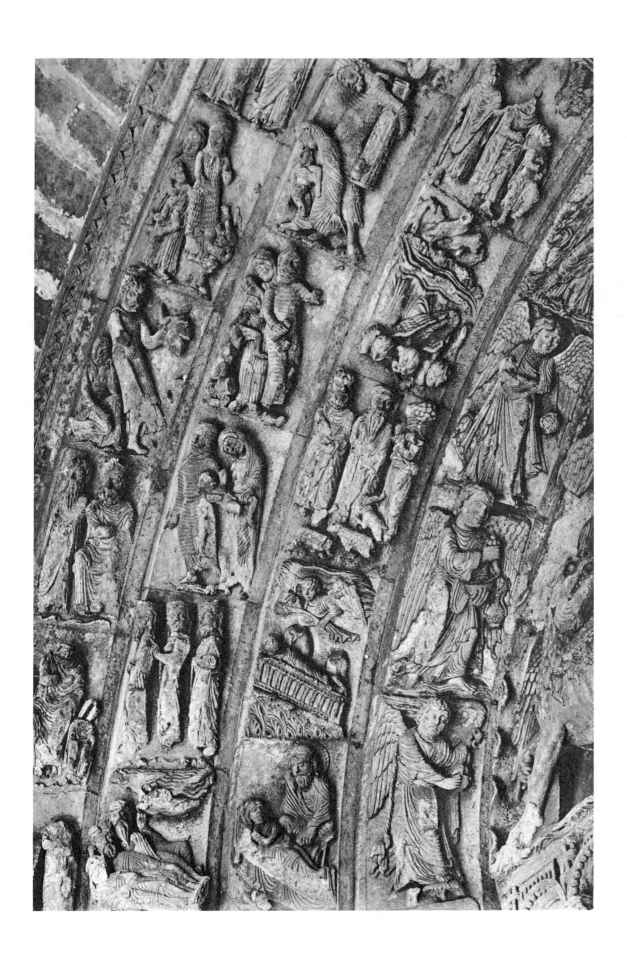

27

BOURGES (Cher). CATHEDRAL
South Door

Tympanum: Christ in Majesty between the Symbols of the Evangelists. *Lintel:* Apostles. *Arch-rims:* Angels, Personages from the Old Testament. *Pillars:* Personages from the Old Testament.

1150-1160

Photo Monuments historiques

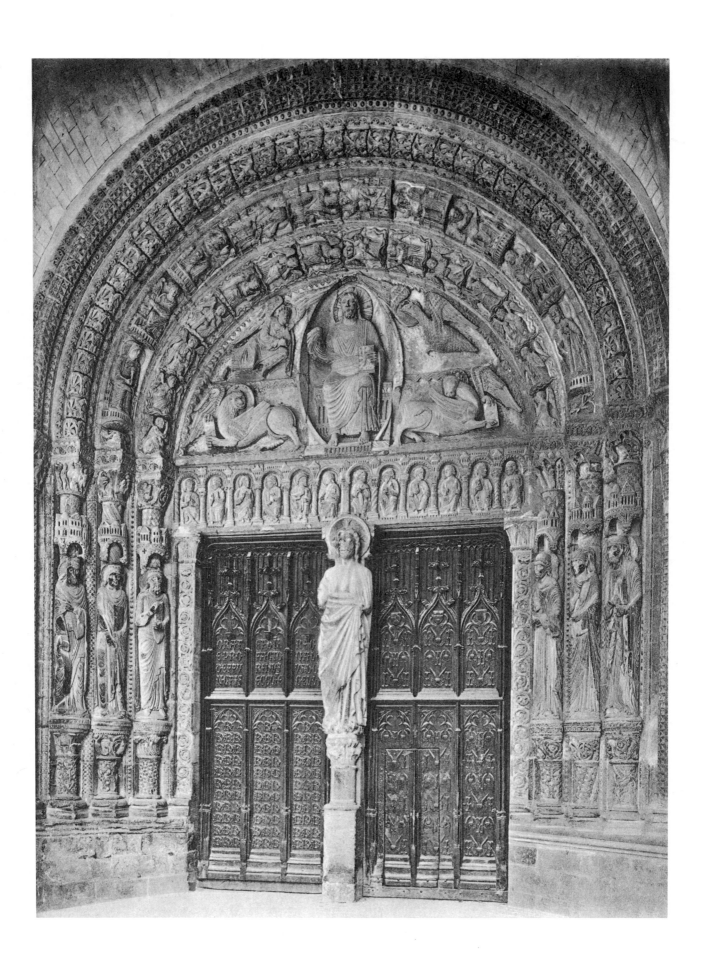

28

BOURGES (Cher). CATHEDRAL
South Door

Right Splaying: Personages from the Old Testament.
1150-1160
Photo E. Lefèvre-Pontalis

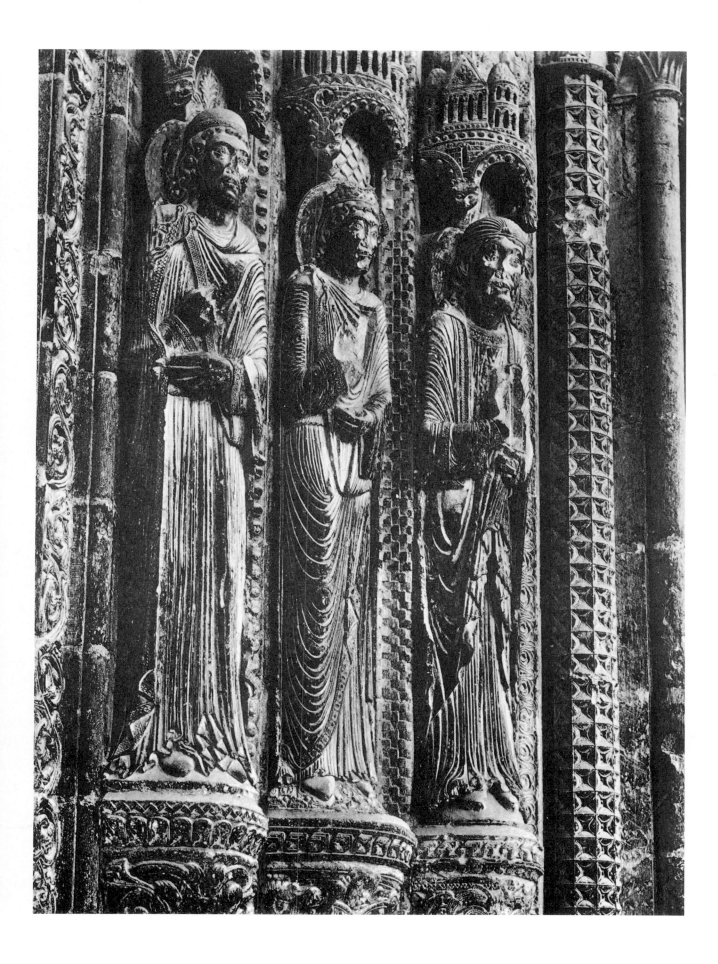

29

BOURGES (Cher). CATHEDRAL
South Door

Capitals and arch-rims, details:

A. Left splaying. B. Right splaying.
1150-1160
Photo E. Lefèvre-Pontalis

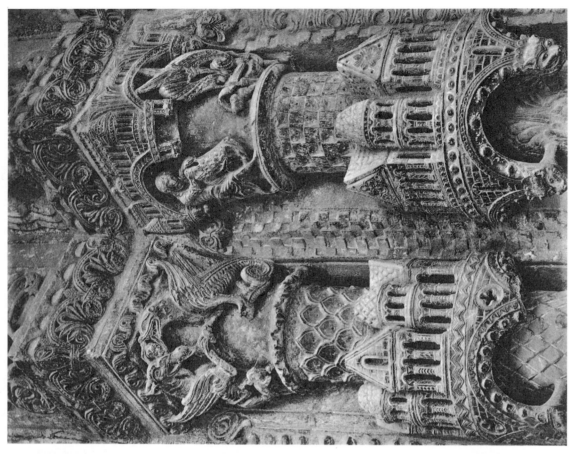

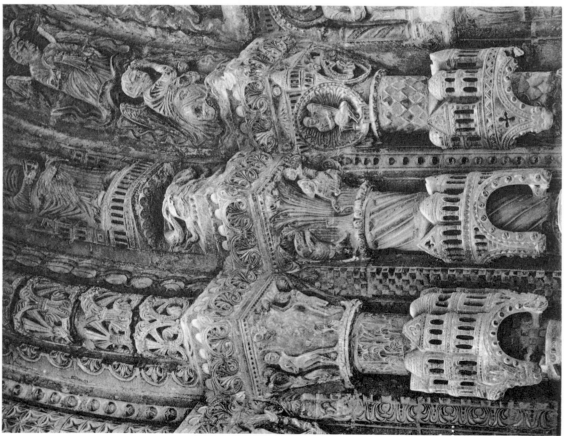

30

BOURGES (CHER). CATHEDRAL
NORTH DOOR

Tympanum: Adoration of the Magi, Annunciation, Visitation.
Pillars: Personages from the Old Testament.

1150-1160

Photo Monuments historiques

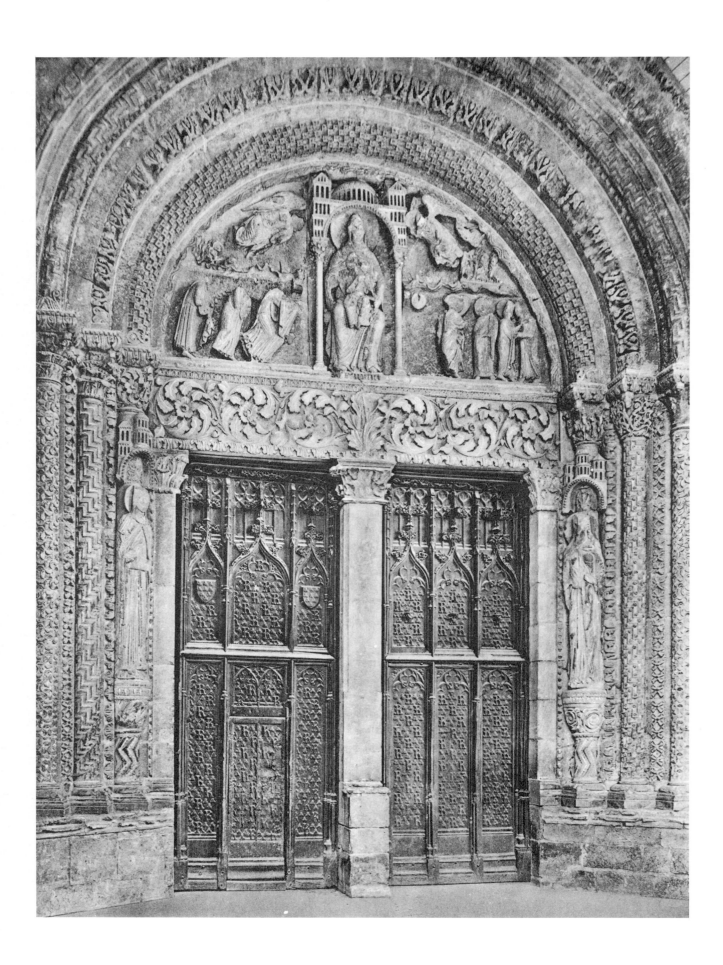

31

ANGERS (Maine-et-Loire). CATHEDRAL
West Door

Tympanum: Christ in Majesty between the Symbols of the
Evangelists. *Arch-rims:* Angels; Elders of the Apocalypse.
Pillars: Personages from the Old Testament.

1150-1165

Photo Neurdein

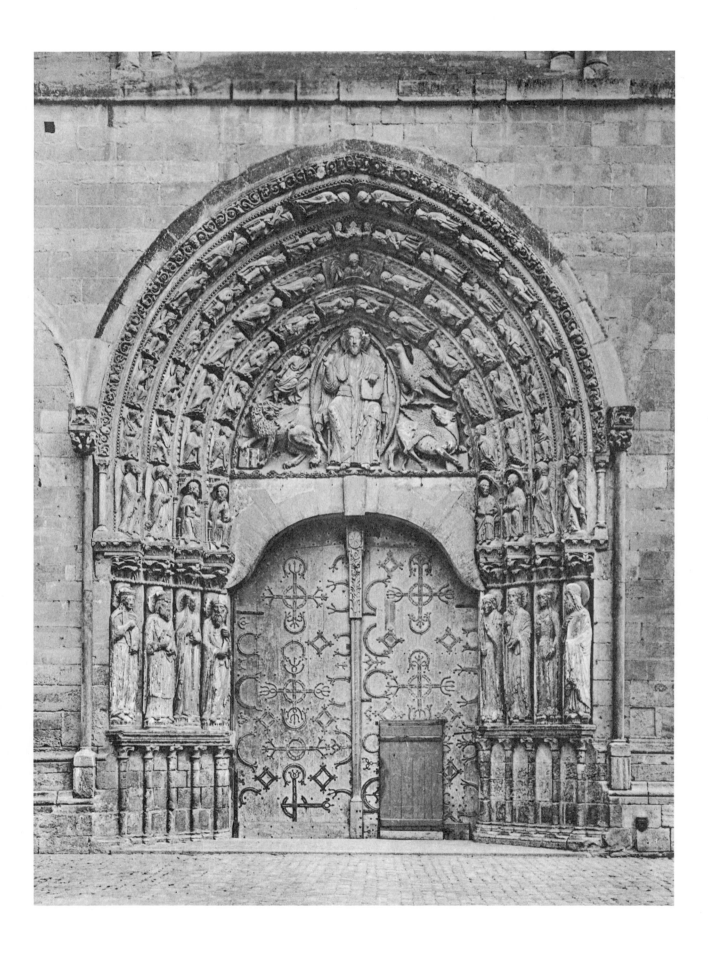

32

ANGERS (Maine-et-Loire). CATHEDRAL
West Door

Right splaying, Details: Personages from the Old Testament.
1155-1165
Photo E. Lefèvre-Pontalis

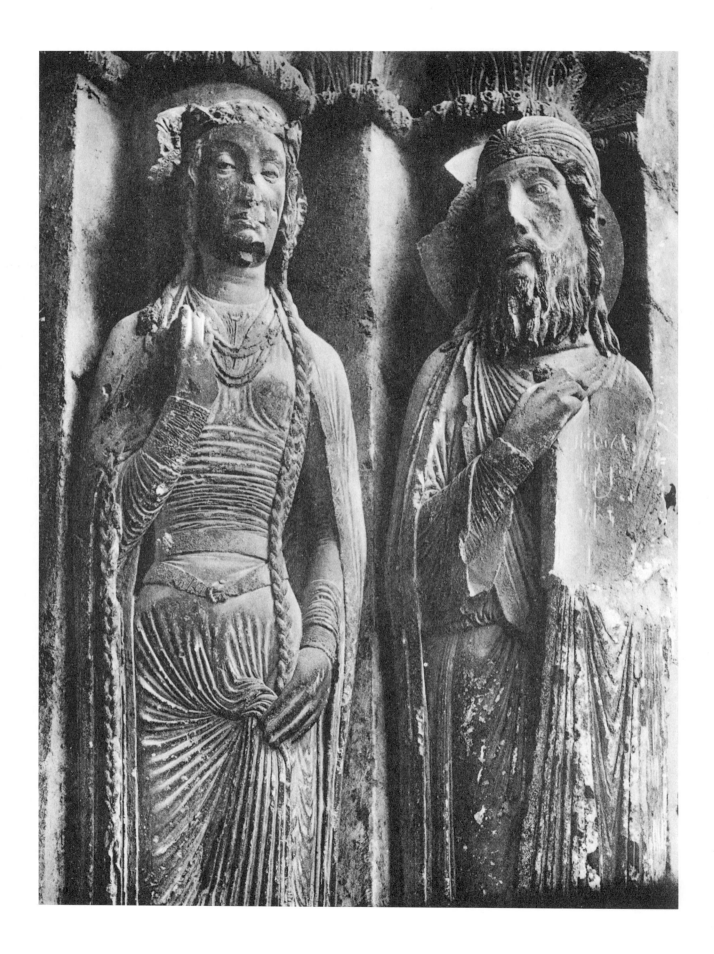

33

PROVINS (Seine-et-Marne). CHURCH OF ST.-AYOUL
West Door

A. *Tympanum:* Christ in Majesty between the Symbols of the Evangelists. *Arch-rims:* Angels, Elders of the Apocalypse, Scenes from Paradise and Hell.

1170-1180

B. *Right splaying:* Personages from the Old Testament.

1155-1160

Photo Monuments historiques

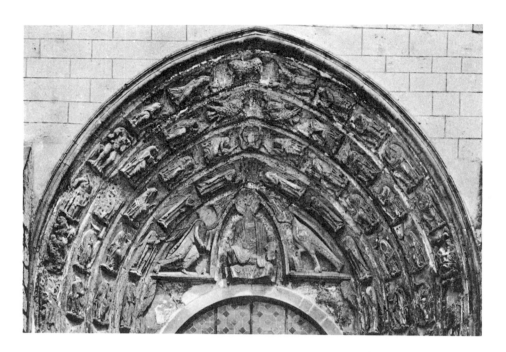

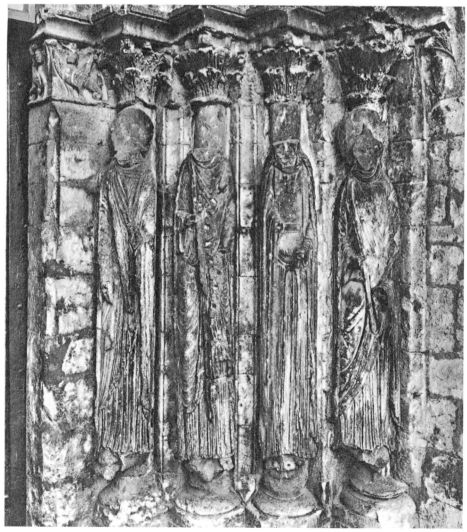

34

SAINT-LOUP-DE-NAUD (Seine-et-Marne).
PARISH CHURCH
West Door

Tympanum: Christ in Majesty between the Symbols of the Evangelists. *Lintel:* Virgin and Apostles. *Arch-rims:* Scenes from the life of the Virgin and the history of St. Loup.

Pier: St. Loup. *Pillars:* Personages from the Old Testament, St. Peter and St. Paul.

1165-1170
Photo E. Lefèvre-Pontalis

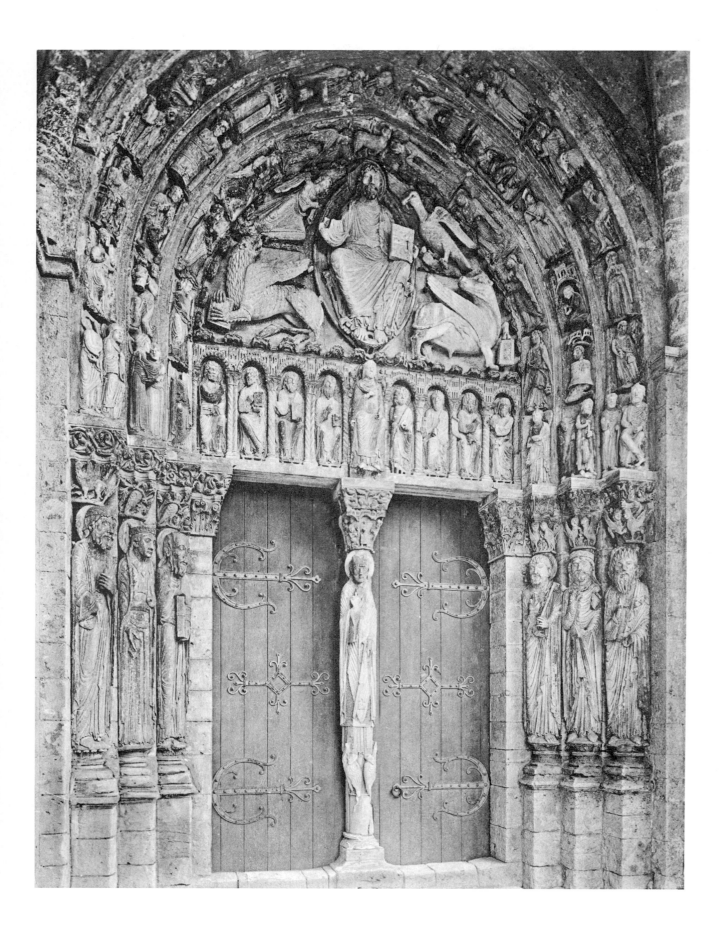

35

SAINT-LOUP-DE-NAUD (Seine-et-Marne).
PARISH CHURCH
West Door

Tympanum: Christ in Majesty between the Symbols of the Evangelists. *Lintel:* Virgin and Apostles. *Arch-rims:* Angels, Scenes from the history of St. Loup; to the left, Annunciation and Visitation.

1165-1170
Photo Monuments historiques

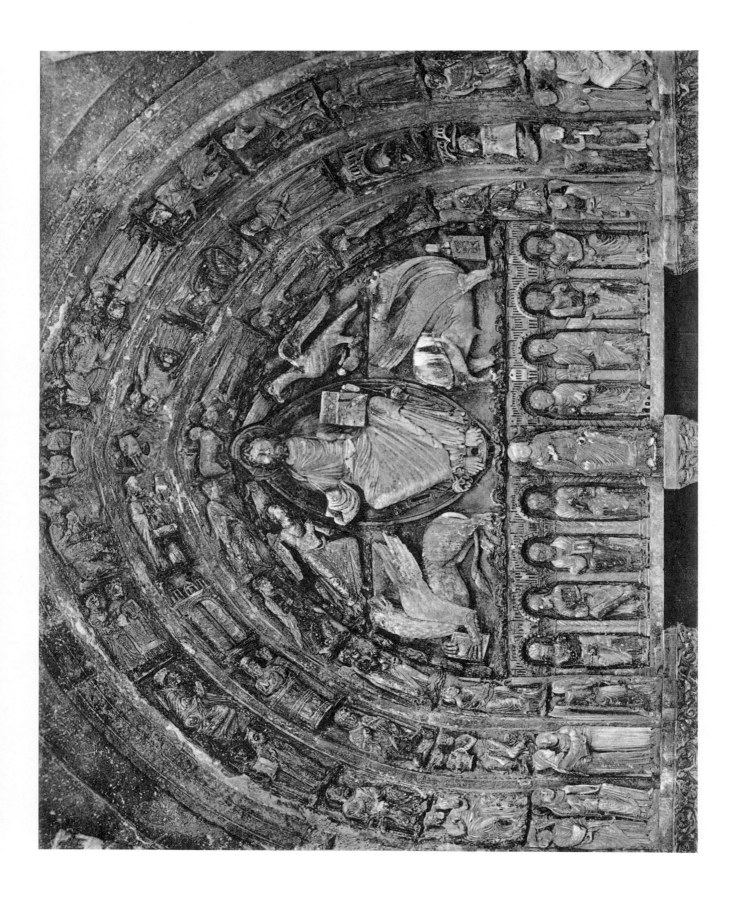

36
SAINT-LOUP-DE-NAUD (Seine-et-Marne).
PARISH CHURCH
West Door
Left splaying: Personages from the Old Testament, St. Paul.
1165-1170
Photo Monuments historiques

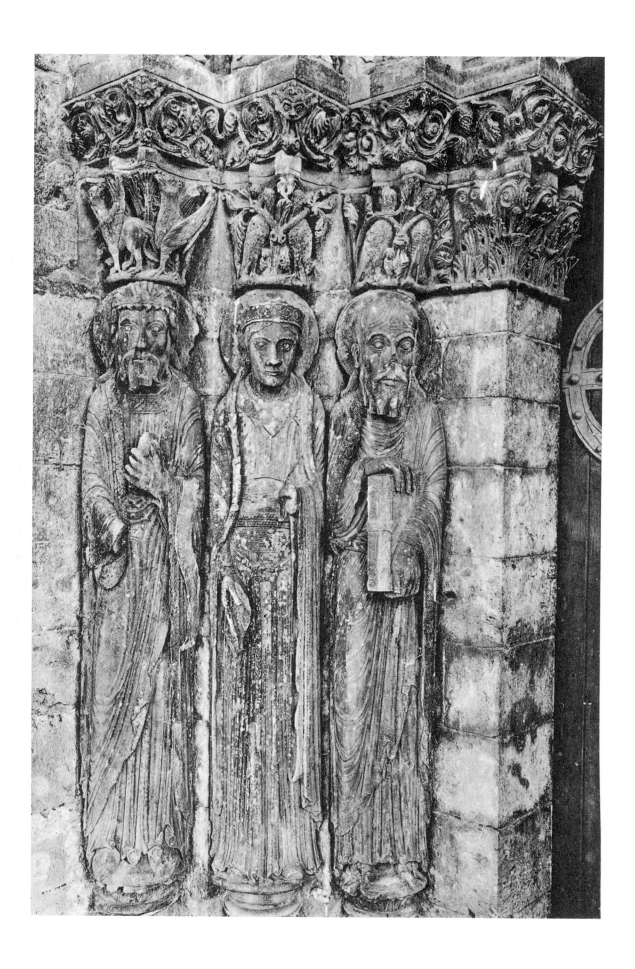

37

SAINT-LOUP-DE-NAUD (Seine-et-Marne). CHURCH
West Door
Detail of the Pier: Head of St. Loup.
1165-1170
Photo E. Lefèvre-Pontalis

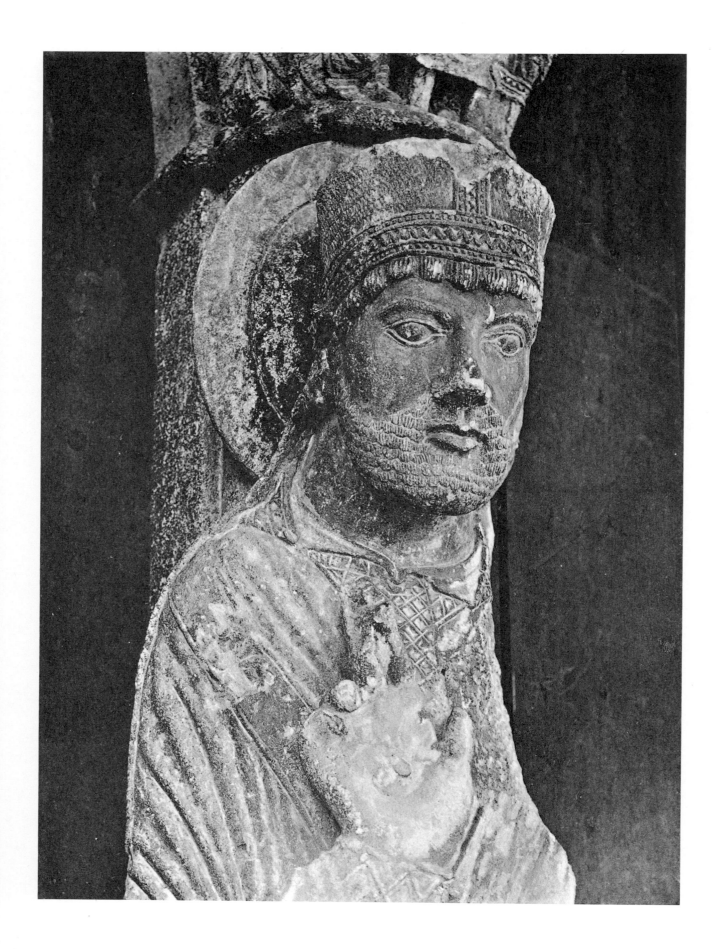

38

A. NESLE-LA-REPOSTE (Marne). ABBEY CHURCH
West Front. Central Door
Splaying, Engraving of *Monumens de la Monarchie Françoise*,
by Montfaucon, I, pl. 15.
THIRD QUARTER OF XII CENTURY

B. PARIS (Seine). SAINT-GERMAIN-DES-PRÉS
West Front. Door
Splayings, Engraving of *Monumens de la Monarchie Françoise*,
by Montfaucon, I, pl. 7:
Personages from the Old Testament.
ABOUT 1163

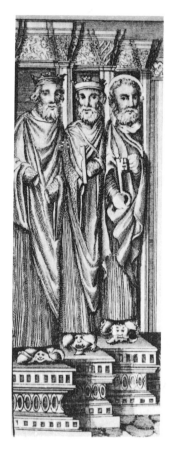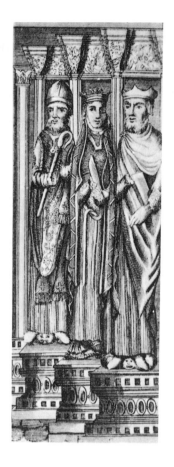

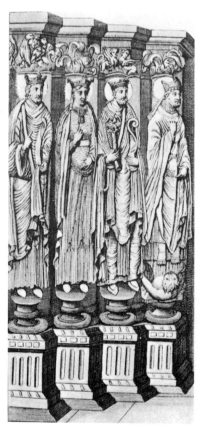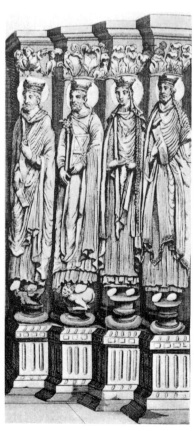

39

CORBEIL (Seine-et-Oise). NOTRE-DAME
West Door

Statues, now in the Louvre, Paris (Catal. 1922, Nos. 50-51)
A. King Solomon. B. Queen of Sheba.
ABOUT 1180
Photo Giraudon

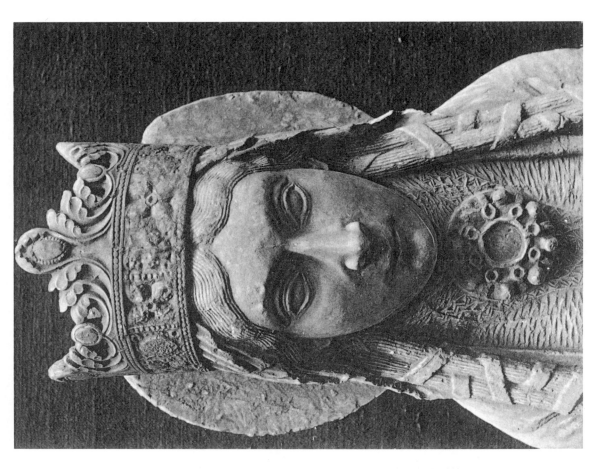

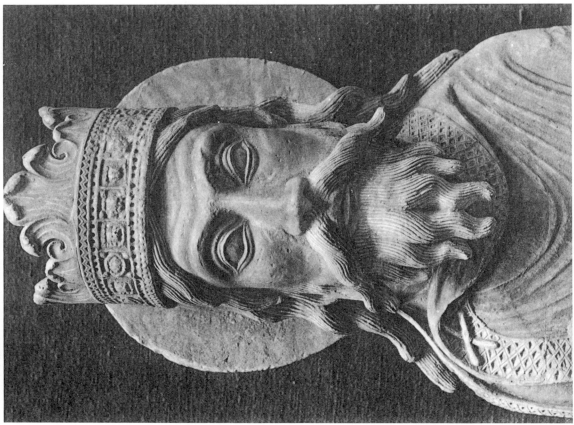

LAON (Aisne). CATHEDRAL
WEST FRONT. RIGHT DOOR

Tympanum: The Last Judgment. *Arch-rims:* The Blessed, Angels,
wise and foolish virgins.

ABOUT 1165-1170
Photo Monuments historiques

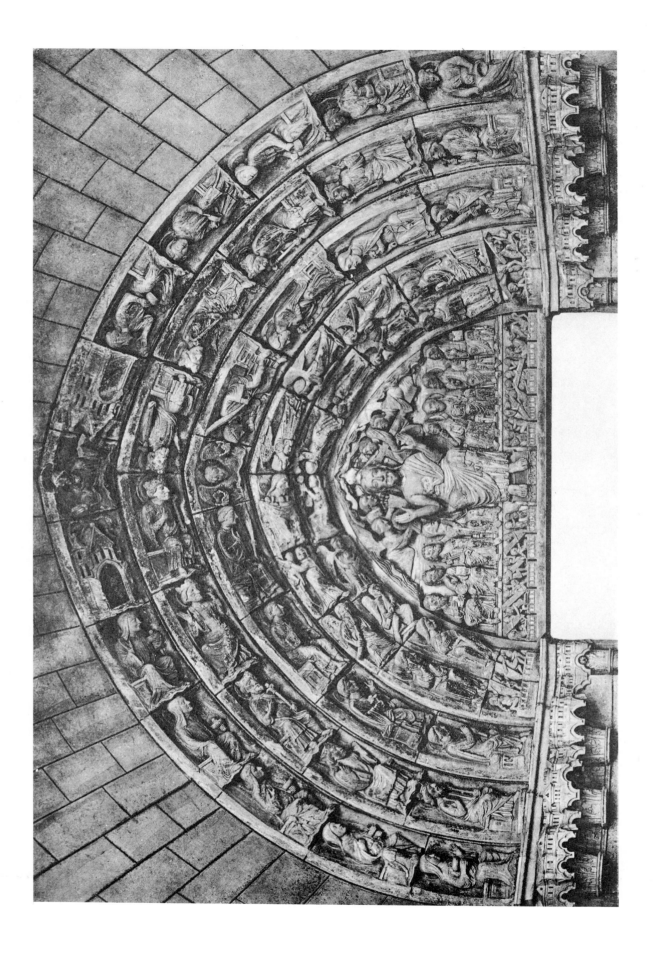

41

PARIS (Seine). CATHEDRAL
West Front. Right Door

Tympanum: Virgin in Majesty between two angels, Louis VII, Maurice de Sully and a clerk. *Second lintel:* Annunciation, Visitation, Nativity, Annunciation to the Shepherds, the Magi and Herod. *Arch-rims:* Angels, Elders of the Apocalypse, Personages from the Old Testament.

ABOUT 1165-1170

Photo Monuments historiques

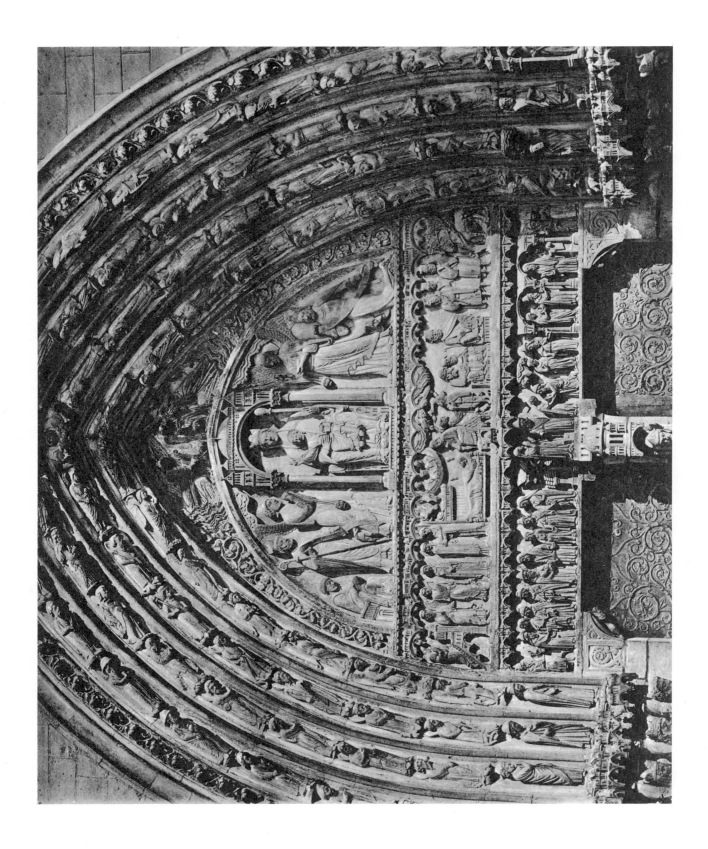

42

PARIS (Seine). CATHEDRAL
WEST FRONT. RIGHT DOOR

Tympanum, Details: A. Annunciation. B. Virgin in Majesty.
Cast of the Trocadero Museum, Paris
ABOUT 1165-1170
Photo Martin-Sabon (Archives d'Art et d'Histoire)

43

RHEIMS (Marne). CATHEDRAL
North Front. Right Door
Tympanum: Virgin in Majesty.
LATTER HALF OF XII CENTURY
Photo Doucet

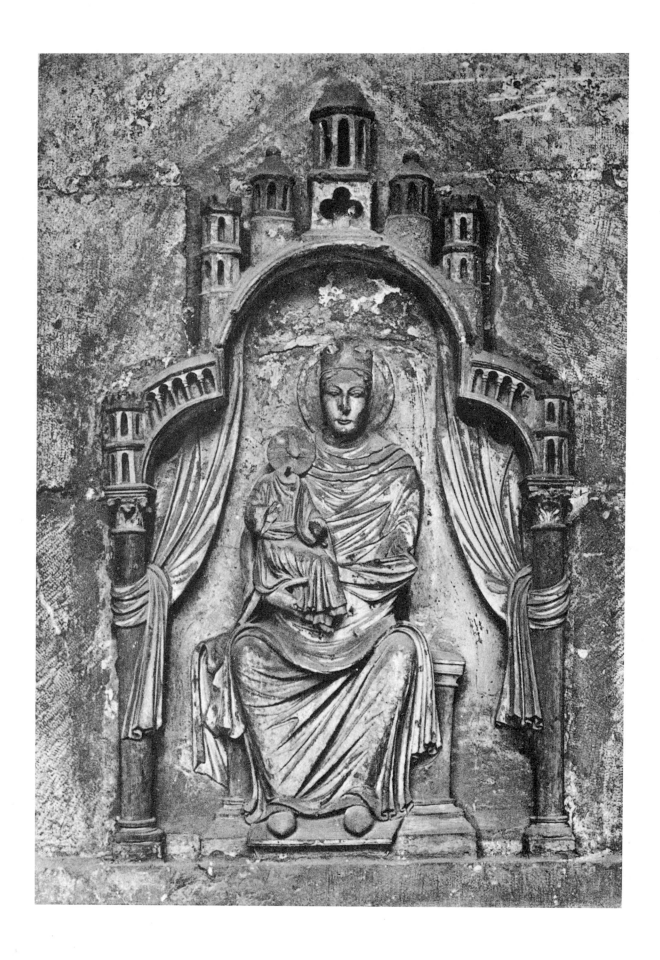

44

A. PARIS (Seine). ST. MARTIN-DES-CHAMPS
Virgin, wooden statuette, now at St. Denis.
LATTER HALF OF XII CENTURY
Photo Giraudon

B. GASSICOURT (Seine-et-Oise). CHURCH
Virgin, wooden statuette.
BEGINNING OF XIII CENTURY
Photo Monuments historiques

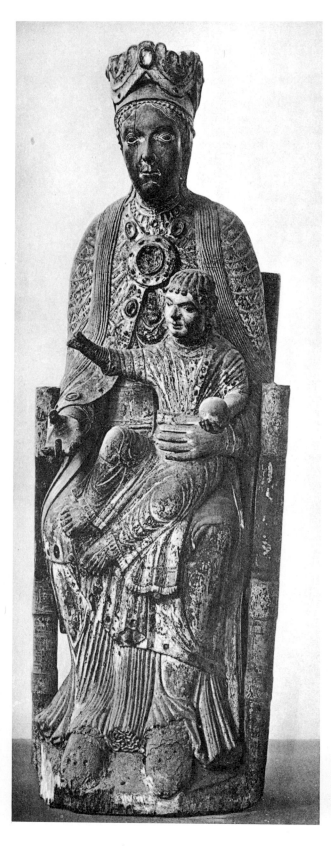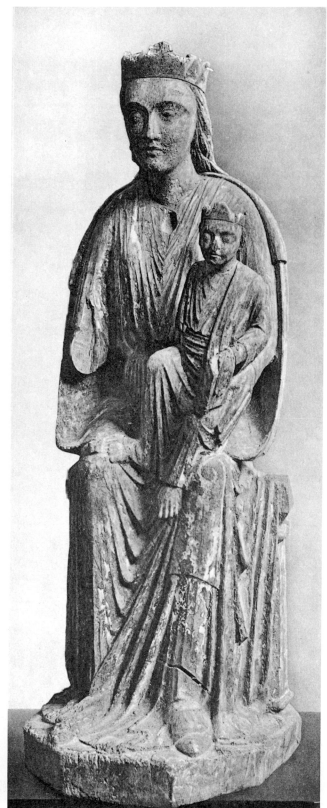

45

BOURG-ARGENTAL (Loire). CHURCH
Door

Tympanum: Christ in Majesty between the Symbols of the Evangelists. *Lintel:* Magi, Nativity, Visitation, Annunciation.

LATTER HALF OF XII CENTURY
Photo Monuments historiques

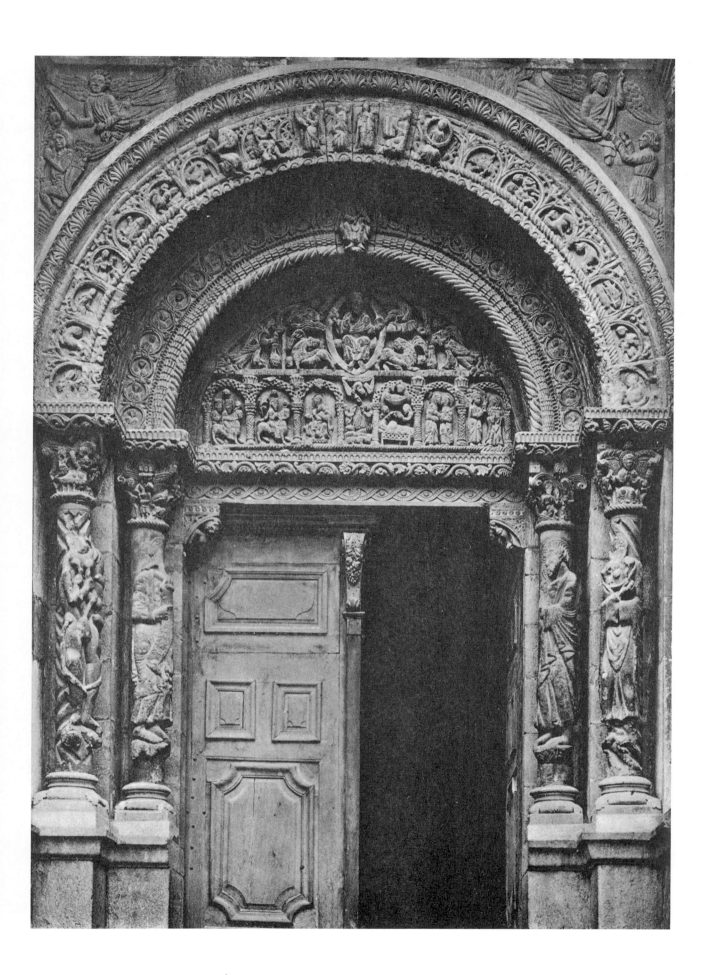

46

A. VERMENTON (Yonne). PARISH CHURCH
West Door
Left splaying: Kings.
THIRD QUARTER OF XII CENTURY

B. AUTUN (Saône-et-Loire). CATHEDRAL
St. Martha, Statue from the tomb of St. Lazarus; now in the
Musée lapidaire at Autun.
1170-1189

C. AVALLON (Yonne). CHURCH OF ST. LAZARUS
West Door. Central Arch
Right splaying: Personage from the Old Testament.
THIRD QUARTER OF XII CENTURY
Photo Monuments historiques

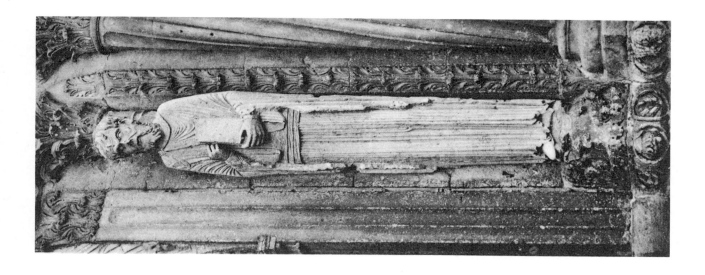

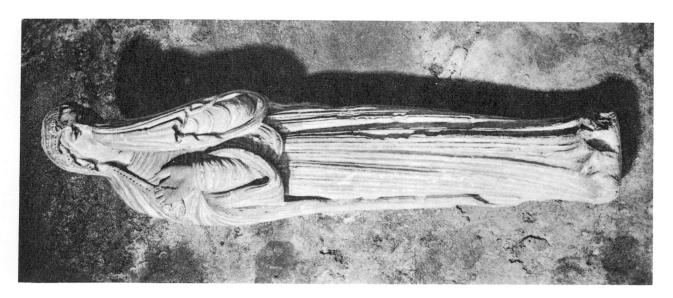

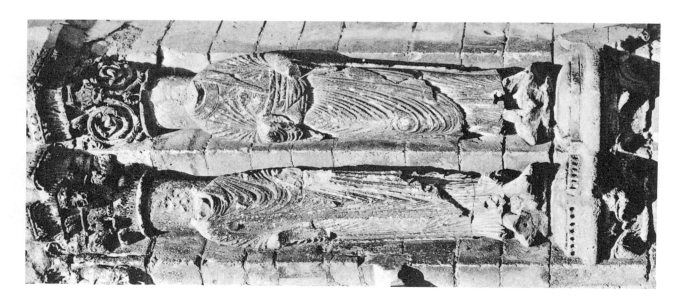

47

AUTUN (Saône-et-Loire). CATHEDRAL
Head of St. Peter from the tomb of St. Lazarus, now in the
Louvre Museum, Paris.
1170-1189
Photo Archives d'Art et d'Histoire

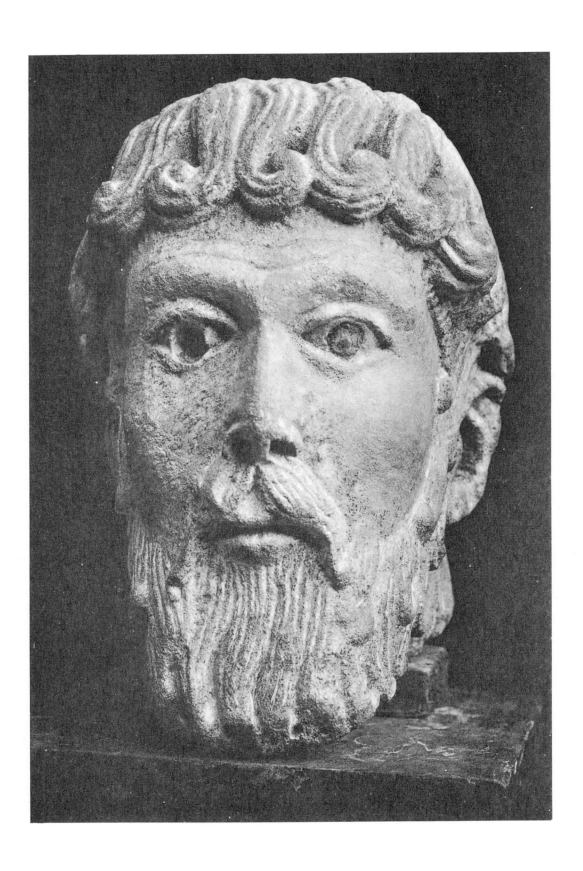

48

ST. GILLES (Gard). ABBEY CHURCH
West Front

Details of the decoration to the right of the central door.
Large statues: Apostles
1160-1170
Frieze: Condemnation of Christ, Flagellation, Christ's carrying
of the Cross.
END OF XII CENTURY
Photo Monuments historiques

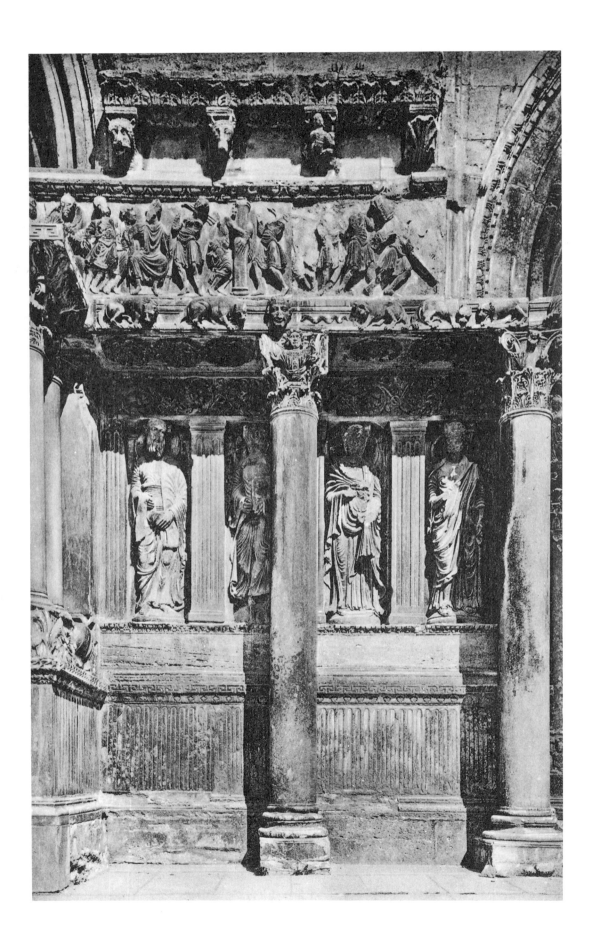

49

ST. GILLES (Gard). ABBEY CHURCH
West Front. Left Door
Tympanum: Adoration of the Magi, Joseph's dream.
Lintel: Entry into Jerusalem.
END OF XII CENTURY
Photo Monuments historiques

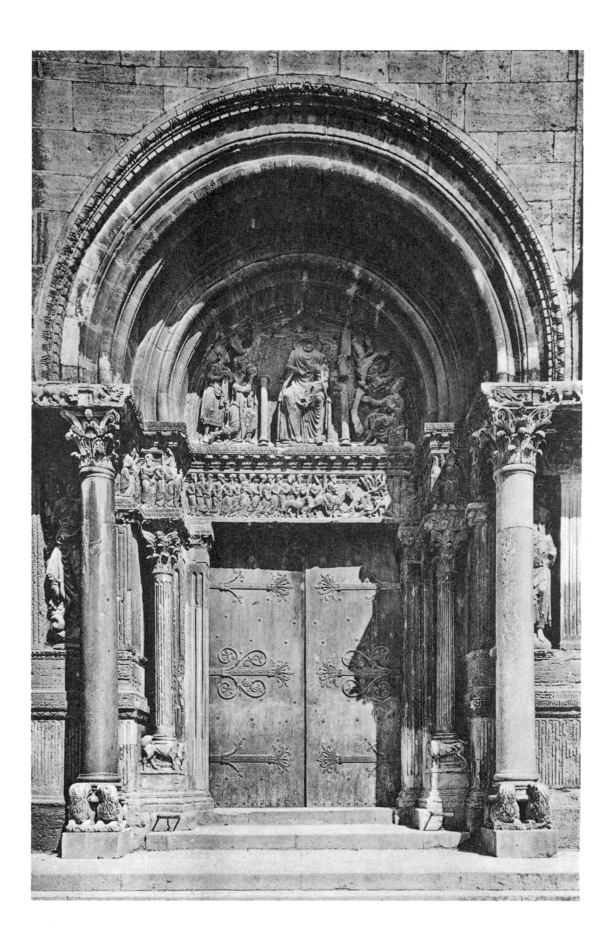

50

A. ST.-GILLES (GARD). ABBEY CHURCH
WEST FRONT. CENTRAL DOOR
Splaying to the right: St. James and St. Paul.
1160-1170

B. ROMANS (DRôME). CHURCH OF ST.-BARNARD
WEST DOOR
Splaying to the left: Apostles.
1170-1180
Photo Monuments historiques

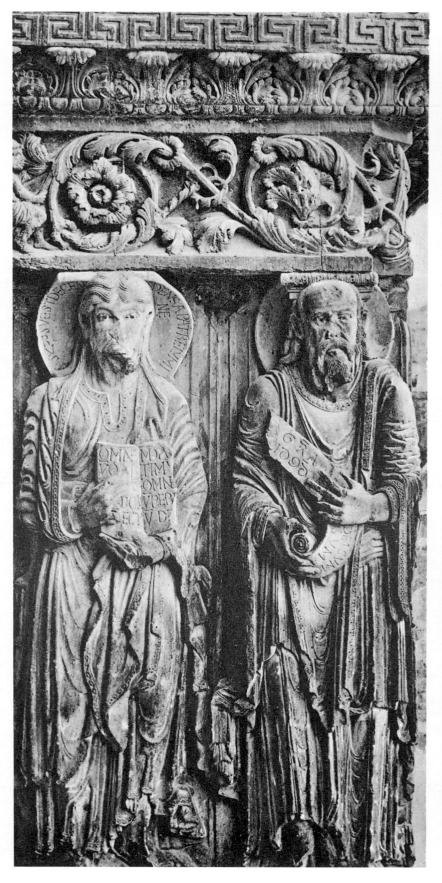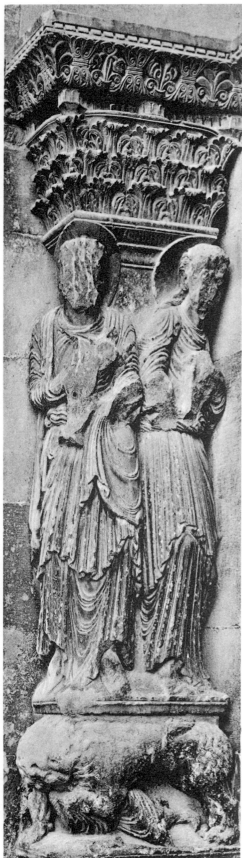

5I

ARLES (Bouches-du-Rhône). CHURCH OF ST. TROPHIME
West Door. Right Side

Large statues: Apostles. In the middle, Martyrdom of St. Stephen.
Frieze: Nativity, Adoration of the Magi, Angel warning the
Magi, Annunciation to the Shepherds. Above, Separation of
the Elect and the Damned.

END OF THE XII CENTURY

Photo Neurdein

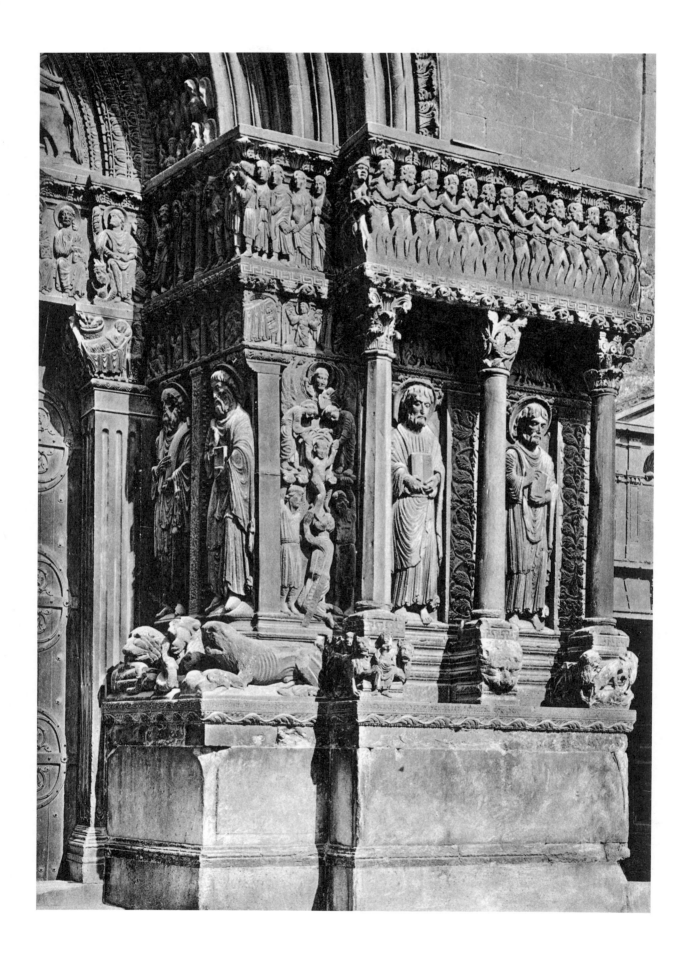

52

A. ARLES (Bouches-du-Rhône). CLOISTER
St. Stephen, statue from column in the North-East corner.
1170-1190
Photo Giraudon

B. VALCABRÈRE (Haute-Garonne). ST. JUST
North Door
Left splaying: St. Just and St. Stephen.
ABOUT 1200
Photo E. Lefèvre-Pontalis

C. ST. BERTRAND-DE-COMINGES (Haute-Garonne)
Column from the cloister.
LATTER HALF OF XII CENTURY
Photo Monuments historiques

D. CHAMALIÈRES (Loire). CHURCH
Stoup, ancient column from the cloister.
LATTER HALF OF XII CENTURY
Photo Monuments historiques

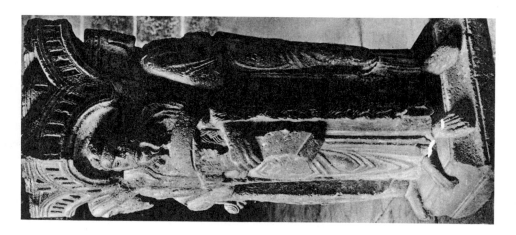

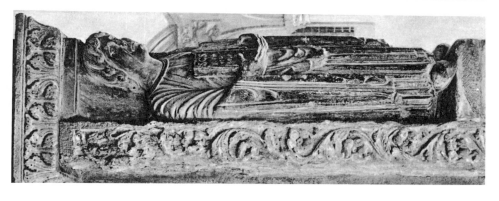

53

A. TOULOUSE (Haute-Garonne). THE LA DAURADE CLOISTER

Door of the chapter hall: Virgin, now in the Musée des Augustins, Toulouse.

BEGINNING OF XIII CENTURY
Photo C. Lassalle

B. TOULOUSE (Haute-Garonne). CHURCH OF THE CORDELIERS

Angel of the Annunciation, now in the Musée des Augustins, Toulouse.

FIRST HALF OF XIII CENTURY
Photo Monuments historiques

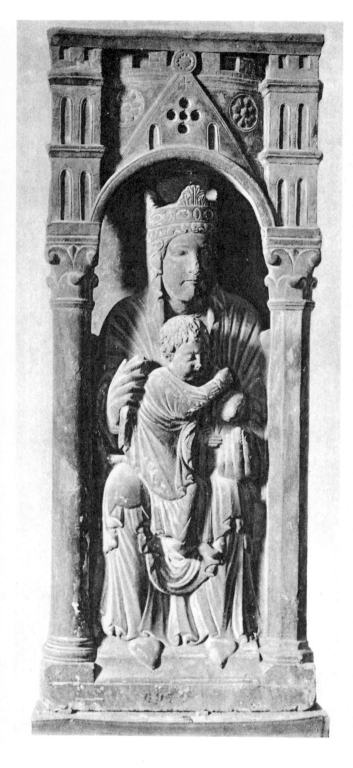 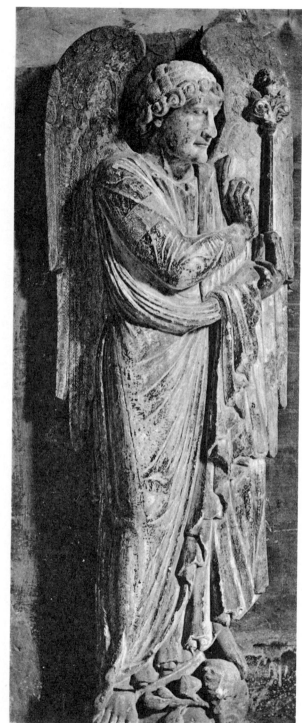

54

SAINT-DENIS (Seine). ABBEY CHURCH
North Door

Right splaying: Statues of kings.
ABOUT 1170-1180
Photo E. Lefèvre-Pontalis

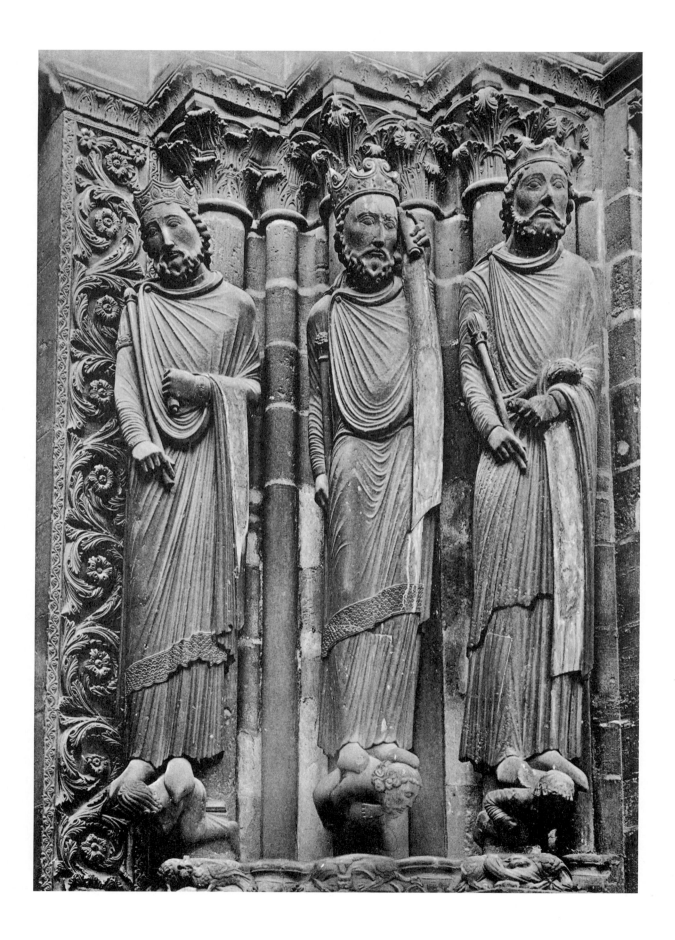

55

SENLIS (OISE). CATHEDRAL
WEST DOOR

Tympanum: Death, Resurrection, Triumph of the Virgin.
Arch-rims: Ancestors of Christ. Personages from the Old
Testament. *Pillars:* Forerunners of Christ.
Basement: Occupations of the Months.

1180-1190

Photo E. Lefèvre-Pontalis

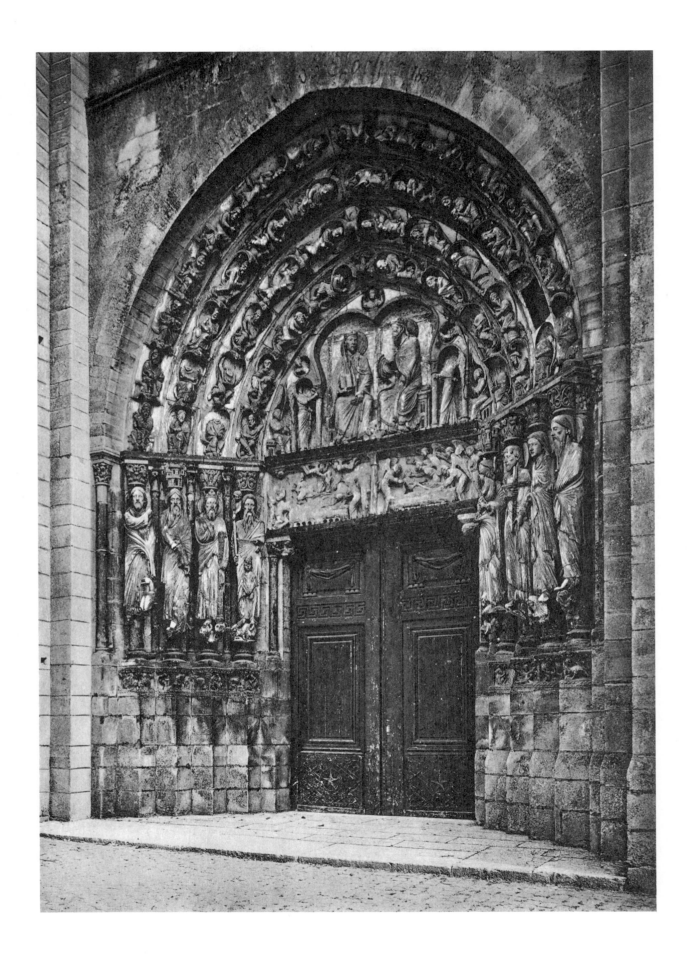

56

SENLIS (Oise). CATHEDRAL
West Door

Tympanum: Death, Resurrection and Triumph of the Virgin.
1180-1190
Photo E. Lefèvre-Pontalis

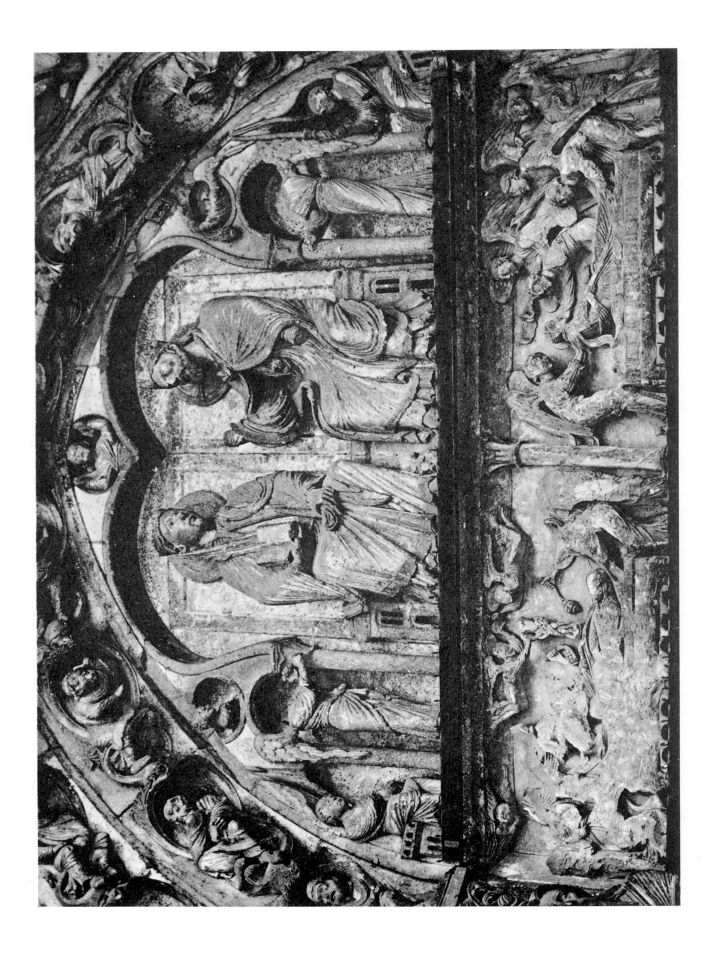

57

SENLIS (OISE). CATHEDRAL
WEST DOOR
Lintel: Resurrection of the Virgin.
1180-1190
Photo E. Lefèvre-Pontalis

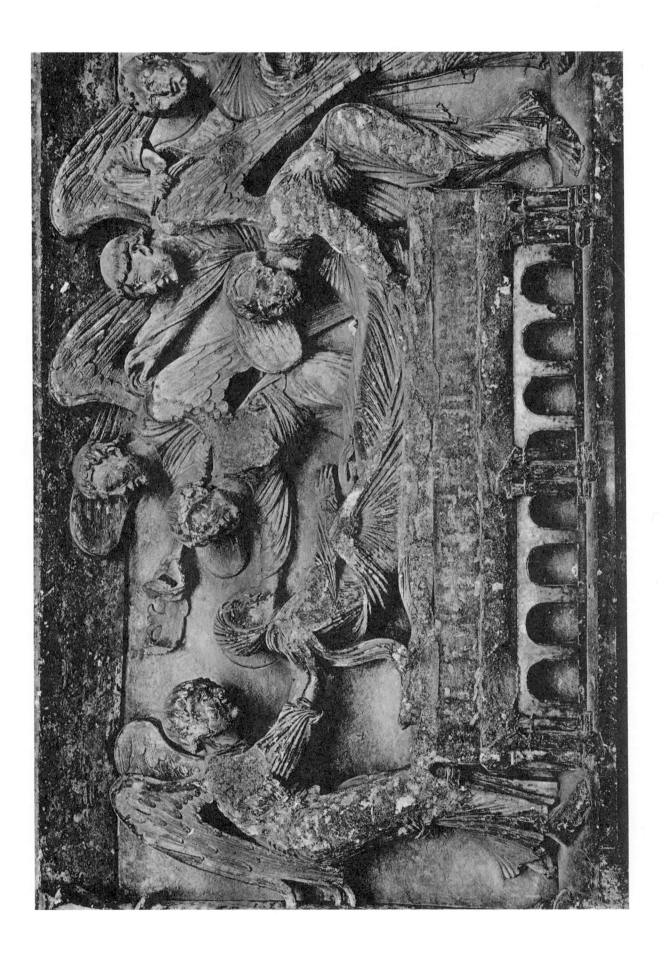

58

SENLIS (Oise). CATHEDRAL

West Door. Details of Splayings

A. Occupations of the Months: February, March. B. Myths.

1180-1190

Photo E. Lefèvre-Pontalis

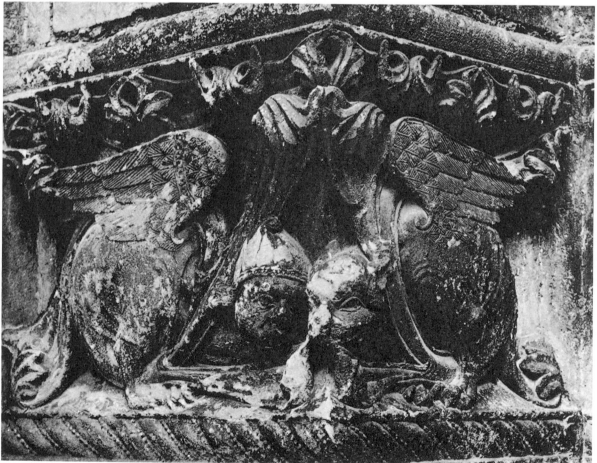

59

SENLIS (Oise). ARCHAEOLOGICAL MUSEUM
Head of prophet from the cathedral.
1180-1190
Photo E. Lefèvre-Pontalis

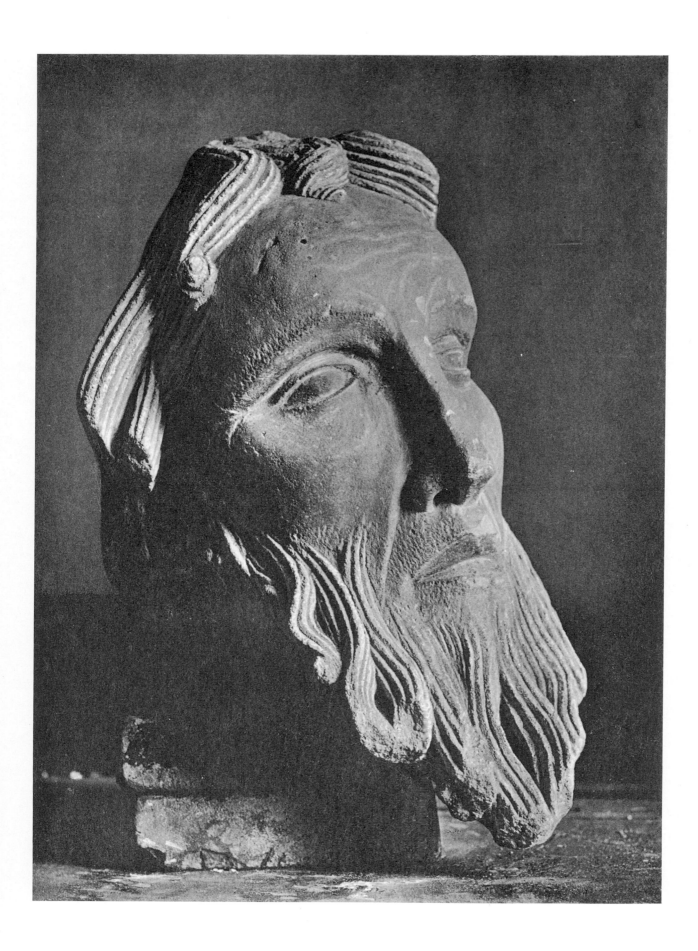

60

MANTES (Seine-et-Oise). COLLEGIATE CHURCH
West Front

A. *Left Door, Tympanum:* Resurrection of Christ.

B. *Central Door, Tympanum:* Death, Resurrection and Triumph
of the Virgin. *Arch-rims:* The Tree of Jesse.

ABOUT 1190-1205
Photo E. Lefèvre-Pontalis

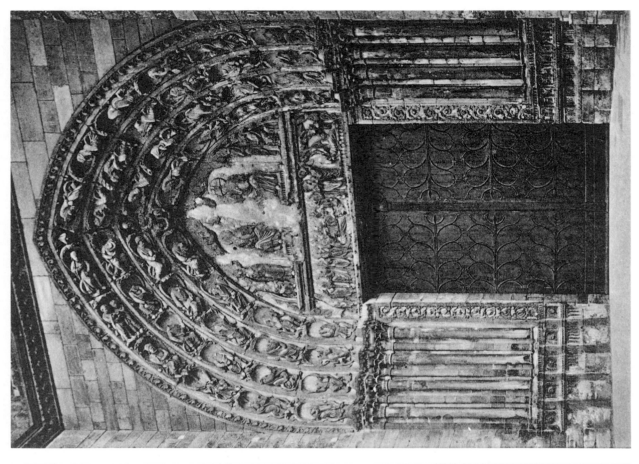

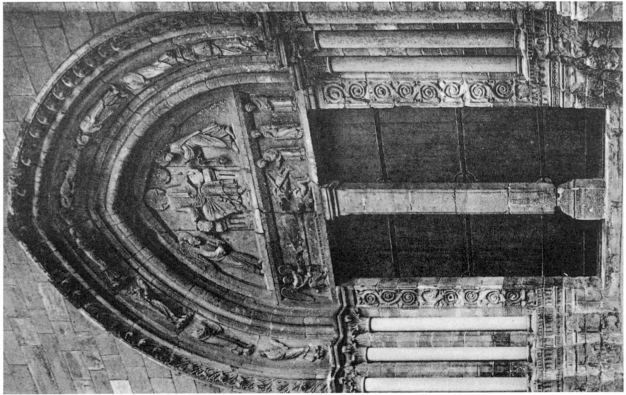

61

MANTES (Seine-et-Oise). COLLEGIATE CHURCH
West Front

Central Door: Tympanum and arch-rims, Details.

A. Fragments of the Tree of Jesse.

B. Details of the Triumph of the Virgin. Below, the Resurrection
of the Virgin.

ABOUT 1190-1205
Photo E. Lefèvre-Pontalis

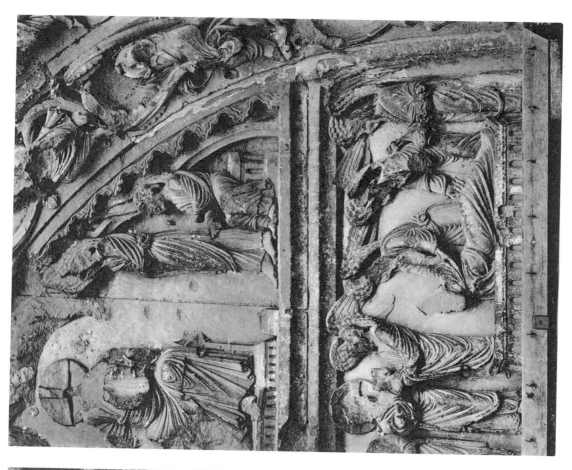

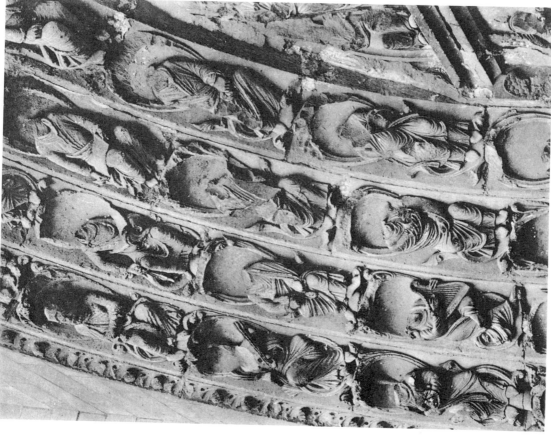

62

SENS (Yonne). CATHEDRAL
West Front. Left Door

A. *Tympanum:* Baptism of Christ. The banquet of Herod.
Beheading of St. John the Baptist.

B. *Splaying:* Liberality.
ABOUT 1195-1210
Photo Monuments historiques

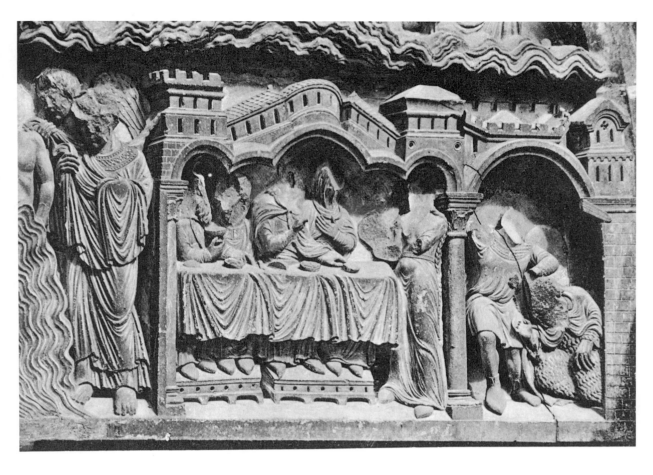

63

SENS (Yonne). CATHEDRAL
West Front. Central Door

A. *Jamb to the left:* Wise virgin.

B. *Jamb to the right:* Foolish virgin.
C.-D. *Left skirting, details:* Fight of man with bear.
Grammar.

ABOUT 1195-1210
Photo Monuments historiques

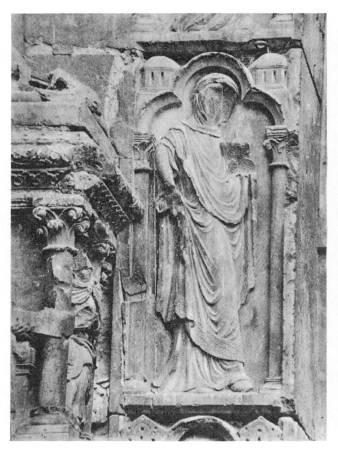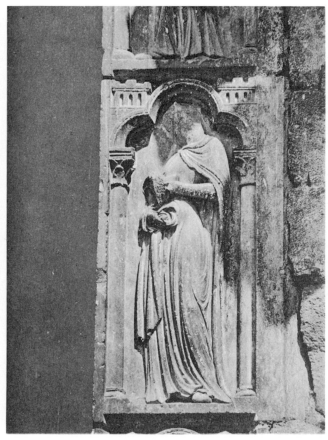
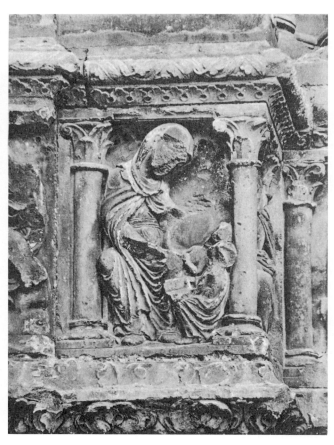

64

A. SAINT-PIERRE-LE-MOUTIER (Nièvre). CHURCH
North Door

Tympanum: Christ surrounded by the four Evangelists.
BEGINNING OF THE XIII CENTURY

B. SAINT-BENOIT-SUR-LOIRE (Loiret). CHURCH
North Door

Tympanum: Christ surrounded by the four Evangelists. *Lintel:*
Discovery and removal of the relics of St. Benedict.
BEGINNING OF THE XIII CENTURY
Photo Monuments historiques

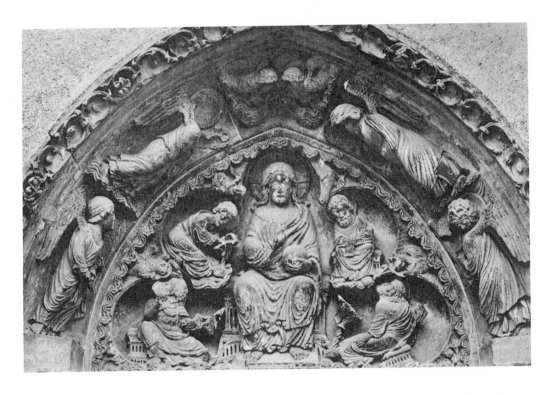

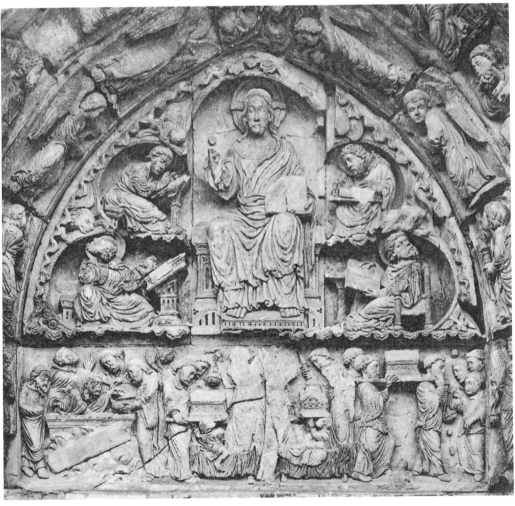

65

LAON (Aisne). CATHEDRAL
WEST FRONT. LEFT DOOR

Tympanum: Annunciation, Visitation, Annunciation to the Shepherds, Adoration of the Magi. *Arch-rims:* Angels, Virtues, Virgins of history.

THE HEADS WERE RESTORED IN THE XIX CENTURY

1200-1210

Photo E. Lefèvre-Pontalis

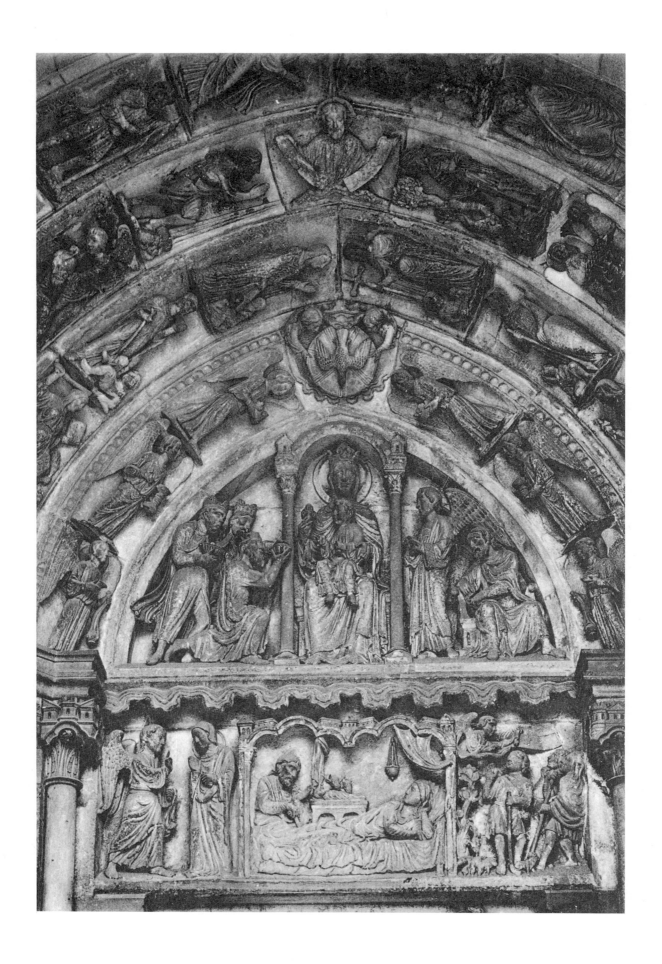

66

CHARTRES (Eure-et-Loir). CATHEDRAL
North Front. Central Door

Tympanum: Death, Resurrection and Triumph of the Virgin.
Arch-rims: Angels, Patriarchs and Prophets.

1200-1210
Photo Giraudon

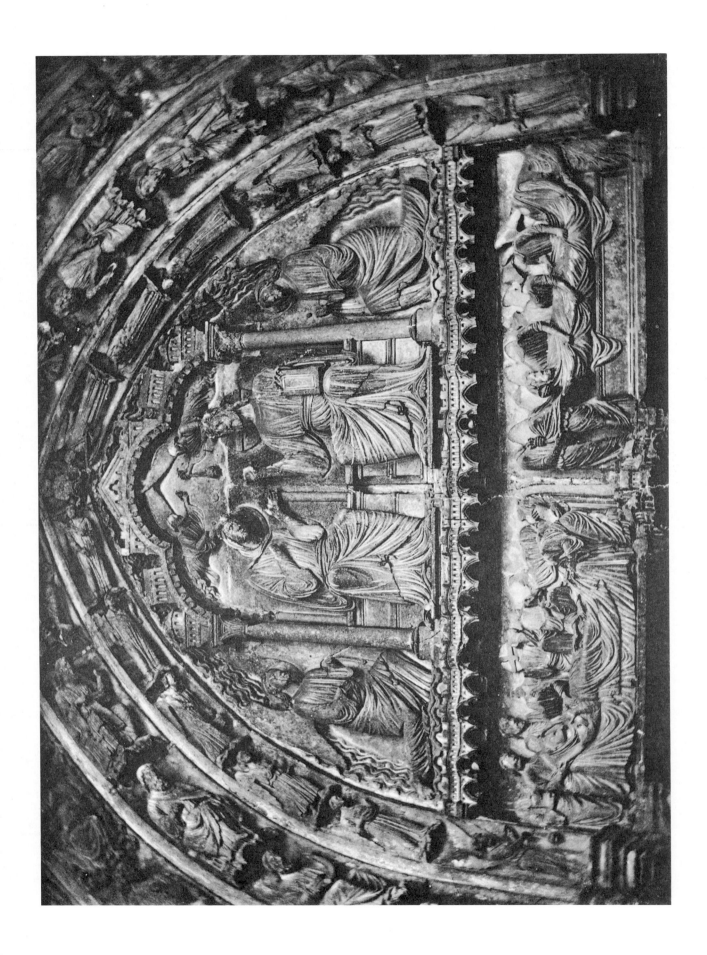

67

CHARTRES (Eure-et-Loir). CATHEDRAL
North Front. Central Door

Pier, Detail: St. Anne carrying the Virgin.

1205-1210

Photo Houvet

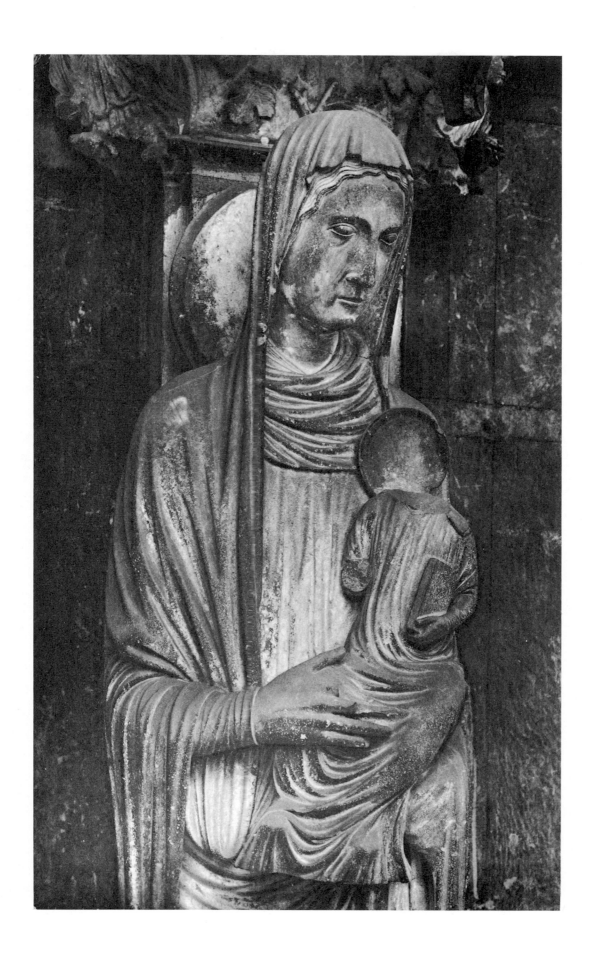

68

CHARTRES (Eure-et-Loir). CATHEDRAL
North Front. Central Door
Left splaying, Detail: Melchisedek, Abraham, Moses.
1200-1210
Photo Houvet

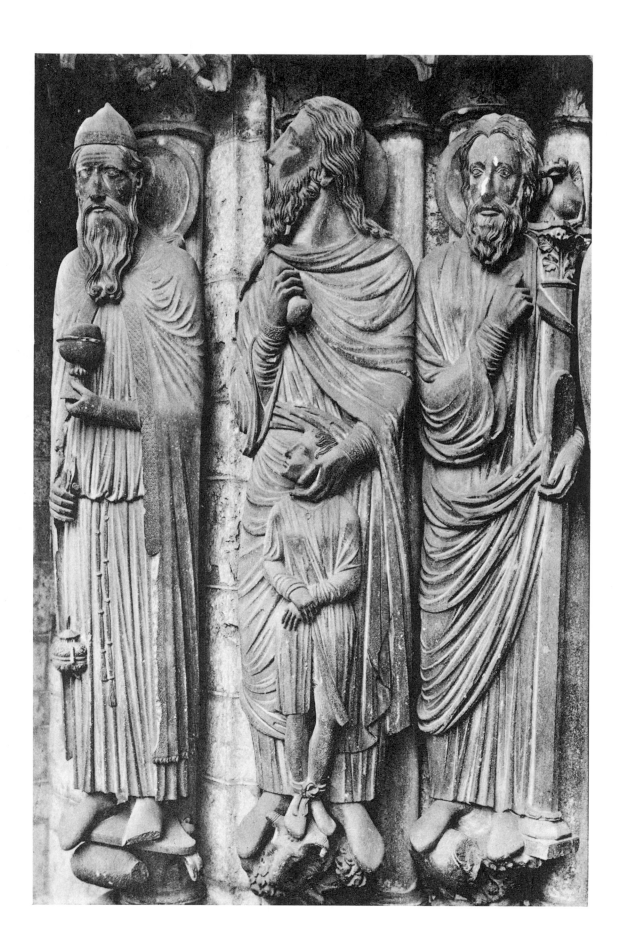

69

CHARTRES (Eure-et-Loir). CATHEDRAL
North Front. Central Door
Splaying to the right: Isaiah, Jeremiah, the aged Simeon.
1210-1215
Photo Monuments historiques

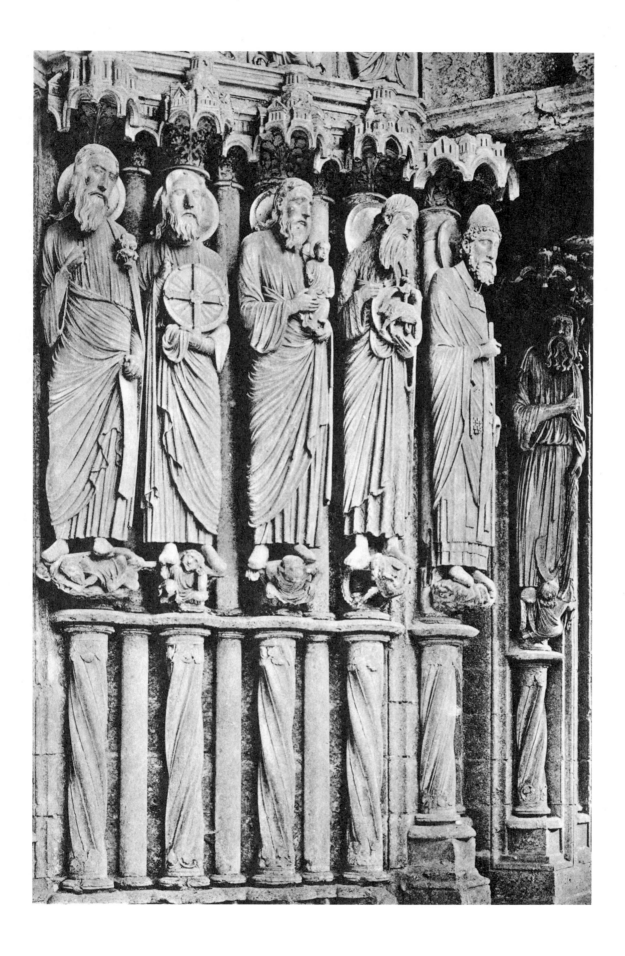

70

CHARTRES (Eure-et-Loir). CATHEDRAL
North Front. Central Door
Splaying to the right, Detail: Head of St. John the Baptist.
1200-1210
Photo Houvet

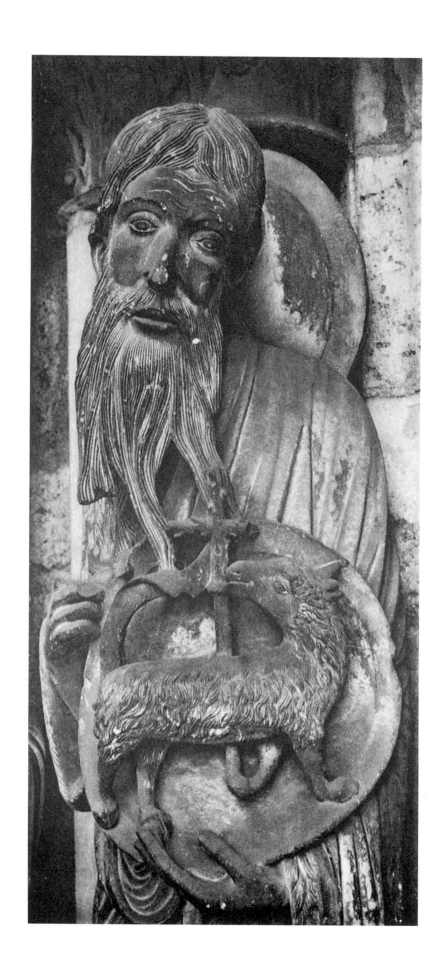

71

RHEIMS (Marne). CATHEDRAL
WEST FRONT. RIGHT DOOR

Right splaying, Detail:
Isaiah, St. John the Baptist, the aged Simeon.

1210-1215
Photo Monuments historiques

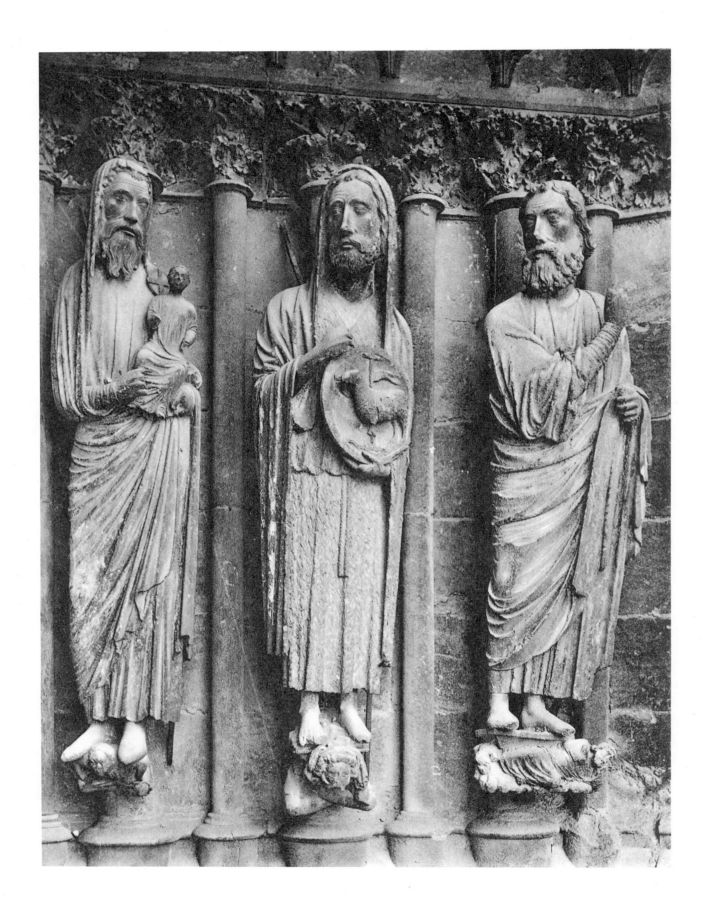

72

BRAISNE (Aisne). CHURCH OF ST. YVED
West Door

Tympanum, Details: Virgin and Christ from the
Triumph of the Virgin.

1205-1216

Photo E. Lefèvre-Pontalis

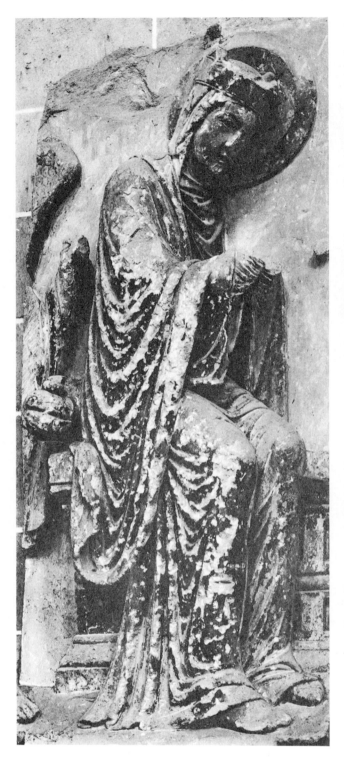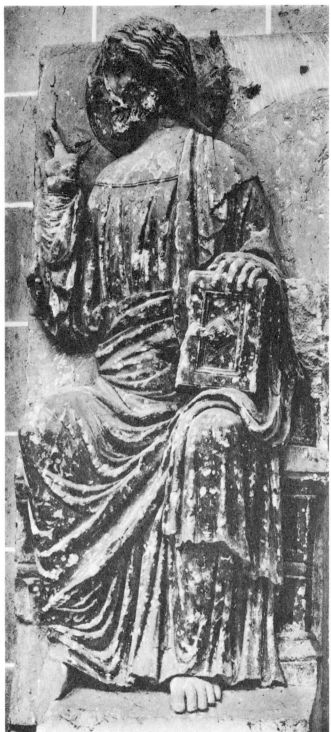

73

BRAISNE (Aisne). CHURCH OF ST. YVED

West Door

Arch-rims, Details: King and Queen from the Tree of Jesse.

1205-1216

Photo E. Lefèvre-Pontalis

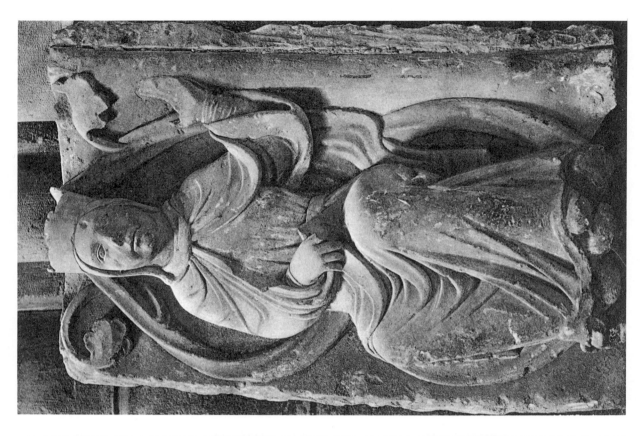

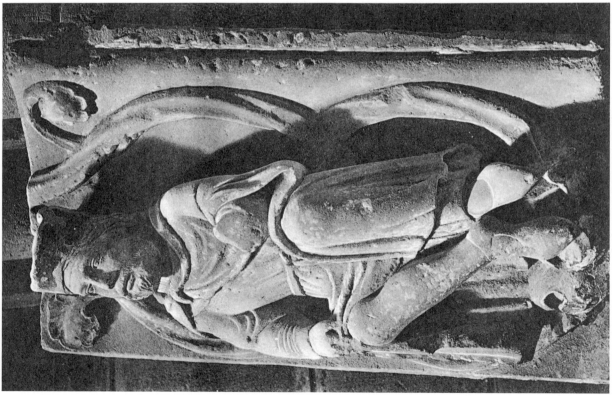

74

CHARTRES (Eure-et-Loir). CATHEDRAL
South Front. Central Door
Tympanum: The Last Judgment.
1205-1215
Photo E. Lefèvre-Pontalis

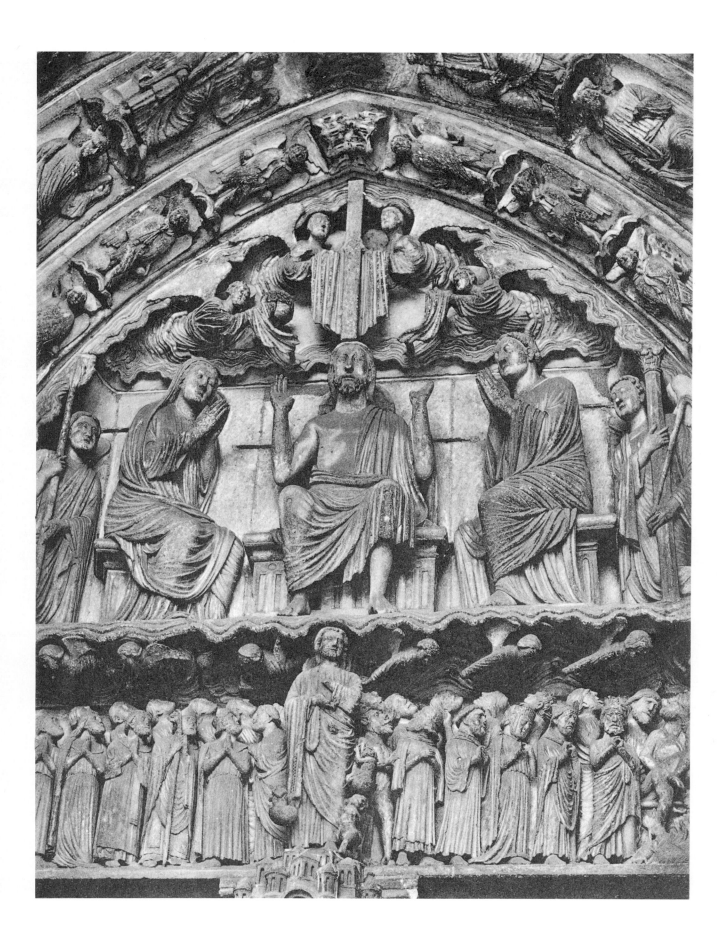

75

CHARTRES (Eure-et-Loir). CATHEDRAL
South Front. Central Door
Arch-rims, Details:
A. Abraham receiving the Elect into his bosom.
B. Demons tormenting the Damned.
1205-1215
Photo Houvet

76

CHARTRES (Eure-et-Loir). CATHEDRAL
South Front. Central Door
Pier: Christ teaching.
1205-1215
Photo Houvet

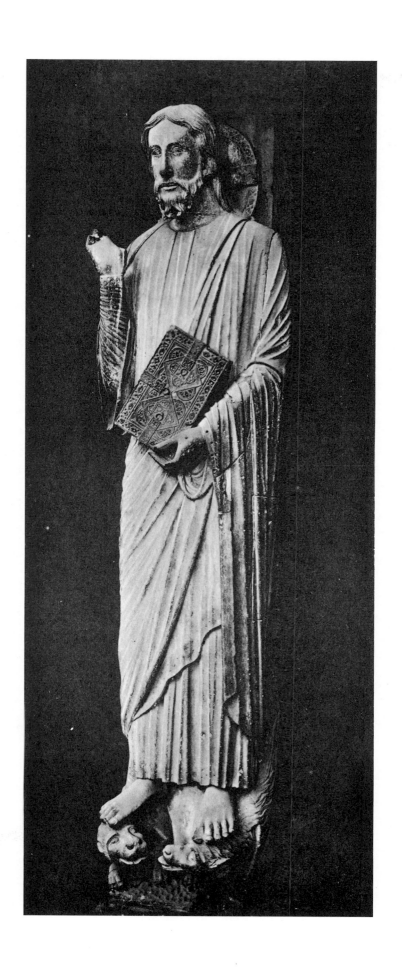

77

CHARTRES (Eure-et-Loir). CATHEDRAL
South Front. Central Door

Right splaying: The Apostles St. Paul, St. John, St. James the
Elder, St. James the Younger, St. Bartholomew.

1205-1215
Photo Houvet

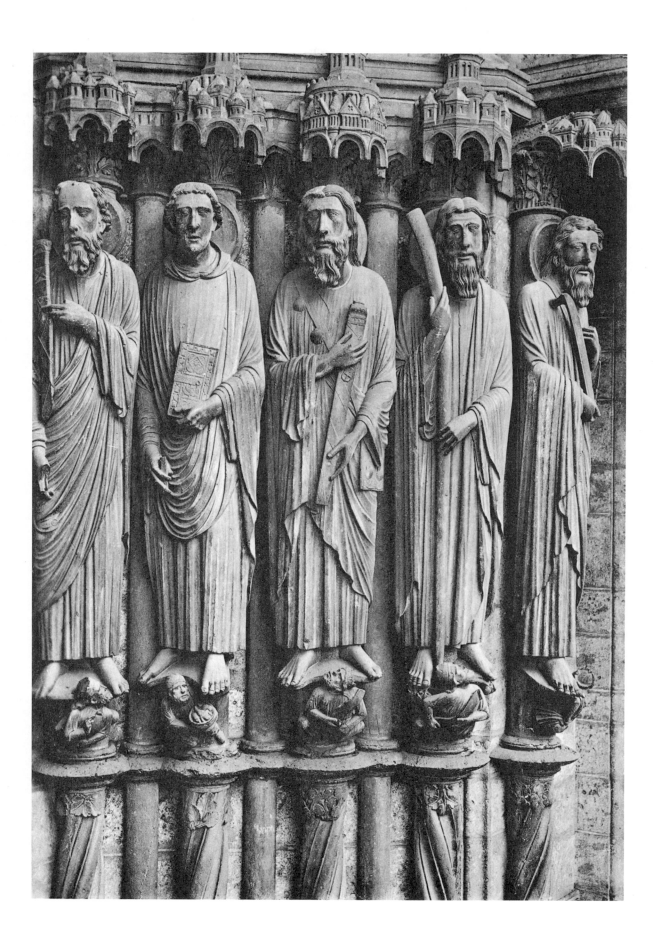

78

A. SENS (Yonne). CATHEDRAL
West Front. Central Door
Pier: St. Stephen.
1195-1210
Photo Monuments historiques

B. CHARTRES (Eure-et-Loir). CATHEDRAL
South Front. Left Door
Splaying to the left: St. Stephen, St. Clement and St. Lawrence.
1215-1220
Photo E. Lefèvre-Pontalis

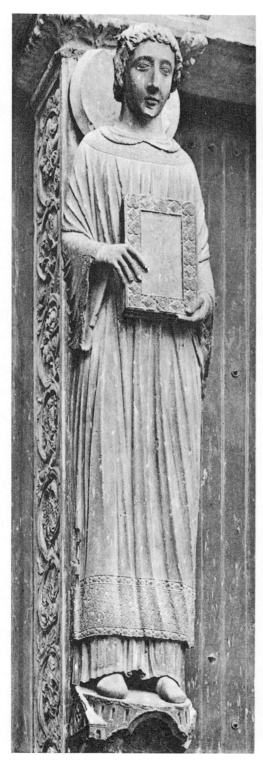
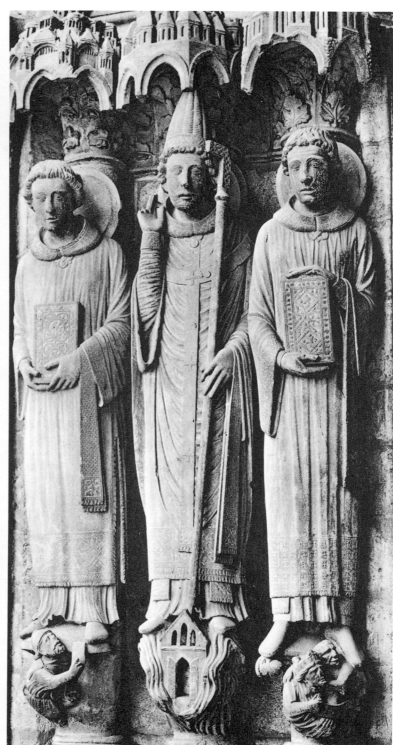

79

CHARTRES (Eure-et-Loir). CATHEDRAL
South Front. Left Door
Right splaying: St. Vincent, St. Denis, St. Piat.
1215-1220
Photo Houvet

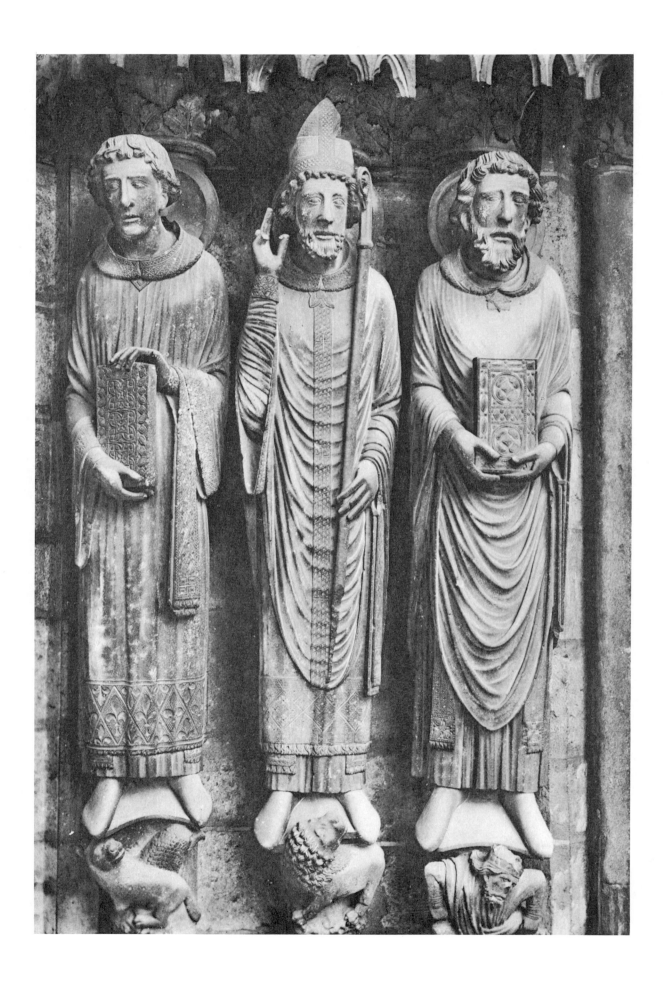

80

CHARTRES (Eure-et-Loir). CATHEDRAL
South Front. Right Door

Tympanum: History of St. Martin and St. Nicholas.

1220-1225
Photo Houvet

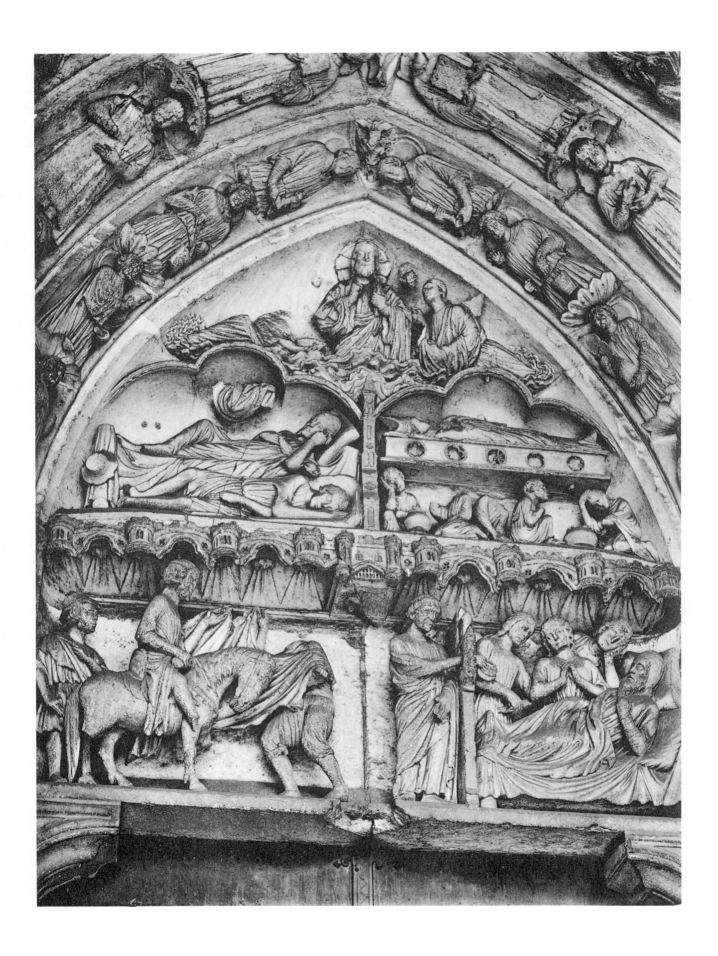

81

CHARTRES (Eure-et-Loir). CATHEDRAL
South Front. Right Door

Arch-rims, left side: The hunt of St. Gilles, Saints confessors.

1220-1225
Photo Houvet

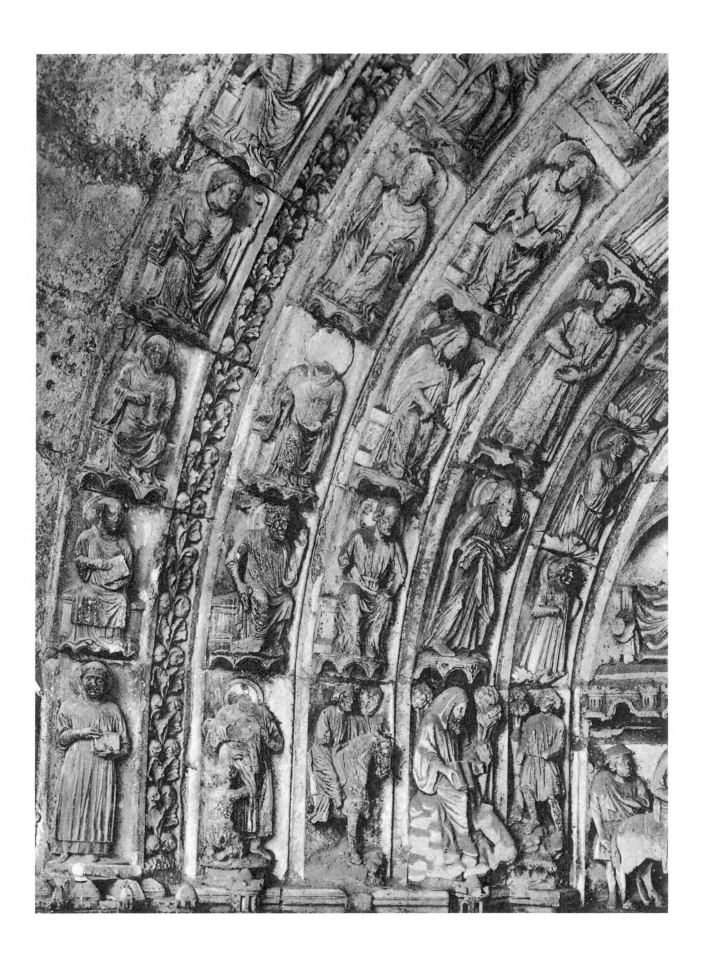

82

CHARTRES (Eure-et-Loir). CATHEDRAL
South Front. Right Door
Left splaying: St. Leon, St. Ambrosius and St. Nicolas.
1220-1225
Photo Houvet

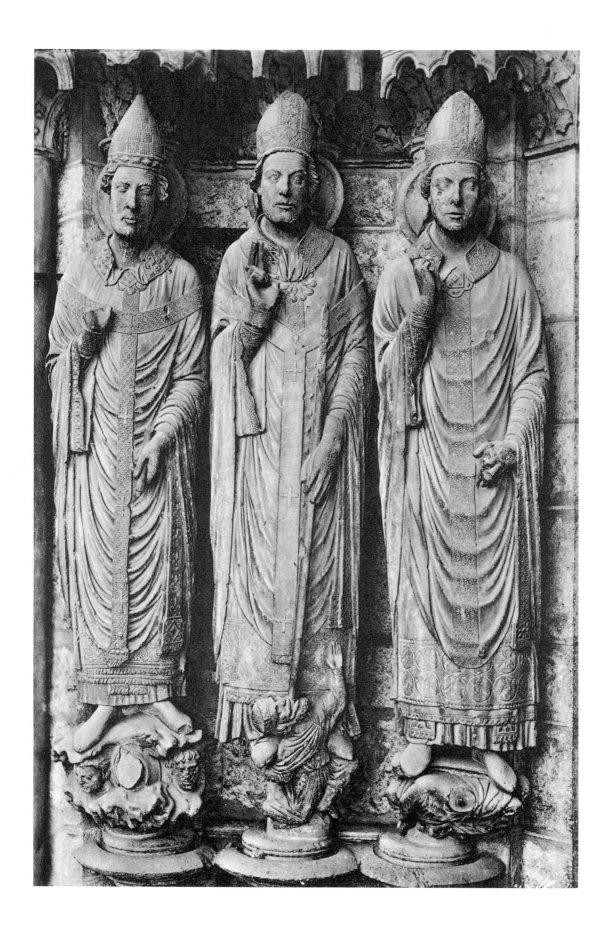

CHARTRES (Eure-et-Loir). CATHEDRAL
South Front. Right Door
Right splaying: St. Martin, St. Jerome and St. Gregory.
1220-1225
Photo Giraudon

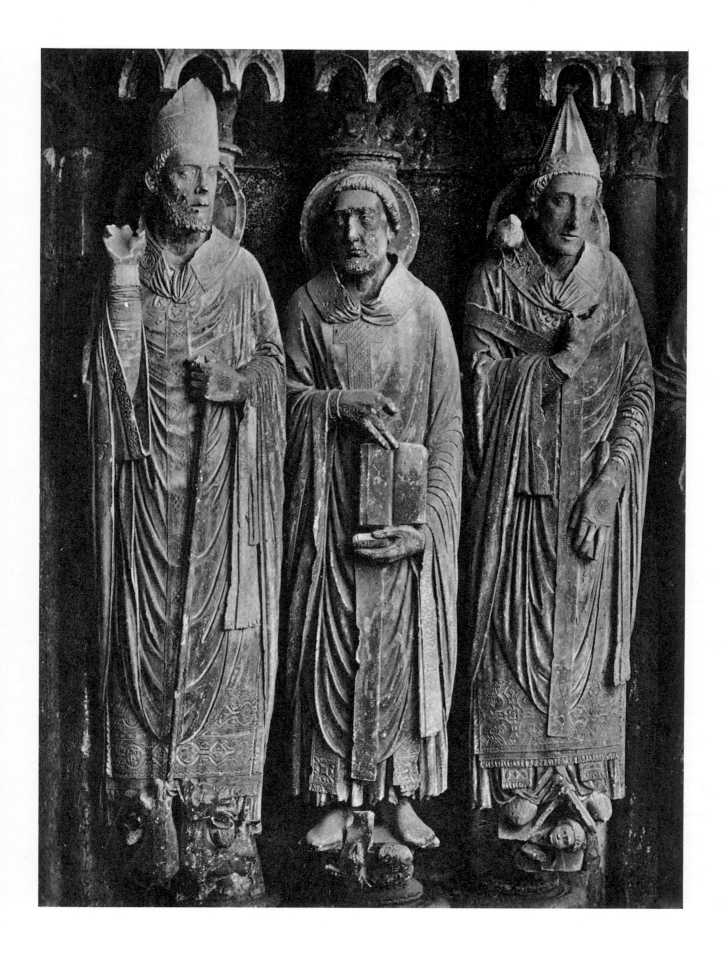

84

CHARTRES (Eure-et-Loir). CATHEDRAL
South Front. Right Door
Right splaying, Detail: St. Gregory.
1220-1225
Photo Houvet

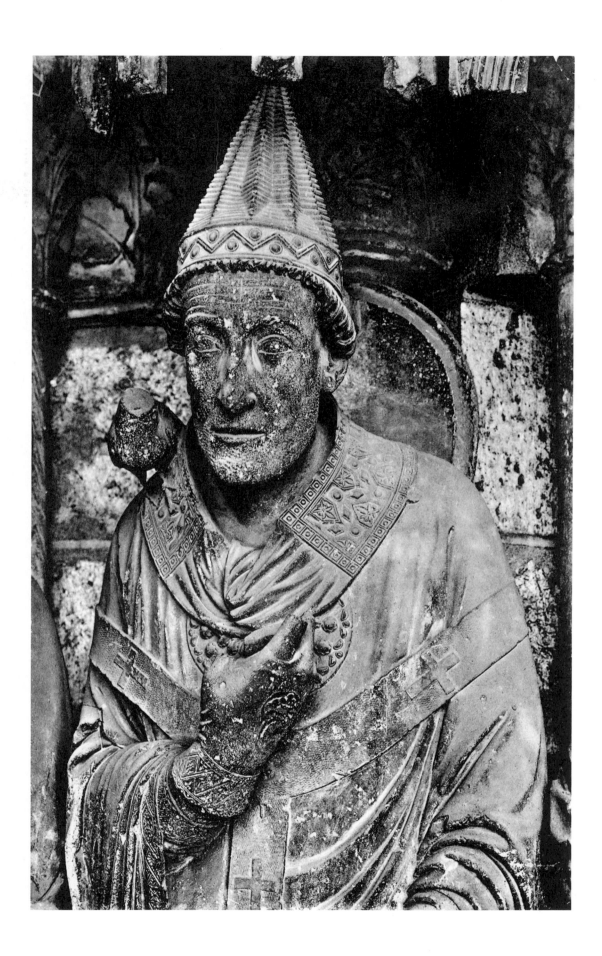

85

CHARTRES (Eure-et-Loir). CATHEDRAL
South Front

A. Central door. *Right splaying, Detail:* St. James the Elder.
1205-1215

B. Door to the left. *Left splaying, Detail:* St. Stephen.
1215-1220

C. Door to the right. *Right splaying, Detail:* St. Jerome.
1220-1225

D. Door to the right. *Left splaying, Detail:* St. Leon
and St. Ambrosius.
1220-1225
Photo E. Lefèvre-Pontalis

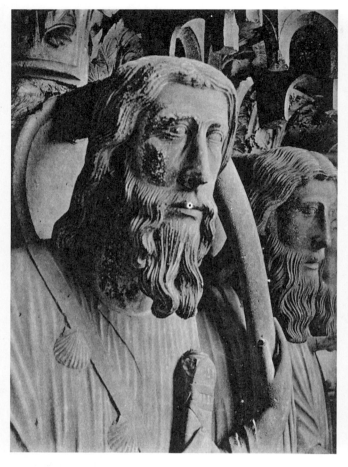 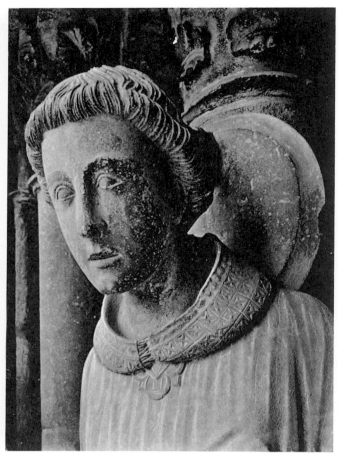

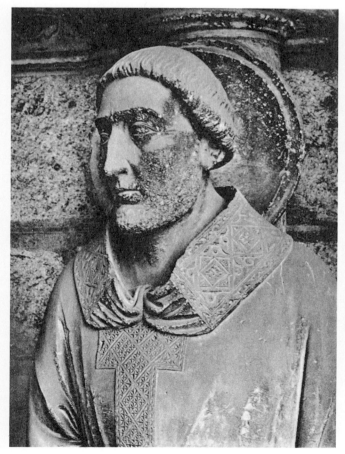 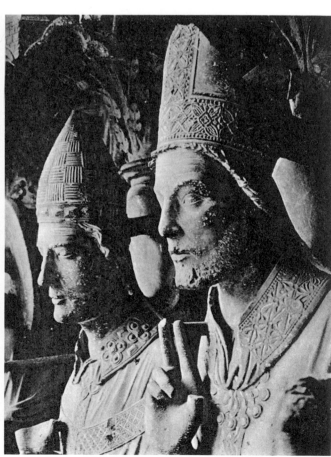

86

PARIS (Seine). CATHEDRAL
West Front. Left Door

Tympanum: Resurrection and Triumph of the Virgin. *Lintel:*
Three prophets and three kings. *Arch-rims:* Angels, prophets
and patriarchs, ancestors of the Virgin.

1210-1220

Photo Monuments historiques

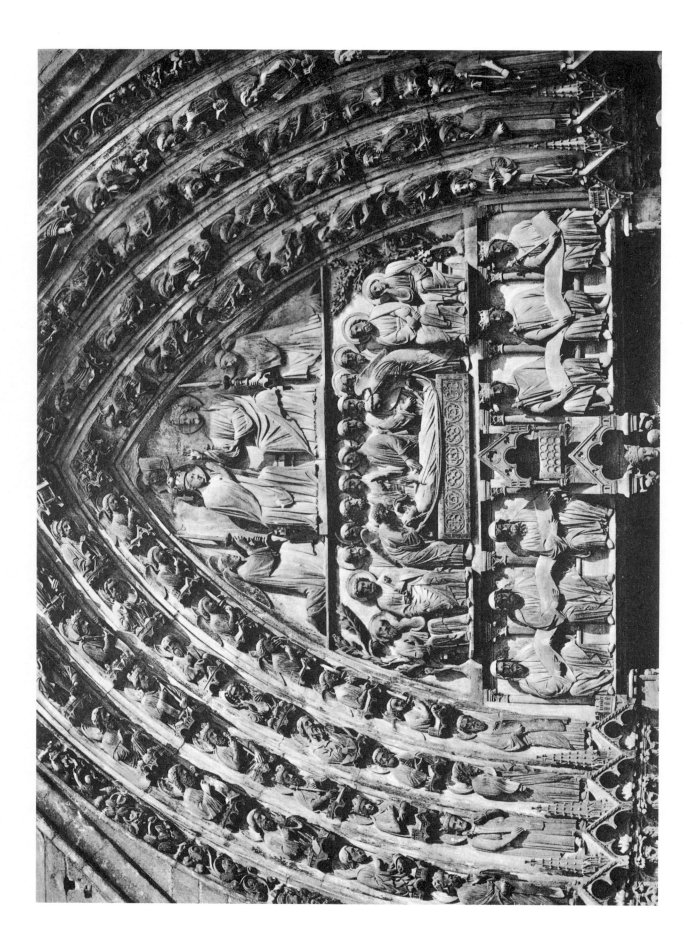

87

PARIS (Seine). CATHEDRAL
West Front. Left Door
Jambs: Details of the Occupations of the Months.
A. May. B. July. C. August.
1210-1220
Photo Giraudon

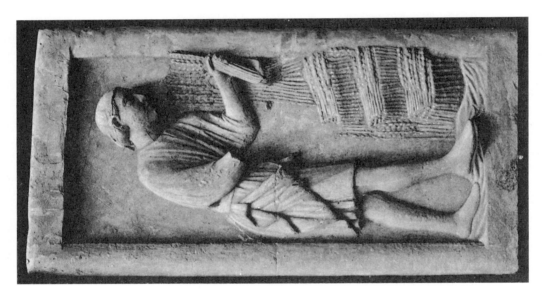

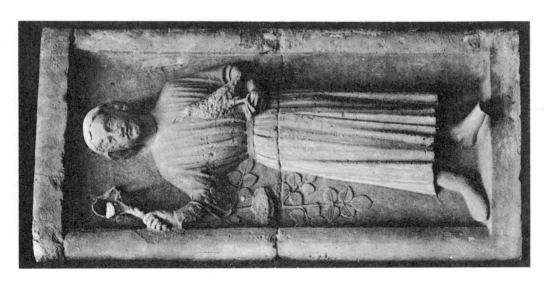

88

PARIS (Seine). CATHEDRAL
West Front. Left Door
Skirting, Details:
A. Triumph of the good angels.
B. Martyrdom of St. Stephen.
1210-1220
Photo Martin-Sabon (Archives d'Art et d'Histoire)

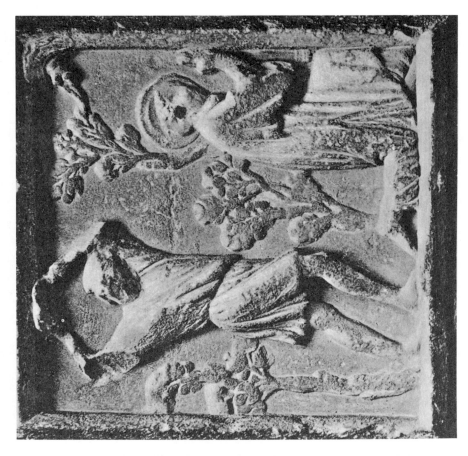

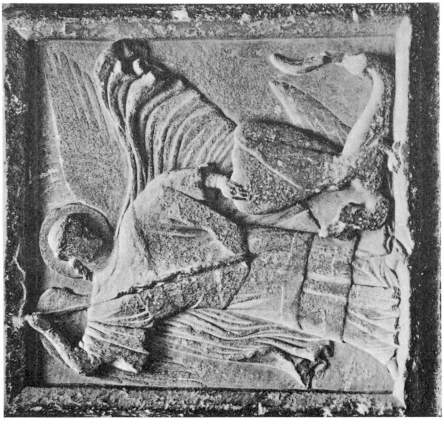

DATE DUE

MAY 7 1974			
GAYLORD			PRINTED IN U.S.A.